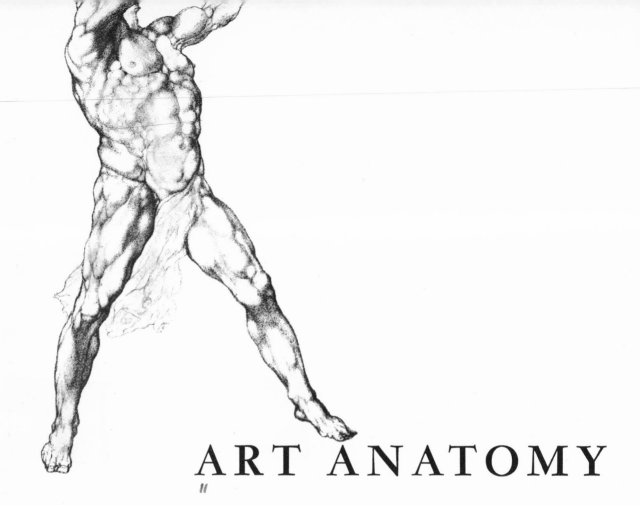

ART ANATOMY

By WILLIAM RIMMER

DOVER PUBLICATIONS, INC.

NEW YORK

Published in Canada by General Publishing Company, Ltd., 30 Lesmill Road, Don Mills, Toronto, Ontario.

Published in the United Kingdom by Constable and Company, Ltd., 10 Orange Street, London WC 2.

PUBLISHER'S NOTE

This new Dover edition, first published in 1962, is an unabridged and revised republication of the work originally published by Little, Brown, and Company in 1877.

For clarity, the arrangement of certain illustrations has been altered, and a few illustrations have been enlarged or slightly reduced in order to fit the work into this new format. The reader will observe that occasionally Rimmer's observations and diagram symbols are not entirely clear or complete. The publisher is aware of this, but chose to present the work without annotation because the faulty references are in every instance only incidental to the point being made. However, Dr. Rimmer's commentary has been edited to delete certain observations regarding minority groups which would seem offensive to the modern reader. Opinion and taste have changed greatly since this book was first published, and we are sure that Dr. Rimmer himself would now agree that these comments could well be omitted.

A new Introduction has been especially prepared for this Dover edition.

International Standard Book Number: 0-486-20908-3
Library of Congress Catalog Card Number: 63-3152

Manufactured in the United States of America
Dover Publications, Inc.
180 Varick Street
New York, N. Y. 10014

INTRODUCTION

WILLIAM RIMMER, sculptor, painter, and art anatomist, was born in Liverpool, England, on February 20, 1816. In 1818 the Rimmer family moved to Nova Scotia, and in 1826 to Boston, where William Rimmer spent his boyhood years.

Few artists in America have had a more unusual background. His mother was an Irish kitchen maid, his father a member of the French nobility who cloaked his identity under the name "Thomas Rimmer" and earned his living making shoes. Born under the Terror, "Thomas Rimmer" had apparently been spirited to England as a child and given to a South Lancashire yeoman family named Rimer to rear as their own son. Informed in early manhood of his aristocratic background, Rimmer waited for the return of his family to power in France; when these Bourbon hopes failed to materialize, he married a red-haired Irish woman, abandoned his commission in the British army, and, in despair and disappointment, sailed for the New World, where he brought up his family in poverty and extreme seclusion. The bitterness of the father passed on to the eldest son. Whatever the truth in the Bourbon claims may have been, there is reason to believe that William Rimmer, America's first great sculptor, grew up in the conviction that he was the son of the Dauphin of France.

For all its poverty, the Rimmer household in South Boston — the Boston of parish priests and street gangs — was one of refinement and learning. Thomas Rimmer educated his children as he himself had been educated, teaching them history, music, mathematics, ornithology, French, Latin, and Hebrew, while he pursued his own hobbies of electricity and metallurgy. Thomas Rimmer may have worked as a cobbler, but he had the viewpoint — and sometimes the nervous instability — of a dispossessed prince.

From an early age the boy William Rimmer showed signs of artistic ability. He cut butterflies from his mother's chintz quilts and at fifteen carved a small figure, called "Despair," from gypsum picked up at a granite yard at Wales Wharf near his home. It survives today to reveal remarkable intensity and instinct for anatomical detail. A study of Rimmer's father, it is perhaps the first male nude figure carved in America, anticipating Crawford's "Orpheus" by fifteen years.

His father's growing mental derangement forced William to assume early responsibility for the younger children. At fourteen he was helping out in the family finances

with his earnings as a draftsman and sign painter, and for the next seven years he worked diligently at typesetting, soap making, shoe making, and lithography. To the end of his life when all else failed him he supported his family by making shoes. Despite these difficulties, young Rimmer managed to produce paintings for the Endicott Street Catholic Church and other chapels and worked furiously at an eight-foot canvas entitled "After the Death of Abel"—afterward exhibited, at an entrance fee of twenty-five cents, by a friend who lost sixty dollars on the deal. Forming a sign-painting partnership with Elbridge Harris, Rimmer painted a huge "Cromwell at the Battle of Marston Moor," which hung opposite Old South Church and shocked Boston with its splashes of yellows and reds.

In 1840 Rimmer married Mary Hazard Peabody, a Quaker, and after a tour through Massachusetts of itinerant portrait painting, charging five to fifty dollars per portrait, settled down at Brockton and began the self-study of medicine. A friendly neighbor, Dr. Abel Kingman, lent him books from his library and allowed him, as did other Brockton physicians, to assist on calls. Rimmer became known for his "cold-water" treatment of typhoid, cholera, and smallpox, and in 1855 received a license to practice from the Suffolk Medical Society. He was the prototype of the country doctor: patient, quiet, sympathetic. Once, thrown from his buggy while on a call, he recovered himself and went on to tend his patients, setting his own nose before starting home. Long after he had abandoned medicine for art, he was known to his neighbors and townspeople as Dr. Rimmer.

It was perhaps because of his growing reputation as a physician that he was not accepted as an artist when his works — created at driving speed during his spare hours to fill out the family income — began to be shown. A head of St. Stephen, which he cut out of solid granite in four weeks of December, 1860, attracted the attention of his neighbors, particularly Stephen Higginson Perkins, who arranged for it to be shown in the Boston gallery of Williams and Everett. The public saw in it only the work of a gifted amateur, as they did in the case of his masterpiece, the "Falling Gladiator," produced under the worst of conditions in East Milton in 1861. For this task the basement was unheated; the clay froze and dried; his hands were bleeding when he finished. He had used no model but his own body, creating out of homemade utensils and smoothing the statue with a toothbrush when it was done. The public called it an "exhibition of muscles" by a dilletante. Even after it had been accepted by the Paris Salon of 1862 it was attacked — as Rodin's "Age of Bronze" would later be — as being a hoax, a cast from life from Rimmer's own body. Rimmer was hurt, but knew too little of the art world to defend himself. Indeed, asked to set a price for his "St. Stephen," he figured it modestly in terms of a stonemason's hourly pay and was amazed to be offered the sum of five hundred dollars.

The "Gladiator," however, made clear what had been only suggested by Rimmer's early work — that no artist in America had more understanding of human anatomy. Dr. Rimmer had seen the human body in sickness and strength; had attended the dissecting rooms of the Massachusetts Medical College and studied the plates in Vesalius, Albinus, Sabatini, Camper, and de Fau and Gray. His models were in his head — the

muscles and tendons of his patients. "Anatomy is the only subject," he once said, and indeed it was as an anatomist that Rimmer was increasingly known.

In 1861 Rimmer was invited to teach art anatomy in Boston and began a series of lectures in room 55 of Studio Building. By 1863 the demand had become so great that he took the lectures to Lowell Institute, where, because of the crowded hall, he delivered an extra series in the afternoon for women students. He had no objection to teaching women, and for those who felt they should be excluded or, as some suggested, veiled, Rimmer had nothing but contempt. "Art is as independent of sex as thought itself," he wrote, and became one of the champions of women's education in America.

From the first, Rimmer was an inspired teacher. He would enter the classroom saying "Here is a face I saw on the way here" and draw a striking likeness on the blackboard. In considering a muscle, he would first draw it independently on the board, then in its relations to the formation of the entire figure. Often his romantic nature would not allow him to stop there, and before the board would be erased it would be covered with clouds, angels, demonic armies in celestial warfare.

Many of his subjects he took from life. Thus the profile of Thomas Rimmer appears as "The Highest Average Outline: English" in a comparison of skull types inspired by Darwin's *Expression of Emotion in Men and Animals*. For other models he used the athletes at a private gymnasium at the corner of Eliot and Tremont Streets. At times the day's events moved him: when Charles Sumner died, Rimmer illustrated his lecture with a drawing of "Grief," for him a familiar subject.

In 1866, after the partial failure of his one public commission, the statue of Alexander Hamilton on Commonwealth Avenue in Boston, Rimmer accepted an invitation from Peter Cooper to become director, at a salary of $4000 a year, of the School of Design for Women at New York's Cooper Union for the Advancement of Science and Art. Rimmer's four years at Cooper Union were both stimulating and stormy. "Stubborn and unreasonable" was the opinion of many of his colleagues when he proposed sweeping changes in the curriculum or suggested women might learn art anatomy as well as "designing for manufacturing patterns." "You are a remarkable man, Dr. Rimmer," Abraham S. Hewitt, speaking for the harried trustees, told him, "but a hard man to manage." Rimmer answered that he had come to manage, not to be managed. When in 1870 he was offered a subordinate position as instructor, he declined and returned to Boston. "The trustees are not artists" was his final word.

By now Rimmer was known as a sculptor and teacher, if an eccentric one. He joined the Boston Art Club and for the first time met the famous artists of his day. He was too much his own man, however, to fit easily into the recognized art world. When the successful painter William Morris Hunt asked him to collaborate on the murals for the New York State Capitol at Albany, Rimmer made such impertinent suggestions for changes that Hunt paid him $100 for his time and was relieved to see him go.

The same lack of success followed him in other ventures. A photo-sculpture concern to which he lent his name proved to be spurious. Inventions by which he hoped to ease

his family's poverty — including a new type of gun lock and an unbreakable trunk — came to nothing. A scientific aquarium he was sponsoring went bankrupt before it could open. As a final blow, a heroic figure of "Faith" which he had designed for the top of the Pilgrim Monument in Plymouth was drastically altered by the plasterer. Rimmer's health broke; he suffered a complete breakdown, and in August, 1879, died at his daughter's home in South Milford, as disappointed by life as his father before him.

When the following year an exhibition of 146 examples of Rimmer's painting, drawing, and sculpture opened in Boston, the public seemed never to have heard of him. Even his closest associates were surprised to learn that he painted; indeed, his paintings were so little valued that today only one-sixth survive. Yet it was immediately apparent to some observers that here was work — in such paintings as "The Lion in the Arena" and pieces of sculpture like "The Dying Centaur" — of great immediacy and power. While a final estimate of his work is yet to be made, the exhibition sponsored jointly by the Whitney Museum of American Art in New York and the Museum of Fine Arts in Boston in 1946-1947 showed Rimmer to be a highly imaginative painter and the most gifted American sculptor of his time. In the boldness and speed of execution of his work, he has been hailed as a forerunner of the Ash Can School and even of modern-day Abstract Expressionism.

He was hampered by many things — the unusual circumstances of his father's birth, the absence of encouragement or contact with other artists, the grinding poverty that followed him all his life. Of equal importance was the fact of his being an American at a time when art was thought to reside in Europe. "Ah! a foreign painting, I see," an interested art dealer said upon seeing his work. "No," Rimmer's friend replied, "it is the work of a poor country physician," whereupon, the friend relates, the dealer "immediately began to discover faults in it." His students knew and appreciated him better. "The poor long-suffering doctor" Daniel Chester French wrote of him, " . . . he just missed being great."

Rimmer's *Art Anatomy* is the product of his later years and perhaps his greatest work. For years concern had been expressed that Rimmer's greatest drawings, the blackboard figures that accompanied his lectures, were being lost; one student, Mrs. John M. Forbes of Milton, had even traced the drawings onto tracing paper, later to be transferred to cloth, to preserve them. At the same time, Rimmer's illuminating comments were, except for lecture abstracts that appeared in the *Providence Journal* in 1872, going unrecorded. The *Art Anatomy*, published by means of a gift of $2000 by Mrs. W. A. Tappan of Boston, answered both problems. Finished by Rimmer during the summer of 1876 at Union, New Hampshire, and reproduced by a heliotype process, in red ink from Rimmer's pencil drawings, the book of eighty pages 10 by 14 inches in size sold for $50 in an edition of 50 copies. It is perhaps the finest work of art anatomy in America.

Rimmer was, of course, a master draftsman, who drew, according to his family, on every scrap of paper in sight, and here, spared the necessities of color, he could go beyond his paintings into a freer treatment of the subject he loved the most — the human body. He drew it, after his own experience, at the limits of human endurance. As the "Falling

Gladiator" represents the body about to break under tension, his many drawings of falling figures (the true test of a draftsman, according to Ingres) represent the body in its final struggle with space. Rimmer saw life as a contest, and it is not without significance that he was fond of Beethoven and valued Blake even above Michelangelo. "Make your men deep-chested and narrow-waisted, like a lion," he wrote, "for we live in this world not by let but by opposition."

If Rimmer loved the body, he loved its features most. He knew Lavater's charts of the emotions and the phrenological system of Spurzheim, and firmly believed that physiognomy had meaning, that no one knew the human face who did not know the battle of morality taking place there. Thus he could speak of "high types" and "low types" of man, and write of a contemporary art critic: "What a supercilious nose; what a half-boorish, sneaking mouth; what a detestable play of muscles of the face."

His aim in the *Art Anatomy,* of course, was pedagogical — he fervently believed in art education and proper training ("As well set a person down to read a foreign language before he has learned the values of the letters . . . as to ask a person to draw a human figure without some knowledge of the bones and muscles which compose it"). The finished product, however, goes far beyond pedagogy. Rimmer had conceived of a book of art instruction; he produced a work of art in itself.

It is safe to say that the kind of art anatomy Rimmer represents — the anatomy of a Leonardo which is itself art — no longer exists in America. We want more objective information now, truth without beauty. Nor can we accept what seems the naïve interpretation of the passions — that nobility resides in the brow or avarice in the mouth. If Rimmer's judgments seem dated to us, however, it is significant that he *made* judgments, that he gave nobility a place at all. We have lost the simple-minded dream, and with it much of the human drama, and much of the art.

The final evaluation of Rimmer is only beginning to be made. As a teacher he influenced such figures as John La Farge, Daniel Chester French, Frederic Vinton, and Frank Benson. As a painter he was a generation ahead of his time. As a sculptor he produced one masterpiece — the "Falling Gladiator" — and had few equals in nineteenth-century America. We believe his *Art Anatomy* to be the greatest art educational work ever produced in the United States.

Dover Publications publishes it now in the hope that it will be as useful and instructive for a new generation as Rimmer's lectures were in his own time. If it has the further virtue of reawakening interest in one of America's greatest and most neglected artists, this book will have fulfilled its purpose.

ROBERT HUTCHINSON

NEW YORK, 1961

CONTENTS

THE HEAD

THE BODY

THE HEAD

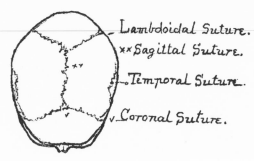

Lambdoidal Suture.
×× Sagittal Suture.
Temporal Suture.
∨ Coronal Suture.

No. 4
Head an egg-shaped oval

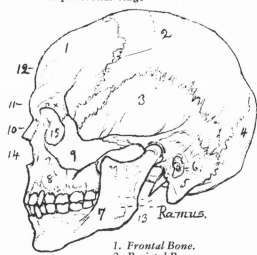

No. 1*
Super-orbital ridge

× *Super-orbital ridge*

Parietal Bone.
Temporal Bone
Occipital Bone.
Mastoid process of Temporal Bone.
Angle of Jaw.

No. 7

1. *Frontal Bone.*
2. *Parietal Bone.*
3. *Temporal Bone.*
4. *Occipital Bone.*
5. *Mastoid Process of Temporal Bone.*
6. *Auditory Cavity.*
7. *Inferior Maxillary Bone.*
8. *Superior Maxillary Bone.*
9. *Malar Bone.*
10. *Nasal Bone.*
11. *Super-orbital Eminence.*
12. *Frontal Eminence.*
13. *Angle of Jaw.*
14. *Wing of Sphenoid.*

No. 5

Frontal-B. *Parietal*

Occipital

× *Malar Bone.* -

× *Mastoid process of Temporal Bone.*

× - × *Temporal Cavity.*

Articular process.
Sigmoid Notch.
Coronoid process.
× *Ramus, or ascending portion of Jaw.*
Alveolar or Cell Border of Jaw.
Angle of Jaw. *Chin projection.*
Basilar or inferior Border.

Frontal Outline.
Malar Bone.
Notice the form of the Orbital Cavities.
Orbital Rim.
Malar Outline.
× *Mastoid process of Temporal Bone.*
Sub-Malar Cavity.
Outline of Jaw.
Occipital Outline.
ⵞ *Sub-Maxillary Region.*
Angle of Jaw.

No. 6
Notice carefully the form of the several parts as seen from beneath.

Nos. 2 and 3 were not included by Dr. Rimmer.

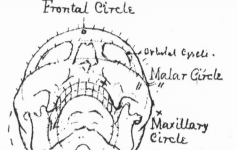

Frontal Bone.

Head an egg-shaped oval.

Temporal Bone.

Notice the form of the Orbital Cavities.

Mastoid process of Temporal Bone.

Angle of Jaw.

No. 8

Frontal Circle

Orbital Eyeli.

Malar Circle

Maxillary Circle

No. 8A
Plan showing the great circles
of the Face.

Superficial Muscles of the Face

1. Frontal portion of Occipito -
 Frontalis Muscle. The
 scalp is attached to this Muscle.
2. Occipital portion of the Occipito - Frontalis Muscle.
3. Articular Muscle of the Eyelid — Orbicularis Palpebrarum.
4. Pyramidalis Nasi.
5. Elevator of the Wing of the Nose
 and of the Upper Lip.
 Levator Labii Superioris —
 Alaeque Nasi.
6. Zygomaticus Minor.
7. Zygomaticus Major.
8. Proper Elevator of the Upper Lip —
 Levator Labii Superioris.
9. Compressor Nasi.
10. Orbicular Muscle of the Lips — Orbicularis Oris.
11. Risorius.
12. Masseter — Great Muscle of the Lower Jaw —
 Superficial portion.
13. Deep portion.
14. Depressor Anguli Oris.
15. Elevator of the Chin — Levator Menti.
16. Depressor Labii Inferioris.
17. Platysma Myoides — Muscle of the Skin.
 A broad thin plane of muscular
 fibres placed immediately
 beneath the skin on the side of the neck.
18. Sterno - Mastoid Muscle.
19. Trapezius Muscle.
20. Splenius Muscle.
21. Levator Anguli Scapulae.
22. Scalenus Posticus.
23. Parotid Gland.

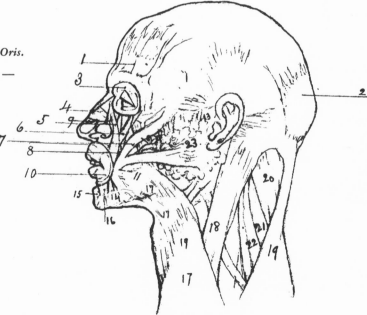

No. 9
Superficial Muscles of the Face

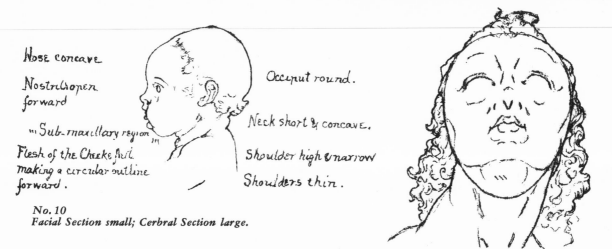

Nose concave

Nostrils open forward

Sub-maxillary region

Flesh of the Cheeke full making a circular outline forward.

Occiput round.

Neck short & concave.

Shoulder high & narrow

Shoulders thin.

No. 10
Facial Section small; Cerbral Section large.

No. 13
Head an Egg-shaped oval
In this position the Cerebral portion of the Head is thrown back and lowered. The facial portion being elevated, is brought forward. See Plan No. 6.

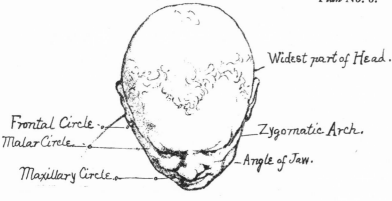

Widest part of Head.

Frontal Circle
Malar Circle

Maxillary Circle

Zygomatic Arch.

Angle of Jaw.

No. 12
Head an Egg-shaped oval
In this position, the Cerebral position of the head is brought into view. The Facial portion by being thrown under is obscured — the Bulb of the Nose covers the lips; the Malar Bones cover the Maxillary Planes; the Super-orbital Eminences cover the Eyes.

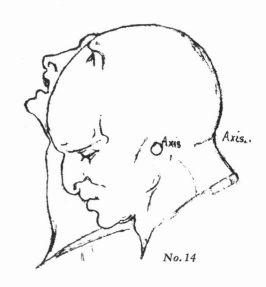

Axis Axis.

No. 14

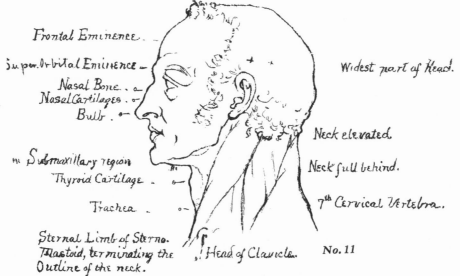

Frontal Eminence

Super Orbital Eminence

Nasal Bone

Nasal Cartilages

Bulb

Sub maxillary region

Thyroid Cartilage

Trachea

Sternal Limb of Sterno. Mastoid, terminating the Outline of the neck.

Head of Clavicle.

Widest part of Head.

Neck elevated.

Neck full behind.

7th Cervical Vertebra.

No. 11

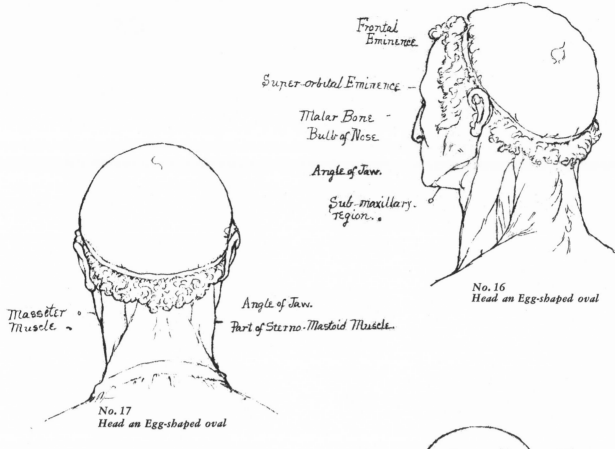

Frontal
Eminence

Super-orbital Eminence

Malar Bone
Bulb of Nose

Angle of Jaw.

Sub-maxillary.
region.

No. 16
Head an Egg-shaped oval

Masseter
Muscle

Angle of Jaw.
Part of Sterno-Mastoid Muscle.

No. 17
Head an Egg-shaped oval

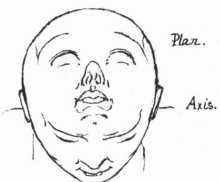

Plan.

Axis.

No. 18
Head, looking up or down,
an Egg-shaped oval.

Find the circles.

What is the form of the Head seen from
above — below — from the side? What parts
come into view as the Head is placed in dif-
ferent positions?

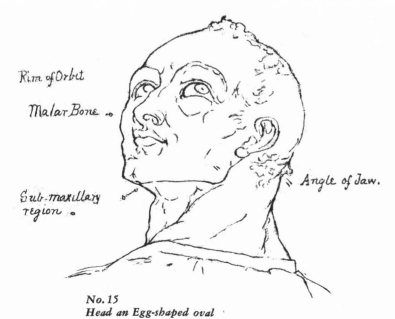

Rim of Orbit

Malar Bone

Angle of Jaw.

Sub-maxillary
region

No. 15
Head an Egg-shaped oval

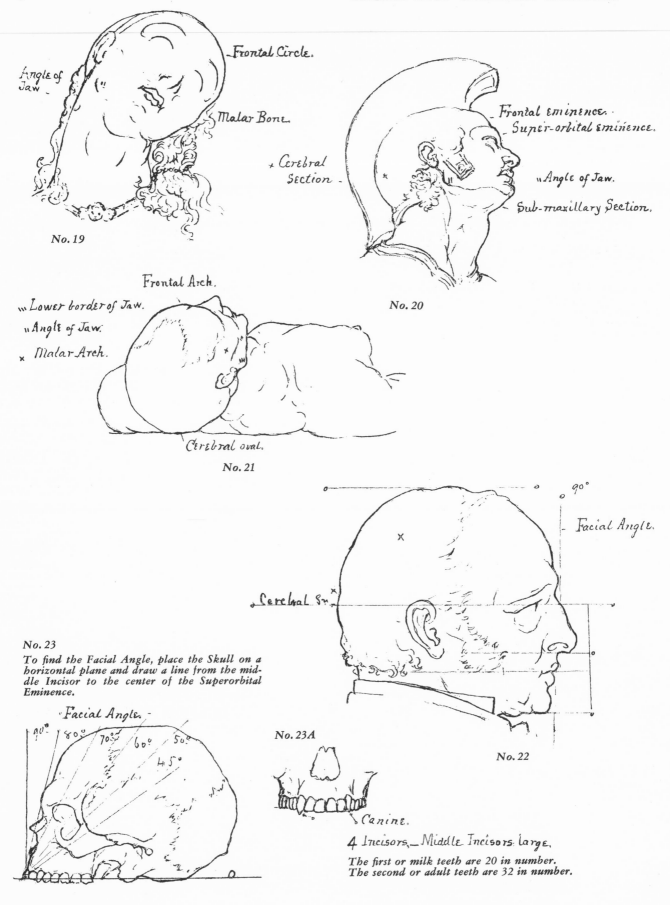

Angle of Jaw

Frontal Circle.

Malar Bone.

Cerebral Section.

No. 19

Frontal eminence.

Super-orbital eminence.

Angle of Jaw.

Sub-maxillary Section.

No. 20

Frontal Arch.

Lower border of Jaw.

Angle of Jaw.

Malar Arch.

Cerebral oval.

No. 21

90°

Facial Angle.

Cerebral Sn

No. 23

To find the Facial Angle, place the Skull on a horizontal plane and draw a line from the middle Incisor to the center of the Superorbital Eminence.

Facial Angle.

90° 80° 70° 60° 50°

45°

No. 23A

No. 22

Canine.

4 Incisors. — Middle Incisors large.

The first or milk teeth are 20 in number.
The second or adult teeth are 32 in number.

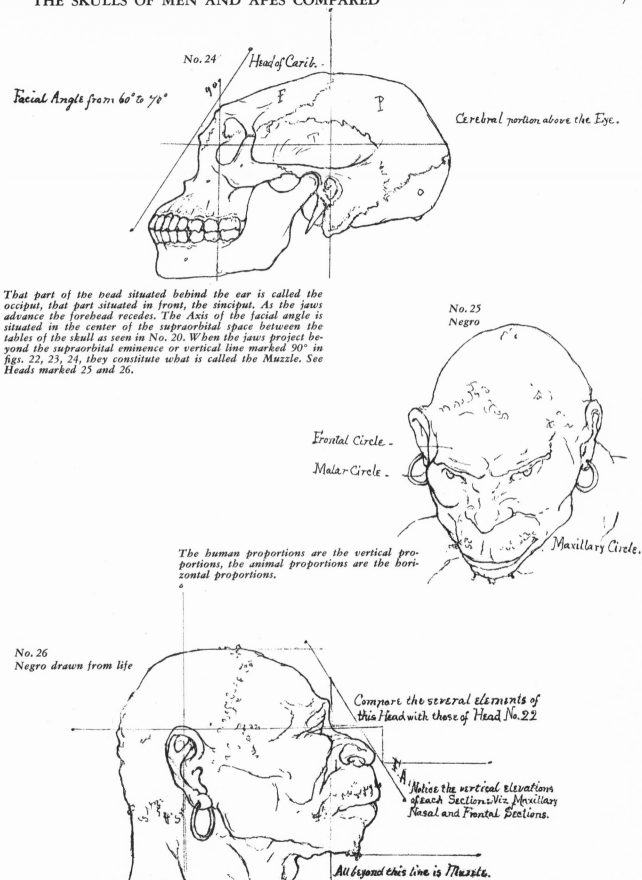

No. 24 · Head of Carib.

Facial Angle from 60° to 78°

Cerebral portion above the Eye.

That part of the head situated behind the ear is called the occiput, that part situated in front, the sinciput. As the jaws advance the forehead recedes. The Axis of the facial angle is situated in the center of the supraorbital space between the tables of the skull as seen in No. 20. When the jaws project beyond the supraorbital eminence or vertical line marked 90° in figs. 22, 23, 24, they constitute what is called the Muzzle. See Heads marked 25 and 26.

No. 25
Negro

Frontal Circle -

Malar Circle -

Maxillary Circle.

The human proportions are the vertical proportions, the animal proportions are the horizontal proportions.

No. 26
Negro drawn from life

Compare the several elements of this Head with those of Head No. 22

Notice the vertical elevations of each Section: Viz Maxillary Nasal and Frontal Sections.

All beyond this line is Muzzle.

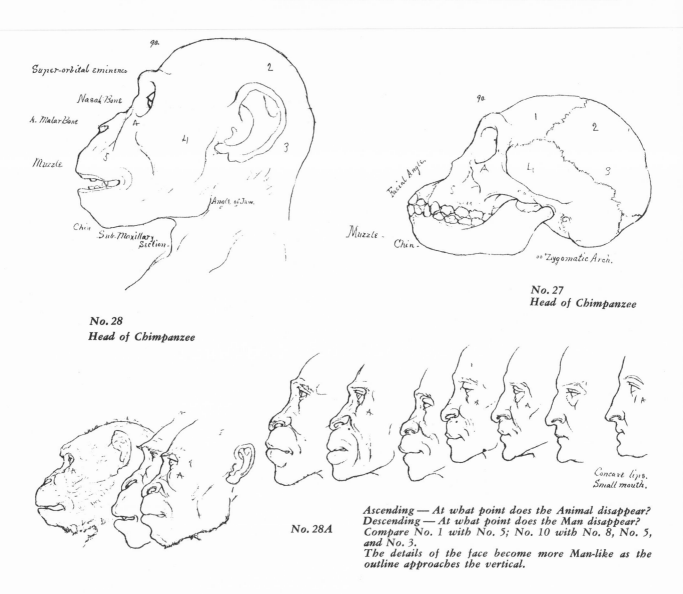

No. 28
Head of Chimpanzee

No. 27
Head of Chimpanzee

No. 28A

Ascending — At what point does the Animal disappear?
Descending — At what point does the Man disappear?
Compare No. 1 with No. 5; No. 10 with No. 8, No. 5,
and No. 3.
The details of the face become more Man-like as the
outline approaches the vertical.

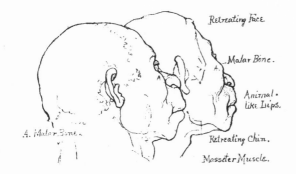

No. 29
Part 1 and 2

No. 32A
Compare with No. 29 Part 1 and 2.

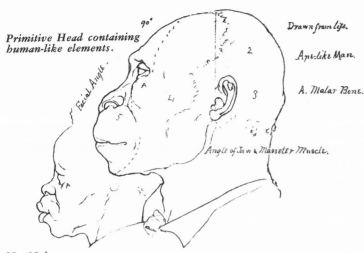

Primitive Head containing human-like elements.

Drawn from life.

Ape-like Man.

A. Malar Bone.

Facial Angle

Angle of Jaw & Masseter Muscle.

No. 29A

Ape-like man drawn from life.

Compare in this drawing the central portion of the Head with the Facial portion and the several Sections defined by the lines — each in the same Head with the other parts, and with other Heads in corresponding parts.

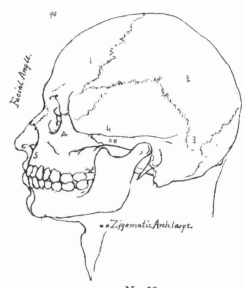

Facial Angle.

Zygomatic Arch large.

No. 30
Compare with Nos. 24 and 27.

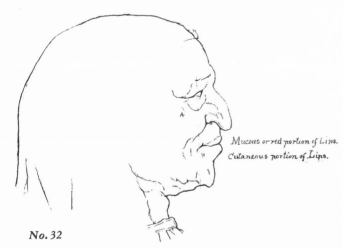

Mucous or red portion of Lips.

Cutaneous portion of Lips.

No. 32

Notice in these Heads the distance of the Malar Bone from the Nasal Bone. Notice, in Heads of Apes and of Ape-like Men, that in consequence of the great size of the Lips, the flesh of the Cheek is driven back upon the Malar Bone. Compare the Lips on Nos. 31 and 32, 20 and 22 with Lips in Nos. 25, 26, 28, and 29. Notice how great the distance from the Nose to the Chin in Heads 26 and 29. Compare with 31 and 32.

*Heads of the Animal type — Nos. 25, 26, 29, and 29 Part 1 and 2 are orderly heads, no part being less animal than another, the whole representing the race, character, disposition, and intellect of the person described.*Nos. 31 and 32 and Nos. 10-18 are orderly heads of the human type.*

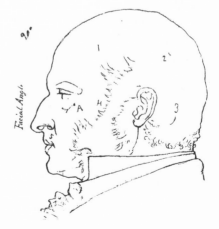

Facial Angle

No. 31

**Suppositional*

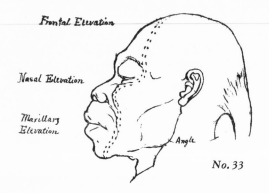

Frontal Elevation

Nasal Elevation

Maxillary Elevation

Angle

No. 33

Important. No intelligent idea of the head can be formed until the student has acquired a thorough knowledge of the Planes of the Face. The outline from the top of the forehead to the chin is the First Plane of the Face. A line drawn from the top of the forehead to the orbital cavity over the facial outline of the malar bone, behind the integument of the corner of the mouth to the corner of the chin (see dotted line No. 33), describes the Second Plane of the Face. Find the First and Second Planes in all the preceding heads. Compare them. Notice that as you ascend from the animal toward the human type, the areas of quantities are more and more inverted. See Plans W.W. In the animal-like head, the forehead retreats; the super-orbital eminences are thin and projecting; the nasal bones flat, rising but little above the malar bones. The lips are large and projecting and the maxillary circle from the nose to the chin arches outward. The malar bones are large and press upon the orbital cavities, at the same time advancing the second Plane of the Face toward the nasal bone. The basilar edge of the jaw is long, the angles project laterally, the chin retreats, the eyes are small and usually elevated at the outer corners, the mouth is deep and the teeth large. This is a description of the First and Second Animal Planes. An inversion of these proportions is seen in all the higher type heads. Plans W.W. give the First and Second Planes of the human head, front view.

Size inverted
Proportion inverted
Expression inverted
Compare throughout.

Facial Angle 75°

Angles of Jaws expanded laterally

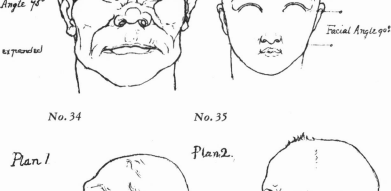

Plan W.

W. Plan.

Facial Angle 90°

No. 34 **No. 35**

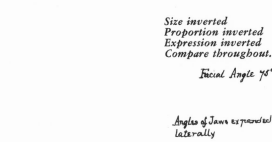

No. 28A
Head of Ourang
Museum of Natural History, Boston, Mass.

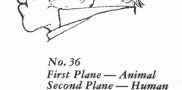

Plan 1 *Plan 2.*

No. 36
First Plane — Animal
Second Plane — Human

No. 37
First Plane — Human
Second Plane — Animal

Notice how much a head is debased when the mouth and jaws are of the animal type. Compare Plans 2 & 4 with 1 & 3.

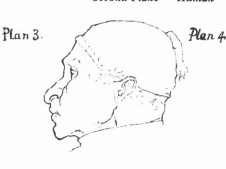

Plan 3. *Plan 4*

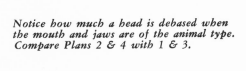

No. 38
Upper parts of First and Second Planes Animal.
Lower parts of First and Second Planes Human.

No. 39
Upper parts of First and Second Planes Human. Lower parts of First and Second Planes Animal-like.

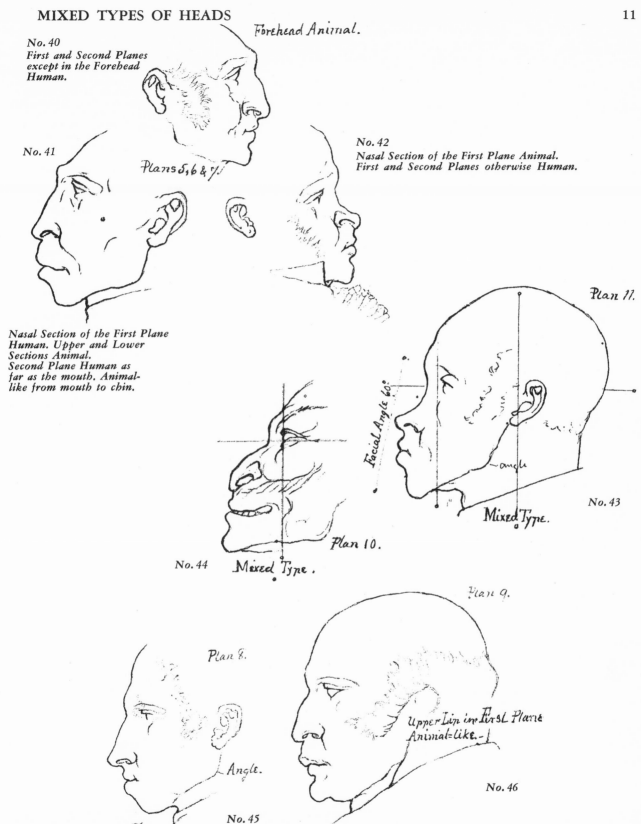

No. 40
*First and Second Planes
except in the Forehead
Human.*

Forehead Animal.

No. 41

Plans 5, 6 & 7.

No. 42
*Nasal Section of the First Plane Animal.
First and Second Planes otherwise Human.*

*Nasal Section of the First Plane
Human. Upper and Lower
Sections Animal.
Second Plane Human as
far as the mouth. Animal-
like from mouth to chin.*

Plan 11.

Facial Angle 60°

angle

No. 43

Mixed Type.

Plan 10.

No. 44 Mixed Type.

Plan 9.

Plan 8.

Upper Lip in First Plane
Animal-like.

Angle.

No. 46

No. 45

Under Lip & Chin, First
Plane, Animal.

*As the head advances from the animal to the human form, the Planes of
the Face separate; the outline becomes more erect and the quantities become
inverted; See Plan W, 34 & 35 and head No. 28. The Planes of the Face in
their numerous inter-relations describe both the physical and intellectual
attributes of the individual.* The skulls of men and of apes have the same
structural peculiarities.*

**Suppositional*

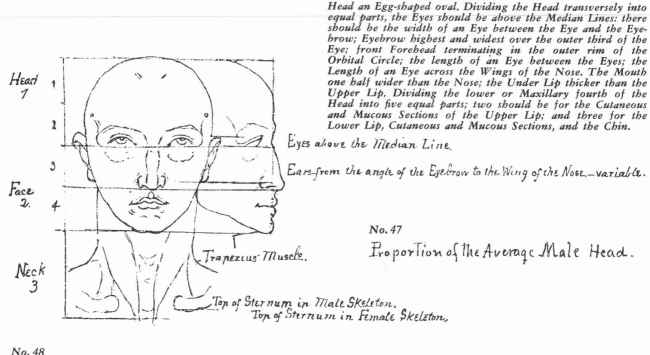

Head an Egg-shaped oval. Dividing the Head transversely into equal parts, the Eyes should be above the Median Lines: there should be the width of an Eye between the Eye and the Eyebrow; Eyebrow highest and widest over the outer third of the Eye; front Forehead terminating in the outer rim of the Orbital Circle; the length of an Eye between the Eyes; the Length of an Eye across the Wings of the Nose. The Mouth one half wider than the Nose; the Under Lip thicker than the Upper Lip. Dividing the lower or Maxillary fourth of the Head into five equal parts; two should be for the Cutaneous and Mucous Sections of the Upper Lip; and three for the Lower Lip, Cutaneous and Mucous Sections, and the Chin.

Eyes above the Median Line.

Ears from the angle of the Eyebrow to the Wing of the Nose,—variable.

No. 47

Proportion of the Average Male Head.

Head 1

Face 2.

Neck 3

1
2
3
4

Trapezius Muscle.

Top of Sternum in Male Skeleton.
Top of Sternum in Female Skeleton.

No. 48
Vertical Section of the Eyeball Notice that the Cornea projects beyond the common surface of the Globe of the Eye.

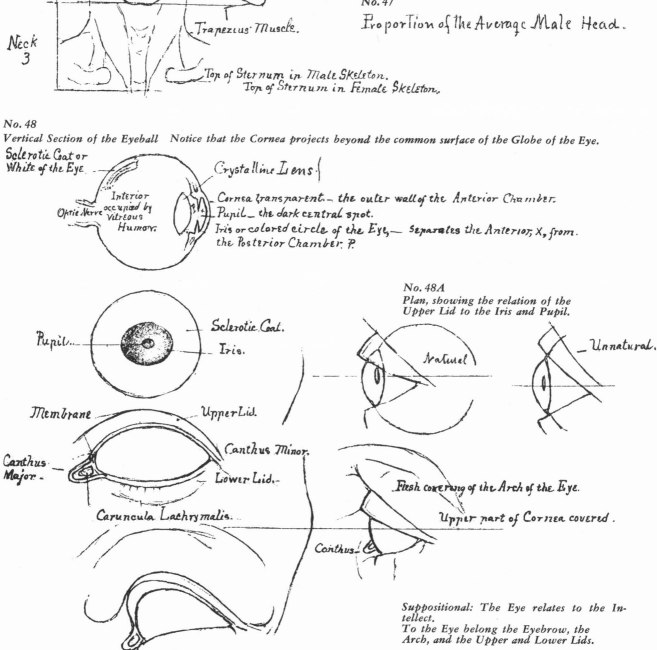

Sclerotic Coat or White of the Eye.

Interior occupied by Vitreous Humor.

Optic Nerve

Crystalline Lens.

Cornea transparent—the outer wall of the Anterior Chamber.
Pupil—the dark central spot.
Iris or colored circle of the Eye,—separates the Anterior, X, from the Posterior Chamber. P.

Pupil

Sclerotic Coat.
Iris.

Membrane

Canthus Major.

Caruncula Lachrymalis.

Upper Lid.

Canthus Minor.

Lower Lid.

No. 48A
Plan, showing the relation of the Upper Lid to the Iris and Pupil.

Natural

Unnatural.

Flesh covering of the Arch of the Eye.

Upper part of Cornea covered.

Canthus.

Suppositional: The Eye relates to the Intellect.
To the Eye belong the Eyebrow, the Arch, and the Upper and Lower Lids.

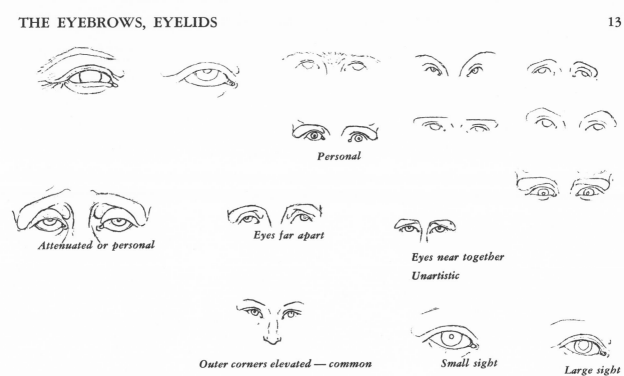

Personal

Attenuated or personal

Eyes far apart

Eyes near together
Unartistic

Outer corners elevated — common

Small sight

Large sight

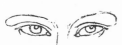

**Outer corners depressed — uncommon
Open Eyes; large Iris; Iris usually
gray, sometimes warm brown**

Individual peculiarity often American

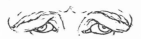

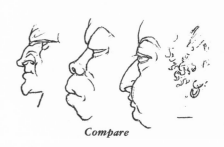

**Long Eyes; small Iris; Iris usually
black; Scleratic Coat porcelain
white or bilious yellow.**

**Individual peculiarity often Scotch
and Irish**

Compare

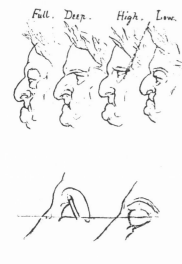

Full. Deep. High. Low.

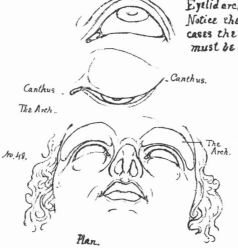

Eyelid arches over the Globe of the Eye.
Notice the projection of the Cornea. In all
cases the convexity of the Globe of the Eye
must be described by the Lid.

Canthus. Canthus.

The Arch.

No. 48. The Arch.

Plan.

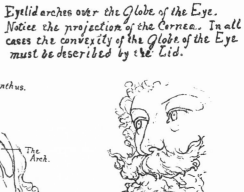

To show more clearly the change effected in the general expression by changing the form of an individual part, a single form of general outline has been adopted, the Head being the same in each Plan, Male and Female.

Fleshy Eminence or Pillar covering the corner of the Mouth.

Mucous portion of Upper Lip, composed of three parts, viz: Body 2, and Wings 1-3.

Mucous Section of Under Lip, - Composed of two parts, viz: Right & Left Lobes.

Capula.

- Upper Lip, Cutaneous portion.

Upper Lip, Mucous portion.

Lower Lip, Mucous portion.

- } Lower Lip, Cutaneous portion.

P.P. Elevated edges separating the Mucous portion of the Lips from the Cutaneous portion.

Chin. The Under Lip in the average Head, see No. 47, would be thicker than the Upper Lip.

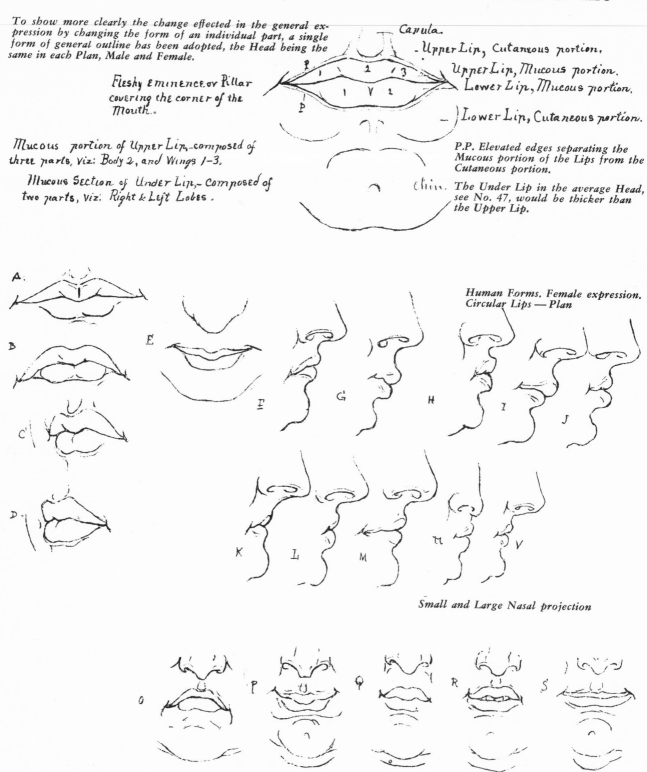

Human Forms. Female expression.
Circular Lips — Plan

Small and Large Nasal projection

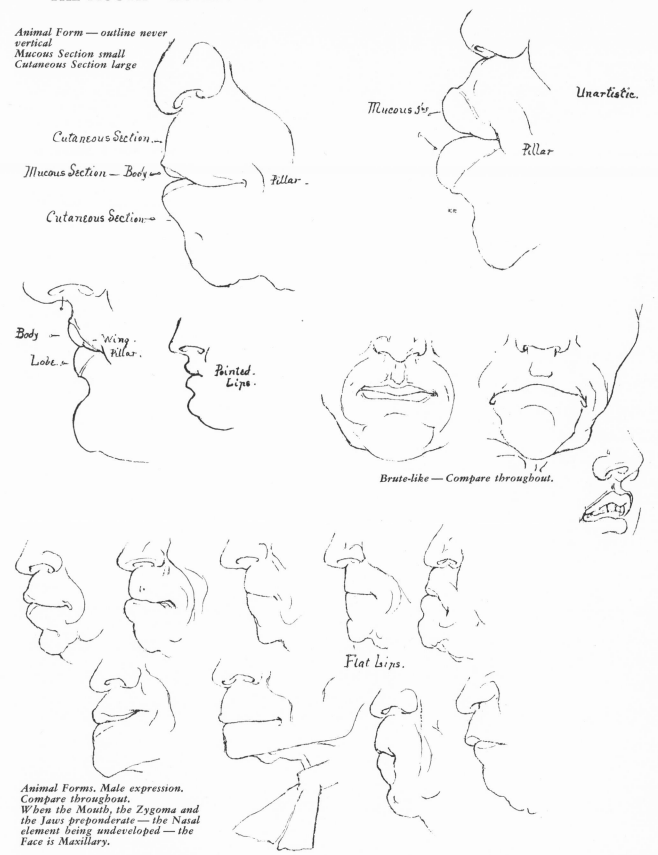

Animal Form — outline never vertical
Mucous Section small
Cutaneous Section large

Cutaneous Section

Mucous Section — Body

Cutaneous Section

Pillar

Unartistic.

Mucous S's

Pillar

Body

Lobe

Wing
Pillar

*Pointed.
Lips.*

Brute-like — Compare throughout.

Flat Lips.

*Animal Forms. Male expression.
Compare throughout.
When the Mouth, the Zygoma and
the Jaws preponderate — the Nasal
element being undeveloped — the
Face is Maxillary.*

*Suppositional: The Mouth relates to the
animal passions and the appetites.*

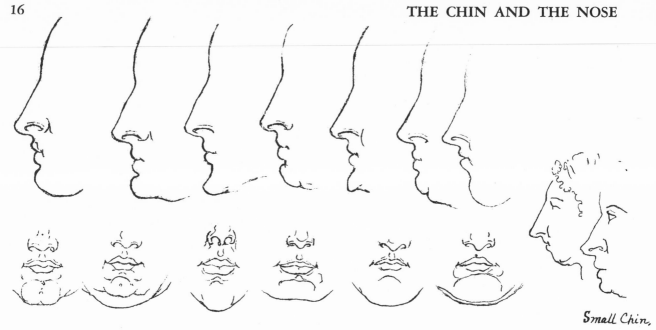

Small Chin.

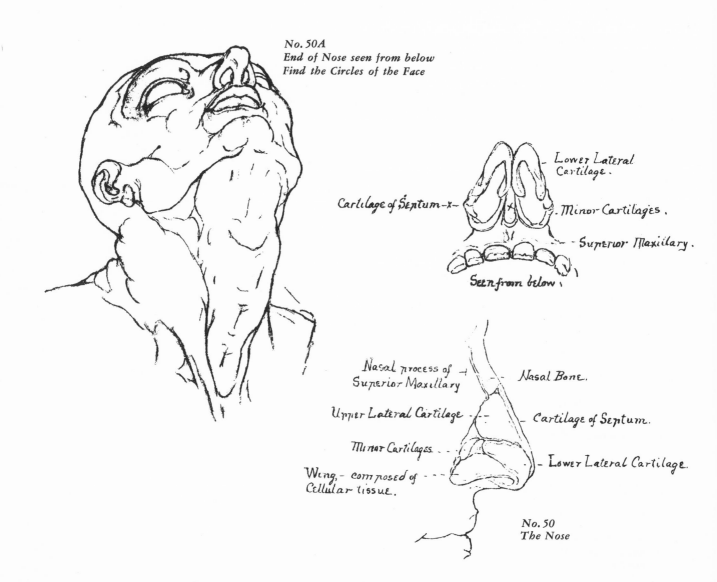

No. 50A
End of Nose seen from below
Find the Circles of the Face

Cartilage of Septum -x-

Lower Lateral Cartilage.

Minor Cartilages.

Superior Maxillary.

Seen from below.

Nasal process of Superior Maxillary

Nasal Bone.

Upper Lateral Cartilage

Cartilage of Septum.

Minor Cartilages

Lower Lateral Cartilage.

Wing, - composed of Cellular tissue.

No. 50
The Nose

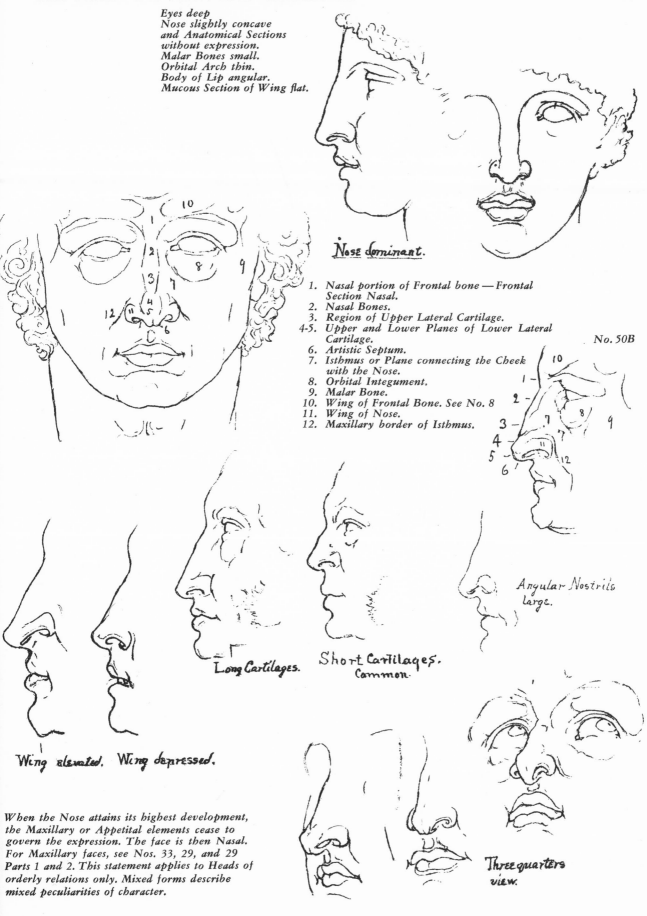

Eyes deep
Nose slightly concave
and Anatomical Sections
without expression.
Malar Bones small.
Orbital Arch thin.
Body of Lip angular.
Mucous Section of Wing flat.

Nose dominant.

1. *Nasal portion of Frontal bone — Frontal Section Nasal.*
2. *Nasal Bones.*
3. *Region of Upper Lateral Cartilage.*
4-5. *Upper and Lower Planes of Lower Lateral Cartilage.*
6. *Artistic Septum.*
7. *Isthmus or Plane connecting the Cheek with the Nose.*
8. *Orbital Integument.*
9. *Malar Bone.*
10. *Wing of Frontal Bone. See No. 8*
11. *Wing of Nose.*
12. *Maxillary border of Isthmus.*

No. 50B

Long Cartilages.

Short Cartilages.
Common.

Angular Nostrils
large.

Wing elevated. Wing depressed.

Three quarters
view.

When the Nose attains its highest development, the Maxillary or Appetital elements cease to govern the expression. The face is then Nasal. For Maxillary faces, see Nos. 33, 29, and 29 Parts 1 and 2. This statement applies to Heads of orderly relations only. Mixed forms describe mixed peculiarities of character.

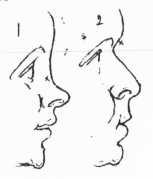
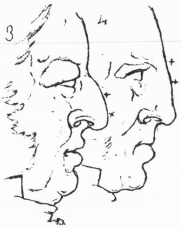
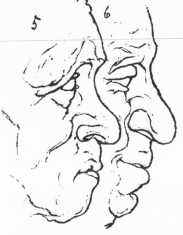

1. *Small Upper Cartilages.*
2. *Short Frontal Section.*

3. *Large Nasal Bones; Large Upper and Lower Cartilages.*
4. *Frontal Section very large; Nasal Bones large — uncommon.*

5. *Frontal Section and Nasal Bones small; Lower Cartilages large; Wings narrow.*
6. *Lower Cartilages very large; Nose bulbous; Wings large.*

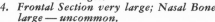

Compare.

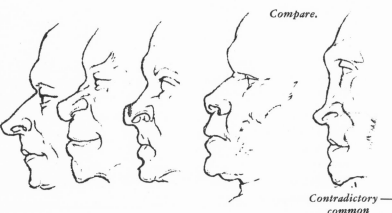
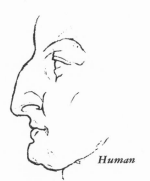

Contradictory — common

Human

A high Nose is seldom found in a Face of the Animal type.

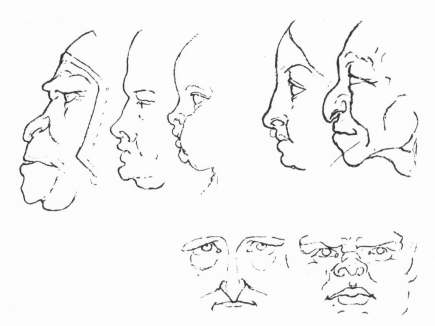
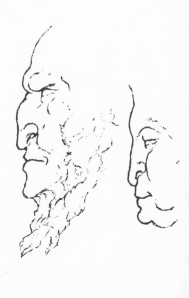

See Nasal Sections generally.

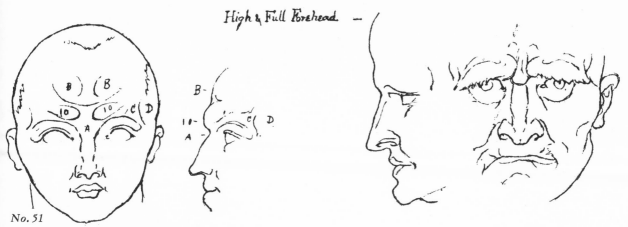

High & Full Forehead.

No. 51

10. *Wings — Superciliary Ridges,*
 Super-orbital Eminences.
A. *Frontal portion of Nasal Section.*
B. *Frontal Eminence — Right and Left Lobes.*
C. *External angular process — Pillar.*
D. *Temporal Cavity.*

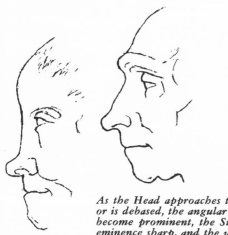

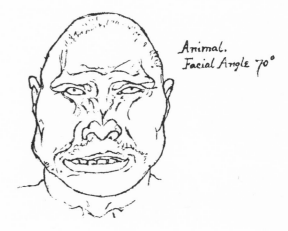

Animal.
Facial Angle 70°

As the Head approaches the Animal form,
or is debased, the angular processes
become prominent, the Super-orbital
eminence sharp, and the whole Forehead
rough and bony-looking.

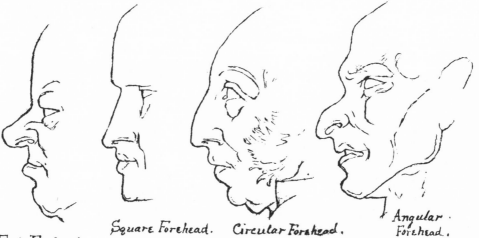

Flat Forehead.

Square Forehead.

Circular Forehead.

Angular
Forehead.

Frontal Eminence small.
A retreating Chin well formed
often accompanies a high Nose.

Suppositional: The Forehead above the Eye-
brows is an element of proportion only. The
Frontal Outline may be in advance of, over,
and behind the Facial Line. See Nos. 33 to 40
and Nos. 58 to 73.

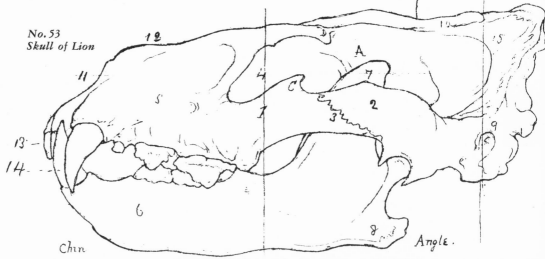

No. 52
Articular process
Masseter Muscle, superficial portion attached to the underborder of the Zygomatic Arch and to the Angle of the Jaw, and to more or less of the inferior border as the Jaws are more or less powerful.

a. Temporal Muscle.
attached to the
Coronoid process.

A. Malar Bone.

× Deep portion.

Masseter muscle

Articular process

Coronoid process.

Under Jaw of Chimpanzee.

Angle.

Chin.

No. 53
Skull of Lion

Chin.

Angle.

Compare the size of the Zygomatic Arch with the size of the whole Head. Make the same comparison with the following Heads.

1. **Malar Bone.**
2. **Zygomatic process of Temporal Bone.**
3. **Line of connection** — *This form of union is never inverted and is representative of the commonness of structure of vertebrates generally. It is sometimes absent.*
1-2. **Zygomatic Arch.**
4. **Orbital Cavity opening into the Temporal Cavity.**
 A. *The partition wall separating these parts in Man and the Apes and Quadrumana generally being undeveloped, as are the outer portions of the Orbital Arch, in this animal.*
 C-D. *The Orbital Chamber, incomplete.*
5-6. **Superior and Inferior Maxillary Bones.**
7. **Coronoid process of Inferior Maxillary.**
 Compare with Skulls of Men and of Apes in previous Sections.

8. **Angle of Jaw.**
9. **Auditory Cavity.**
10. **Bony Ridge for the attachment of the Temporal Muscle. See Nos. 52 and 56. Compare.**
11. **Nasal Cavity.**
12. **Nasal Bone.**
13. **Incisors** — *Six in number.*
14. **Canines.** *The Canine Teeth in Animals of this class are used both as instruments of destruction and prehension.*
15. **Occipital Bone** — *Nos. 53, 56; with certain variations in the size and form of individual parts, this is the representative form of Carnivorous Animals generally.*

Important — *The Size of the Masseter Muscle is in direct proportion to the length and strength of the Jaw.*

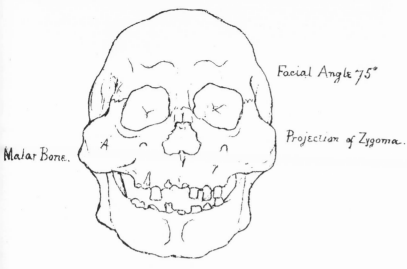

Facial Angle 75°

Projection of Zygoma.

Malar Bone.

A

No. 54
Skull of California Indian
Museum of Natural History, Boston, Mass.

Plan.

Zygomatic Arch —

Compare with No. 56.

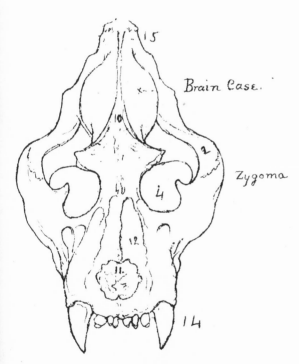

15

Brain Case.

2

Zygoma

12

11.

14

No. 56
Skull of Lion
seen from above three quarters

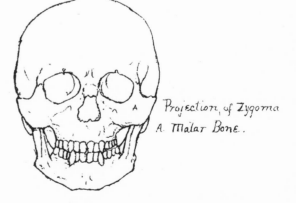

Projection of Zygoma
A. Malar Bone.

No. 55
Skull of Anglo-American
Compare with Skulls of Lions and Apes.

No. 58
*Long Jaw; wide Arch; protruding
Nasal and Maxillary Sections;
Zygoma strongly marked;
Cheeks flat.*

No. 57
*Head square
Oval irregular*

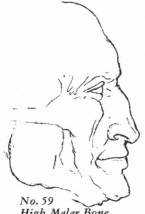

Malar Bone

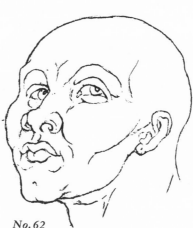

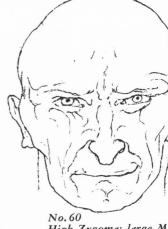

No. 59
*High Malar Bone
Masseter Muscle large*

No. 60
*High Zygoma; large Malar
Bone; deep Jaws; carvernous
Cheeks*

No. 62
*Broad Malar Bone;
Zygoma prominent.
Personal.*

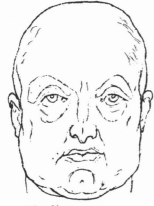

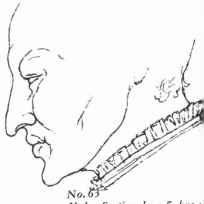

No. 61A

No. 63
Malar Section low & broa

No. 61
*Small Zygoma; small Malar
Bone; fleshy Cheeks & Chin.*

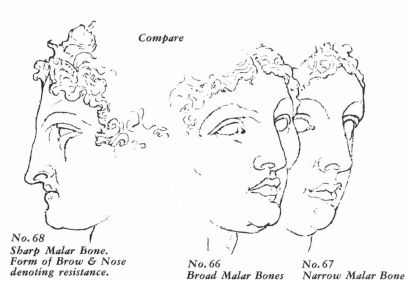

Compare

No. 68
Sharp Malar Bone.
Form of Brow & Nose
denoting resistance.

No. 66
Broad Malar Bones

No. 67
Narrow Malar Bone

No. 64
Oval irregular — Animal Form

When the Malar Bones are large, the Forehead is usually low, and the Brow thin. A fine Brow is seldom found in a Head in which the Jaws are coarse or Animal-like. No Head, however, is so finely formed that, being fully developed, it represents only the Spiritual in Art. It should not be forgotten that within the limits of the highest type many forms are possible — as many as there are intellectual graces or physical beauties. In describing the several passions, it should be remembered that a thoroughly Animal-like Head is a subject unfit for artistic representation.

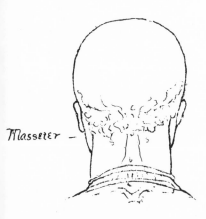

Masseter —

No. 65
Oval regular — Human Form

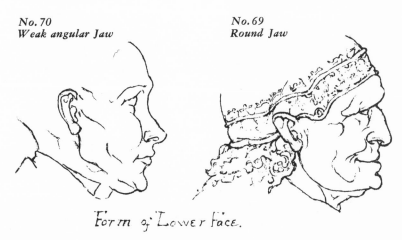

No. 70
Weak angular Jaw

No. 69
Round Jaw

Form of Lower Face.

No. 71
Square Jaw;
Long Zygoma.

No. 73
Concave Jaw;
Short Zygoma.

No. 72
Short Zygoma;
Fleshy Jaw.

No. 73A

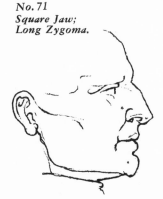

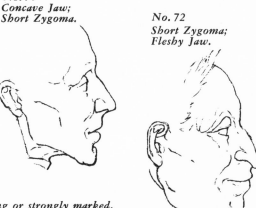

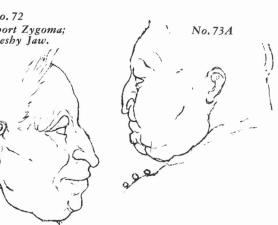

For Female form, see Chin section.
The jaws of women are seldom strong or strongly marked.
Men gesticulate less than women.

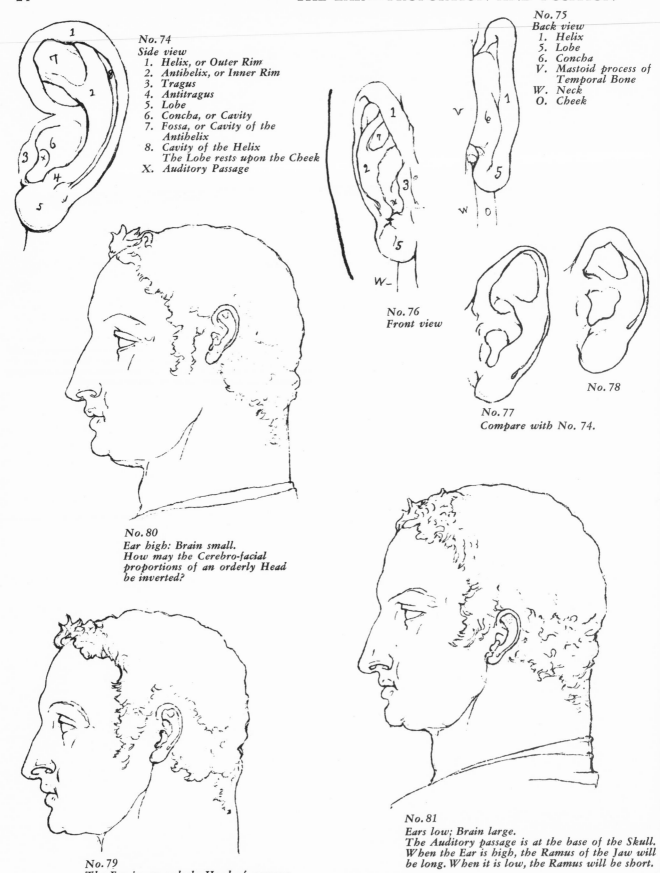

No. 74
Side view
1. *Helix, or Outer Rim*
2. *Antihelix, or Inner Rim*
3. *Tragus*
4. *Antitragus*
5. *Lobe*
6. *Concha, or Cavity*
7. *Fossa, or Cavity of the Antihelix*
8. *Cavity of the Helix*
 The Lobe rests upon the Cheek
X. *Auditory Passage*

No. 75
Back view
1. *Helix*
5. *Lobe*
6. *Concha*
V. *Mastoid process of Temporal Bone*
W. *Neck*
O. *Cheek*

No. 76
Front view

No. 77
Compare with No. 74.

No. 78

No. 80
Ear high: Brain small.
How may the Cerebro-facial proportions of an orderly Head be inverted?

No. 79
The Ear in an orderly Head of average proportions should be slightly toward the Occiput, looking at the Brow.

No. 81
Ears low; Brain large.
The Auditory passage is at the base of the Skull. When the Ear is high, the Ramus of the Jaw will be long. When it is low, the Ramus will be short.

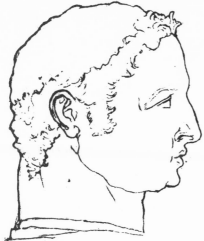

No. 82
*Ears far back; deep Face; small Occiput.
How may the Occipito-Frontal
proportions of an orderly Face
be inverted?*

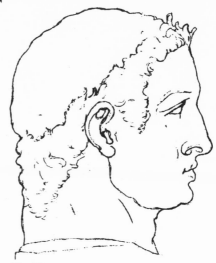

No. 83
*Ears in the middle of the Head
Small Face*

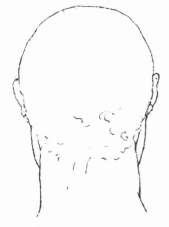

Compare

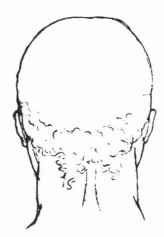

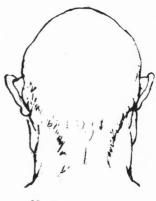

No. 84
*Proper position
See No. 79.*

No. 85
Ears high

No. 86
Animal-like

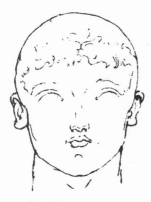

No. 87
Lobes projecting

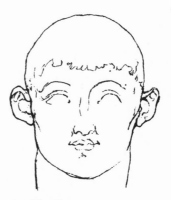

No. 88
Helix projecting

*Suppositional: The Ear is an element of proportion only. When
the Ears are coarse, the Hands and Feet are coarse. When the
Ear is well made, the Hands and Feet are well made.*

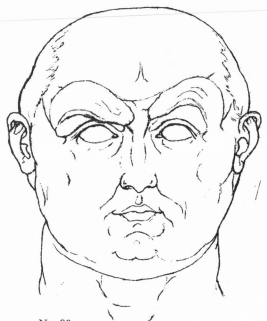

No. 89
Small Features; broad Head.

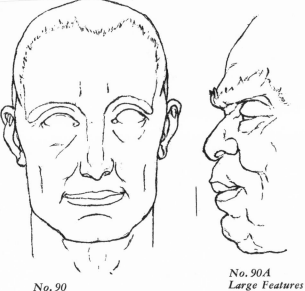

No. 90
Large Features; narrow Head.

No. 90A
Large Features

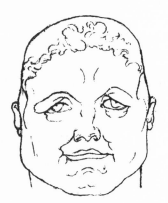

No. 91
Narrow Cranium;
Broad Face.

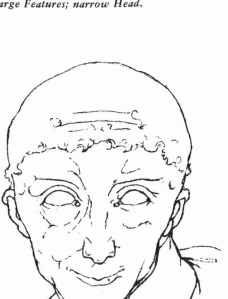

No. 92
Large Cranium; small Face; long Neck.

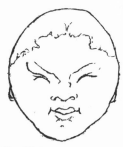

No. 92A
Oriental Head, nearly circular.

It should be noticed in reference to its artistic uses that the size of the Head relates rather to the perfection and activity of the whole Physical Economy than to the Intellect. The size of the Brain has no special connection with the strength of the understanding, other than as described above. The Cerebral part of the Head is an element of proportion only, and without the facial part is meaningless. Any covering may hide the Head above the Brow without greatly changing the expression of the Face. When the Forehead is covered, the Planes of the Face determine the Character.

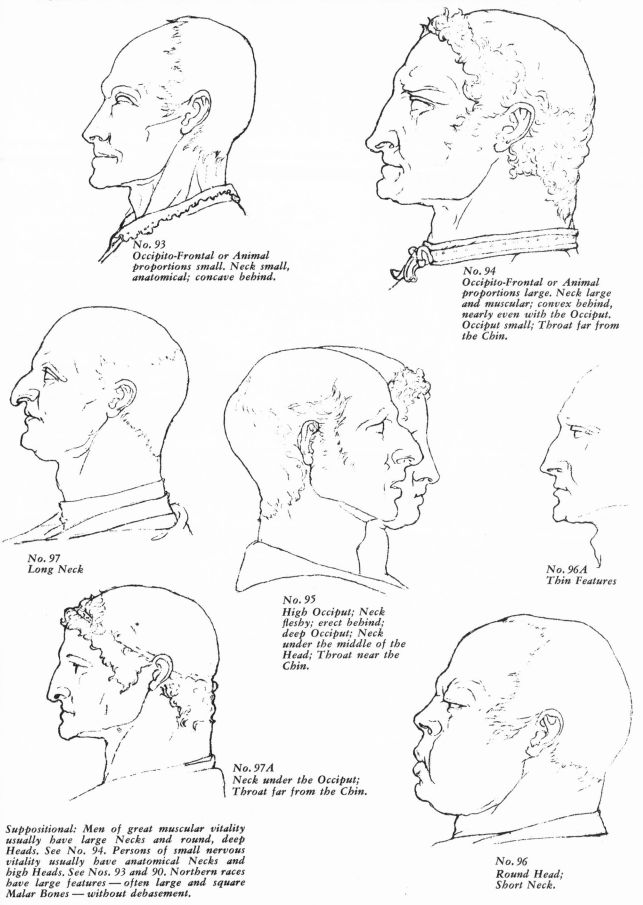

No. 93
*Occipito-Frontal or Animal
proportions small. Neck small,
anatomical; concave behind.*

No. 94
*Occipito-Frontal or Animal
proportions large. Neck large
and muscular; convex behind,
nearly even with the Occiput.
Occiput small; Throat far from
the Chin.*

No. 97
Long Neck

No. 95
*High Occiput; Neck
fleshy; erect behind;
deep Occiput; Neck
under the middle of the
Head; Throat near the
Chin.*

No. 96A
Thin Features

No. 97A
*Neck under the Occiput;
Throat far from the Chin.*

*Suppositional: Men of great muscular vitality
usually have large Necks and round, deep
Heads. See No. 94. Persons of small nervous
vitality usually have anatomical Necks and
high Heads. See Nos. 93 and 90. Northern races
have large features — often large and square
Malar Bones — without debasement.*

No. 96
*Round Head;
Short Neck.*

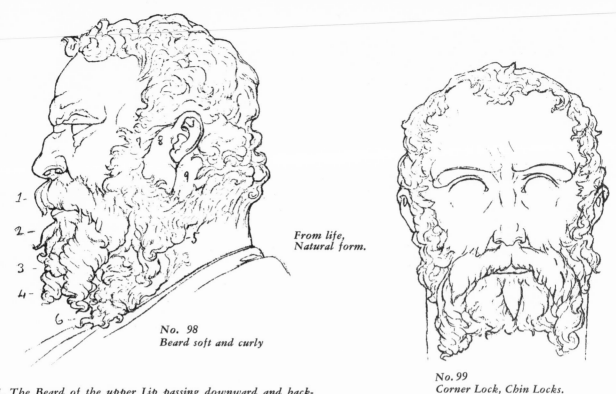

From life,
Natural form.

No. 98
Beard soft and curly

No. 99
Corner Lock, Chin Locks.

1. *The Beard of the upper Lip passing downward and backward, describing the Maxillary Arch, and enclosing the Beard of the Chin.* 2. *The central Lock of the under Lip.* 3. *Beard of the Chin.* 4. *The Beard of the sides of the Chin — Chin Locks.* 5. *Beard of the Angle of the Jaw.* 6. *Beard of the Throat.* 7. *Beard of the Cheek.* 8. *Open space between the Beard of the Cheek and the Angle of the Jaw.* 9. *Open space behind the Angle of the Jaw. The Hair of the Angle does not always join the Hair of the Occiput as here described.*

Strong, curly Hair usually denotes a strong Constitution. Heads of the highest type in both planes have generally soft, curly, or waving Hair. A coarse, thin Beard is seldom found when both Planes are of the highest type. The Beard of the upper Lip is harder than the Beard of the Cheek. The lower the Race, the coarser the Beard. A few coarse Hairs on the edge of the Lip marks one kind of Animal proportion. Women are seldom bald, Men often. Women are seldom gray, Men often.

No. 100
Compare with No. 98.
Exceptional

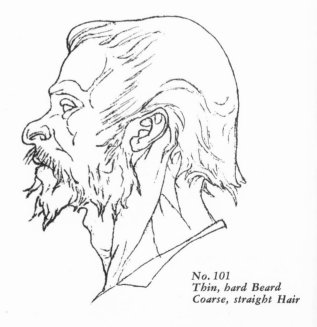

No. 101
Thin, hard Beard
Coarse, straight Hair

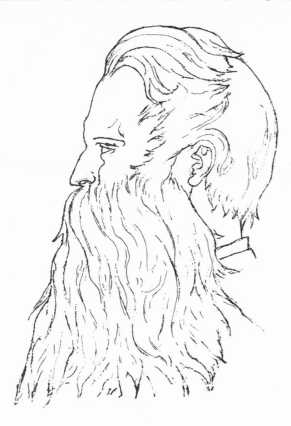

No. 68A
Head of Negro — from life.

No. 102
Hair straight, coarse, and abundant —
Animal texture. Beard coarse and
abundant — quality same as the Hair
on the Head.

Compare with Nos. 98, 99, 104, & 107.

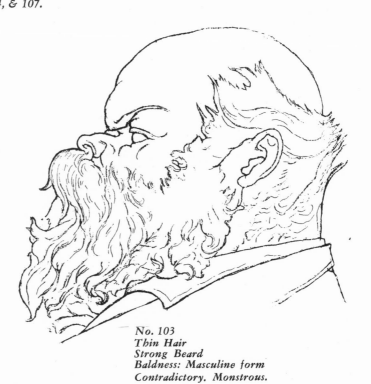

No. 103
Thin Hair
Strong Beard
Baldness: Masculine form
Contradictory. Monstrous.

Suppositional: The Beard and Hair relate to
the Physical Constitution.

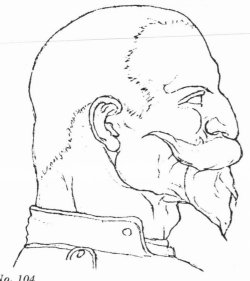

Compare

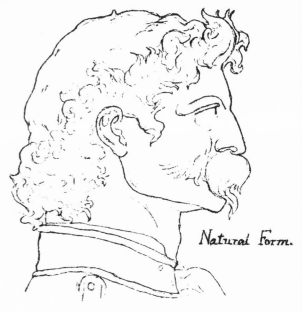

Natural Form.

No. 104

A natural form of Beard — found only where the Jaw is large and deep; generally where the Occipito-Frontal Elements preponderate. Beards in Heads of other forms are often made to resemble what is natural in this by shaving the Cheeks.
It should be noticed here that every artificial form of Beard has its antitype in nature.

No. 105

In some Heads, the lines of the Beard conform to the lines of the Planes of the Face. Compare No. 104 with No. 105.

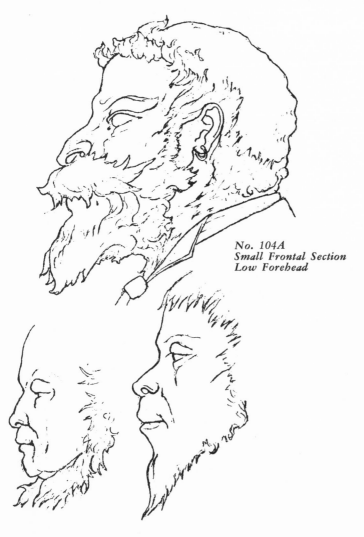

No. 104A
Small Frontal Section
Low Forehead

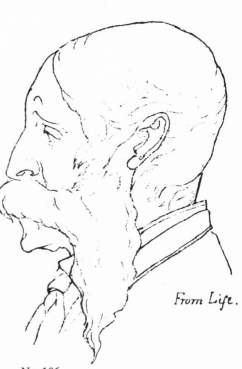

From Life.

No. 106

A weak Face may be further weakened by the disposition of the Hair and Beard.

No. 107
The Beard may hide the Features, but can never dominate in the expression of an intellectual Head. Compare with Nos. 104, 105, and 106.

No. 107A
Beard of the Angle of the Jaw
Large Frontal Section
High Forehead

No. 108
The Hair of the Head sometimes extends over the Frontal Section almost to the Brows. A low Forehead is a Forehead in which the Frontal Section is small. When the Forehead is much covered, the Planes of the Face determine its character.

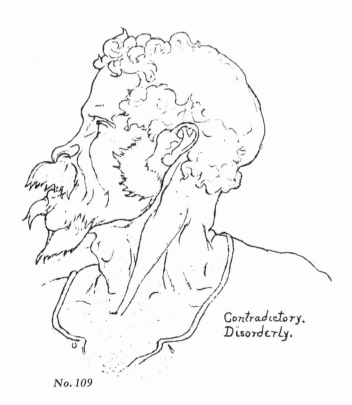

Contradictory.
Disorderly.

No. 109

Proportionate to the size of the Frontal Section, the naked portion is rather larger in Men than Women. See Heads of Women.

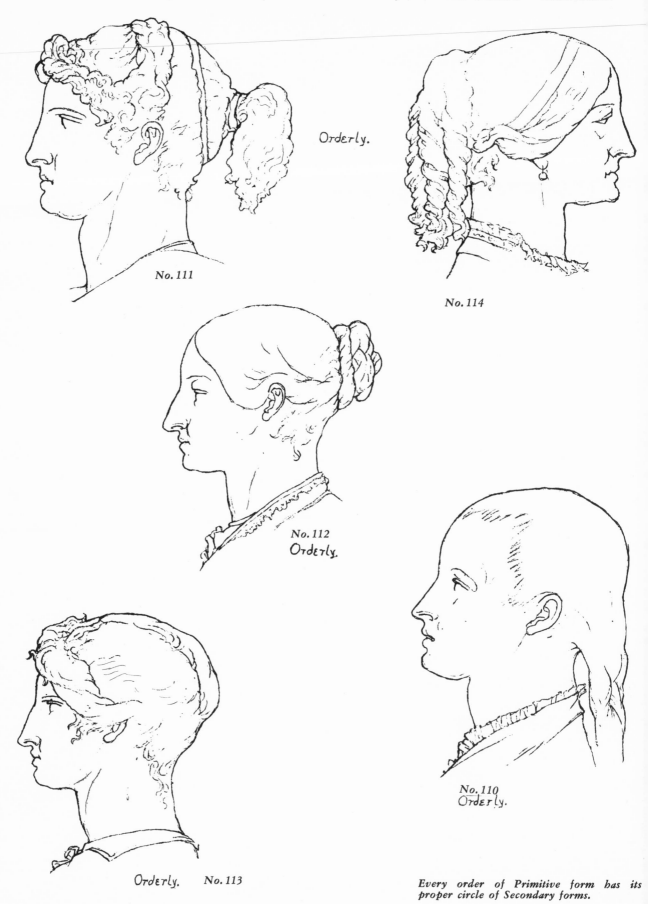

Orderly.

No. 111

No. 114

No. 112
Orderly.

No. 110
Orderly.

Orderly. No. 113

Every order of Primitive form has its proper circle of Secondary forms.

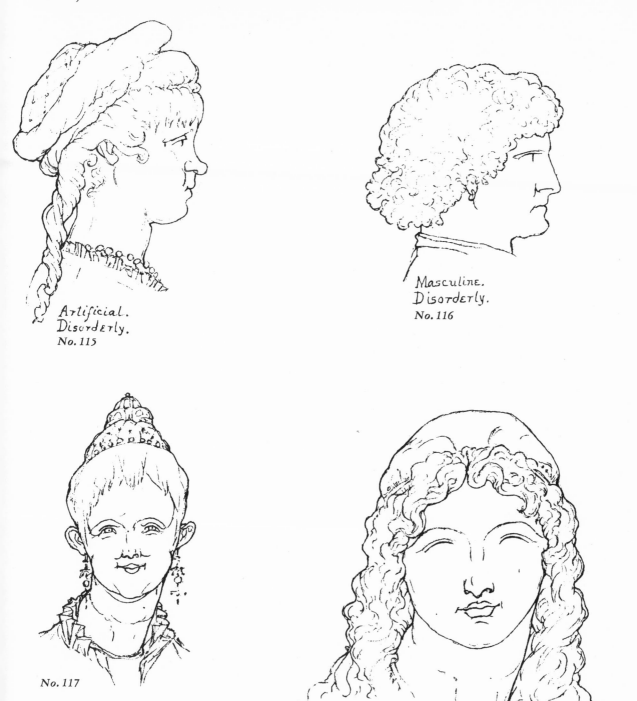

Artificial.
Disorderly.
No. 115

Masculine.
Disorderly.
No. 116

No. 117

No. 118

As it becomes necessary in representing Female Heads to make special dis-
position of the Hair, to gather it up without affectation in some natural form
of support suited to the shape of the Face is all that is required. Nothing can
exceed the beauty of the natural outline of a well-formed Head. It should
never be altogether obscured, nor its natural proportions defaced.

Suppositional: The vices and virtues of personal character stand in closest
relation to the vices and virtues of personal ornamenture.

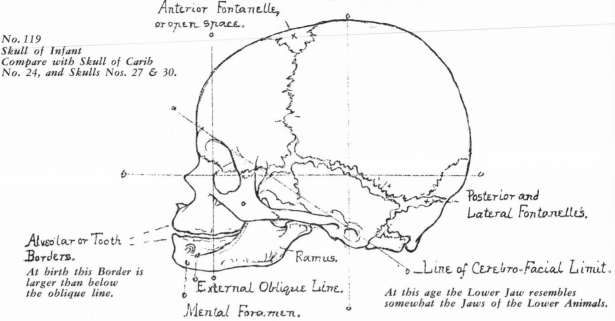

Anterior Fontanelle,
or open space.

No. 119
Skull of Infant
Compare with Skull of Carib
No. 24, and Skulls Nos. 27 & 30.

Alveolar or Tooth
Borders.

At birth this Border is
larger than below
the oblique line.

External Oblique Line.

Mental Foramen.

Ramus.

Posterior and
Lateral Fontanelles.

Line of Cerebro-Facial Limit.

At this age the Lower Jaw resembles
somewhat the Jaws of the Lower Animals.

Notice that the Head of the Child differs from the Head of
the adult Male in being longer in proportion to its height; in
having a larger Cerebral Section in proportion to the size
of the whole Head; in having larger Orbital Cavities, thinner
Malar Bones, narrower Jaws, and a large Occiput. Notice that
the shallowness of the Jaws is partly due to the absence of
Teeth in, and partly to the smallness of, the Ramus. Notice
that the distance from the center of the Orbital Cavity to the
Chin is much less in proportion to the height and depth of
the Cerebral Section than in the Adult.

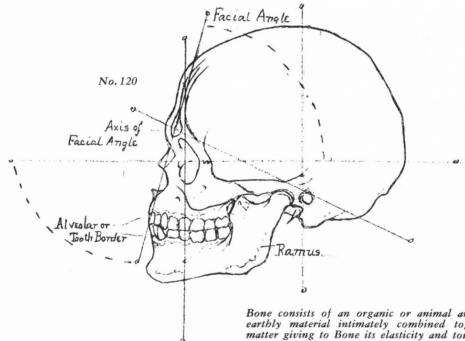

Facial Angle

No. 120

Axis of
Facial Angle

Alveolar or
Tooth Border

Ramus.

Bone consists of an organic or animal and an inorganic or
earthly material intimately combined together; the animal
matter giving to Bone its elasticity and toughness, the earthly
part, its hardness and solidity. The animal matter is a sub-
stance closely resembling Cartilage, but differs from it in
being softer and more flexible and in being resolvable under
proper conditions into a substance almost entirely gelatinous.
In very early Infancy the Bones are largely cartilaginous. The
increase of Bones in height and breadth terminates when the
several pieces of which they are each composed are united.
As the Bones advance toward maturity, they become harder
and larger by the gradual increase of inorganic substances. In
the Aged, it is not uncommon to find the Bones thin and
translucent and often extremely brittle.

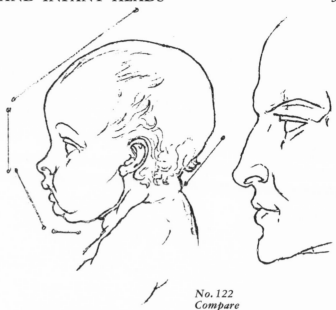

No. 122
Compare

Cerebral Section large; Ear low; Eye large; Nasal Bone flat; Nose small; Nostril opening forward — line ascending from upper Lip to the end of the Nose. Low Frontal Section. Frontal Eminence only. Concave Nasal outline. Eyebrow generally elevated. Cheek pressing more or less forward over the Maxillary Section. Chin small. Sub-Maxillary Section fleshy. Cheek pendulous. Mouth small. Under Lip small. Neck short. Back flat. Shoulder high, with protruding Occiput.

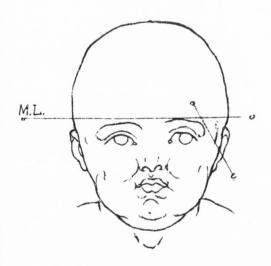

No. 121
*Eyes below the Median Line. See No. 47.
Facial Oval small below.*

In early Infancy the Table of the Cranium is composed of a single Plate only. As this rests immediately upon the surface of the Brain, the Frontal portion of the Brain being circular, the Frontal Section possesses but one Eminence. As development goes on, the outer or Cutaneous Table is at length fully separated from the inner or Vitreous Table. The Super-orbital Eminence then appears as in No. 120 — there being in the Adult Male Head a complete separation of the inner and outer Plates of the Skull at the point here described. The Frontal Section then has two Eminences, viz.: Frontal Eminence and Super-orbital Eminence.

In early Infancy the Bones and Muscles are alike rudimentary and incomplete. The nutrient portions of the general economy have a greater activity and compose a larger portion of the general Bulk than the mechanical portions. The Bones and Muscles are covered by a thick, fatty Integument which conforms in its growth to the natural muscular outline of the Adult Body. The Legs are shorter in proportion to the whole height than in the Adult; Head larger; Hands and Feet smaller; Abdomen fuller; etc.

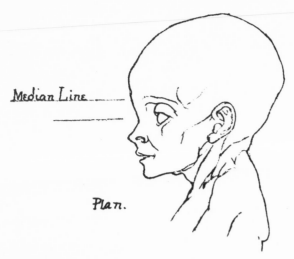

Median Line

Plan.

Compare.

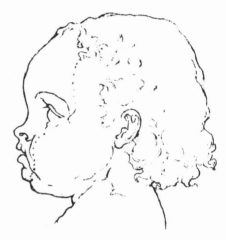

No. 123
Integument full; showing the form,
framework of the Head.

Compare the Areas of the Infant Head with the Areas
of the Adult Animal Head. See Nos. 28 and 28a, Brute
form; Nos. 25, 26, 29, 33, and 58, Human Form. The
Facial Angle, in representing a particular structural
peculiarity, represents at the same time all other pe-
culiarities naturally related to it. In passing from the
Adult Animal to the Adult Human Form, the Jaws
recede more and more toward the vertical or Facial
Angle 90°, and become smaller throughout; the Nasal
Bones advance; the Malar Bones recede; the Zygomatic
Arch from its relation to the Inferior Maxillary Bone
becomes shorter; the Ear descends, and the Chin ad-
vances. Meanwhile, the Cerebral Section increases in
size from the Ear upward and backward, and from the
Eye upward and forward; the Brain increasing and ad-
vancing, and the Jaws receding and diminishing, till
the vertical is attained. The Head is composed chiefly
of two parts, the Cerebral and Maxillary — the one rep-
resenting the Intellectual and Nervous forces, the other
the Animal Appetites and the Physical Forces.

No. 124
Integument full; showing the form,
proportion, and direction of the First
and Second Planes of the Face in the
average Infant Head.

Describing the Infant Head, see general remarks under Heads 119, 120, 121,
122.
1st. The same preponderance of the Cerebral over the Maxillary and of
its Nutrient and Integumentary Elements over the Osseous and Muscular that
characterizes the Infant Man characterizes the Infant State of all other Mam-
miferous Animals.
2nd. In consequence of the greater size of the Cerebral Section in proportion
to the Facial Section in Infant Heads in the lower races of Men when com-
pared with their Adult Heads, the Infant and Female Heads of these races
(See Heads of Females) resemble the Adult Heads of the higher races more
than do their Adult Heads.
3rd. The ascent from the Infant Form is toward the physical perfection of
the Adult form, whatever that may be, and is mainly in reversed order to
that of the ascent of the Animal Form toward the Ideal Human Form as
above described: viz., the Jaws increase in size throughout; the Frontal Emi-
nence recedes; the Super-orbital Eminence advances; the Bulb of the Nose
descends; the Nostrils open downward and often backward (See Plan O);
the Malar Bone advances; the Zygoma widens and lengthens; the Eyes become
smaller, and the Bony Arch more prominent; the External Angular Process
more prominent; the Occiput descends and becomes smaller in proportion
to other parts; the Ears higher; the back of the Neck fuller and the Mouth
larger. In these changes the Integumentary details of Form give place to the
Muscular and Bony details; the Nasal Bones advance and the Forehead
heightens and becomes broader — more or less — as distinctive elements
of masculine proportion. See Heads of Women.

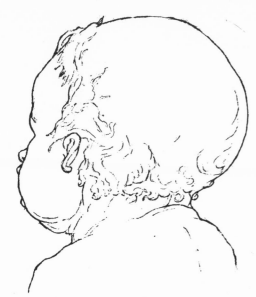

No. 126
General outline Form—three-quarters
view from behind. Large Occiput.
Integumentary Cheek. Short Neck.

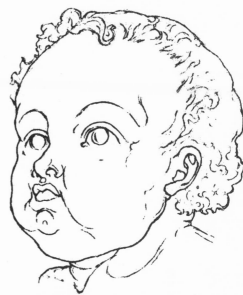

Plan O.

Nostril
opening backward.

No. 125
Three-quarters view: average outline
and Facial details. Low Frontal Section.
Integumentary Sub-Maxillary Section.
Small Nose, Mouth, and Chin.
Integumentary Cheek. Protruding
Upper Lip.
Line of the Pillars of the
Mouth commencing with the lower
Line of the Cheek.

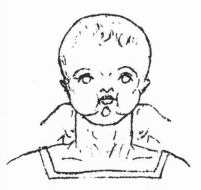

No. 125A

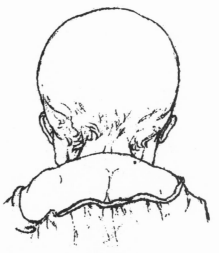

No. 127

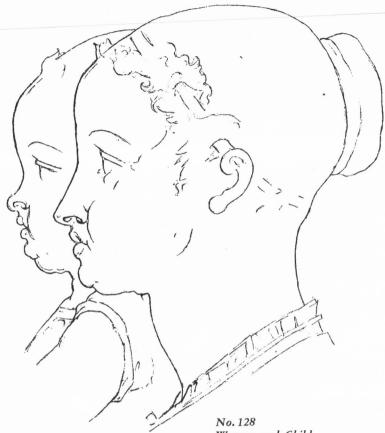

No. 128
Woman and Child
Same family

*Cerebral Section large; Facial Section small; Nose elevated;
Chin and Mouth small; Ear low; Occiput prominent; Neck
concave; Lips short and fleshy; Sub-maxillary Section
fleshy; Nostril opening forward; Frontal Eminence large;
Super-orbital Eminence small; Face Integumentary throughout.
With the naming of the parts, compare the Male, Female, and
Infant outline. From Frontal Eminence to end of Nose generally
concave. In Female Heads the Nose lengthens more rapidly than
it increases in height.*

*The Bones and Muscles of Women being generally
smaller and less compact in structure than the Bones and
Muscles of Men, the rudimentary relations of child-
hood in some degree remain with them. Compared with
the fully developed Male proportions, they are as fol-
lows, viz., the Cerebral Section is larger in proportion
to the Facial Section; the Malar Bones are farther back
and narrower; the Ears lower; the Nasal Bones less
prominent; the Nose thinner; the Mouth smaller; the
Maxillary portion of the Isthmus farther forward as in
Children; the Mucous portion of the lips fuller; the
Cutaneous portion shorter; the Chin less prominent;
the end of the Nose more elevated; the Eyes larger; the
Angular Process of the Frontal Section smaller; the
Forehead more prominent; the Frontal Eminence fuller;
the Super-orbital Eminence smaller; the Forehead nar-
rower and lower at the top; the Head wider through
the center of the Brain over the Ears; narrower through
at the Ears; the Occiput more prominent — the whole
Head in both Planes showing the preponderance of the
Cerebral over the Facial at the representative period of
Feminine Life. Compare with that of the Male Head at
the representative period of Masculine Life. This com-
parison applies to the Males and Females in the same
family and to the average Male and Female proportions
in the Human Race at large, but not to the proportions
of the Males and Females of different families, the mem-
bers of one family being often in excess in the propor-
tions in which the members of another family are defi-
cient.*

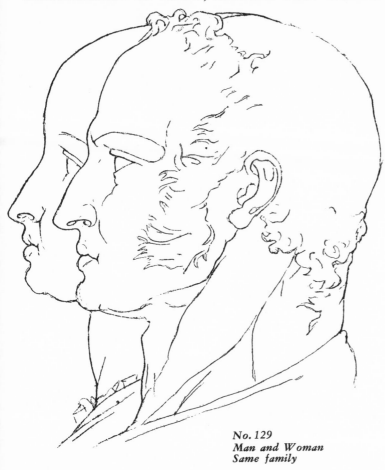

No. 129
Man and Woman
Same family

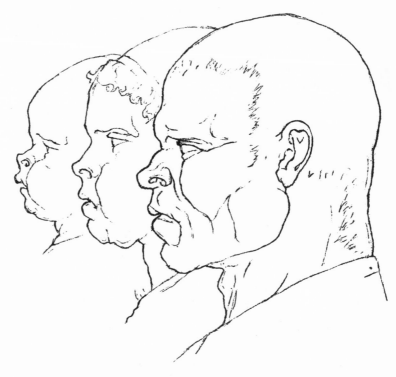

No. 130
Child, Woman and Man
Same family

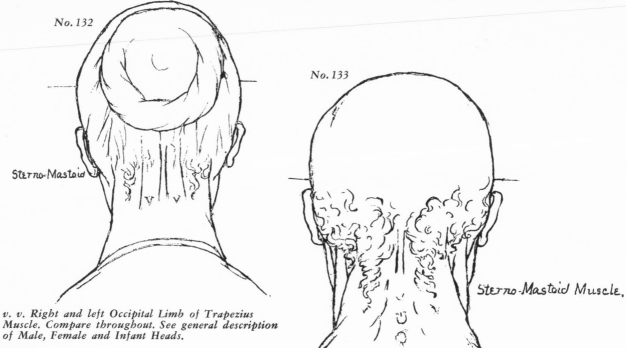

No. 132

Sterno-Mastoid

No. 133

Sterno-Mastoid Muscle.

v. v. Right and left Occipital Limb of Trapezius Muscle. Compare throughout. See general description of Male, Female and Infant Heads.

Neck large: Head broad Sexual in all Animals

No. 131

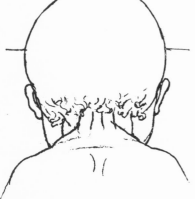

Infant, Female and Male Heads seen from behind. Neck short; shoulders high and narrow.

The type of form peculiar to the Skeleton and the type of form peculiar to the Fleshy parts of the Body are not the same. The Features have a development of their own at a time when the Bones undergo no change. In some Heads the Features govern from the beginning. While the Bones and Muscles after maturity are diminished in strength, the Features are generally becoming larger.

*No. 134
Old Age, Masculine
and Feminine.
Ears strongly marked.*

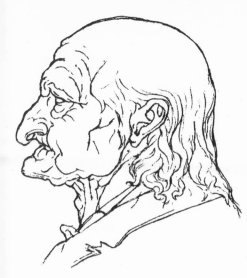

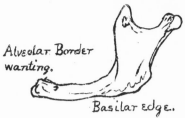

Alveolar Border wanting.

Basilar edge.

No. 135
Inferior Maxillary — Old Age
Distance from the Nose to the Chin made less by loss of Teeth and absorption of the Alveolar Borders of the Superior and Inferior Maxillary Bones. Notice that in consequence of the want of support afforded by the Teeth and the Alveolar Borders of Jaws, the Mucous portion of each Lip inclines toward the Cavity of the Mouth.

After maturity (Forty years of age for Women and Fifty for Men), the Bones and Muscles of Women often assume a higher development, while the same parts in Men not infrequently become smaller and weaker; though the peculiar structural proportions of Men and Women never lose their distinctive characteristics. Yet because of the changes here referred to, Male and Female Faces are more alike in old age than at the period of highest physical activity. After maturity the Integument throughout the entire Body loses its strength. In the Face the Eyelids droop; the Flesh of the Cheeks becomes pendulous; the Under Lip falls; the Pillars of the Mouth project; the Integument of the Sub-maxillary Region and Neck becomes greatly enlarged, often hanging in folds from the Chin to the Throat; the Sub-orbital Integument assumes a special fullness; and the Skin of the Forehead becomes heavy and wrinkled.

No. 136 No. 137
Large and small Alveolar Borders

No. 138 No. 139

Masculine and Feminine average
outline peculiarities compared

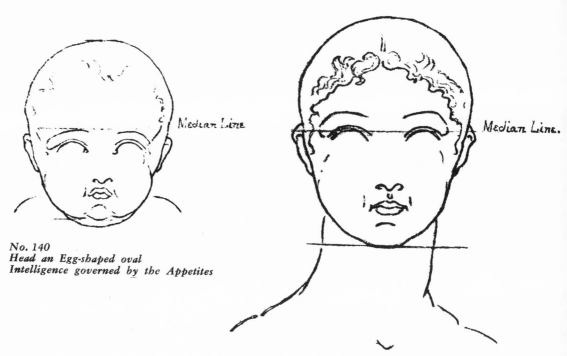

No. 140
Head an Egg-shaped oval
Intelligence governed by the Appetites

No. 141
Intelligence governed by the Sensibilities

General Remarks

In the progress of growth from Infancy upward, the Female Body never attains the highest point of mechanical completeness. Consequently the Integument with its accompanying condition of the Bones and Muscles never altogether loses its preponderance. In the Female Body, the structure is complete when the principles of structures are fully developed. In the Male Body, through the great activity of the Physical Constitution, the Masculine Form passes over the Ideal, or the development of the principles of structure, toward the Animal to meet the requirements of actual use.

The Female Head, in its general proportions and in the proportions of its several parts, representing the degree of the Female Body — and, too, its relation to the Ideal in the Infantile and Masculine modification of its proportions — becomes the representative of Human proportions and their Ideal. As the general character in each form of Life — Masculine, Feminine, and Infantile — is in natural relation to the proportions and states of the Body under which it exists, and of which the Head is the proper representative, the relation of the several parts of the Head to the Median Line cannot be much changed without changing the general character in the direction of the attributes represented by them — the Head being the representative alike of the Physical and all Intellectual activities, in all things which are common to the three Estates.

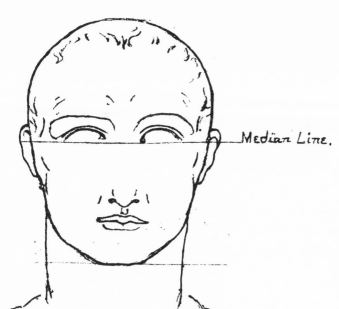

Median Line.

No. 142
Intelligence governed by the Will
Though these proportions are variable, they are in
the great majority of Heads as here represented

Proportions at Large
Male Body: Mechanical throughout
Female Body: Mechanical, Integumentary, and Sexual
Infant Body: Rudimentary and Integumentary

Each Estate of Life, however, having for its support
that modification of the Human Constitution that gives
expression to the Ideal of proportions — the changes of
form that occur in one can never be of the same sig-
nificance as those which occur in another, but express
rather in each the different ways in which the elements
of proportion through the Construction Physical and
Intellectual may be combined without changing their
relation to their own proper central activities — Mascu-
line, Feminine, or Infantile, as the case may be. Orderly
changes in the Animal proportions assert the strength
and plasticity of the Animal Constitution, but are in no
degree an abandonment of the peculiar activities that
underlie and sustain them.

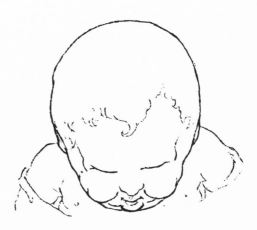

No. 143

Latent. Facial angle 90°. Until the vertical is attained in the Facial outline, First and Second Planes, the horizontal is not attained in the disposition of the Features.

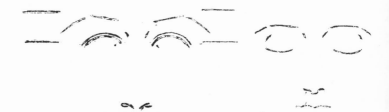

*No. 144 Features horizontal
When the Mind is in repose
the Features are at rest.*

A kindly expression will beautify the coarsest Features. A good expression in a good Face, and a bad expression in a bad Face, represent the widest extremes of Character. The permanent expression of a Face describes the final balance and proportion of all the intellectual and passional forces underlying it. However bad the expression of a Face may be, it never reaches its greatest depth until it loses its directness and sincerity. Never debase a Head throughout. The expression of a Face is more noticeable than the form of a Face. All passions should be of the Intellect, and therefore the passions of the Intellectual; but in avoiding the things which are purely Animal, we should be careful not to so obliterate all marks of animal strength as to make the Head a meaningless study of proportion only. In the Male Head the Animal Form is often retained when the expression is altogether obliterated. The highest possible extreme of passion should never be described. When both the action of the Face and the action of the Body are expressive of the same purpose, both should be temperate. Neither the ghastly nor the bloody should ever be represented. Never exaggerate or overdo in anything. In passional expressions, the prevailing passion or sensibility described should govern all the Features.

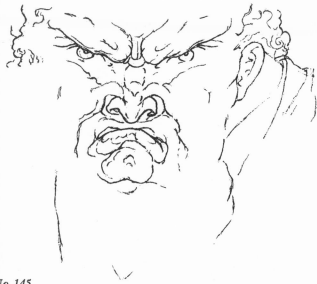

No. 145
To make a strong Man scowl, is to make him a ruffian.

Animal affection

Plan of the disposition of the Features in the Offensive Passions

Pride
Contempt
Hatred
Malice
Revenge
Anger
Rage
Fury of Rage

In the offensive and defensive passions, the Eyebrows are lowered and brought together in a downward direction toward the Nose in such a way as to cover the central and inner portions of the Eyes. The upper Eyelids are drawn back; the Skin of the Forehead and of the frontal portion of the Nose is wrinkled; the Nostrils are dilated and elevated at their inner corners, opening toward the sides of the Face; the Under Lip rises in the center pressing the Upper Lip toward the Nose; the corners of the Mouth are drawn down; the Chin is thrust forward, and the Integument of the Nose above the Nostrils rises in an upward fold — all the Features being drawn together toward the center of the Face at a point near the junction of the Nasal Bones and the upper lateral Cartilages. In these passions the Maxillary portion of the Face — especially that part properly belonging to the Mouth, Lips, and Chin — is made to appear large and more or less Brute-like. In the suppositional relation of the use, form, and action of the Features to the elements of Character, the general intention is expressed in the expression of the Eyes, and as this is the form peculiar to all Animals, so far as the

features are capable of any change whatever, it may be conceived to be the neutral form for intent to injure — and means aggression. The Mouth may be supposed to denote the animal forces and their determination and strength. What part shall be assigned to the expression of the Nasal elements — the Isthmus, the Wings, the openings, the Nasal portion of the Isthmus, etc. — it is not easy to discover, since in some of the passions no change whatever is made in the position of any of its detail. The Sensibilities sometimes, however, move them when the Face is otherwise latent and general and constitutional irritability is occasionally associated with a sharply defined concave Nasal outline. If, however, the Sensibilities can be supposed to find expression in this Section of the face, even in part, it will give to the three great divisions of the Face a completeness in correspondence with the three great elements of Character. Otherwise the Nasal Section, except in the structural relation to a particular sense, is a meaningless quantity. As a sustaining part of the passions here described, the expressions of the Nasal Section denotes irritability.

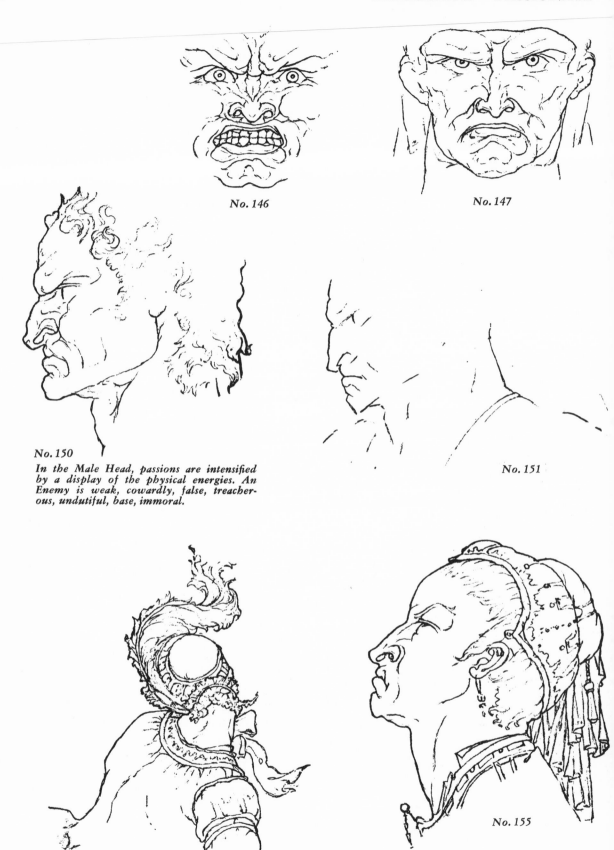

No. 146

No. 147

No. 150

In the Male Head, passions are intensified by a display of the physical energies. An Enemy is weak, cowardly, false, treacherous, undutiful, base, immoral.

No. 151

No. 151A

No. 155

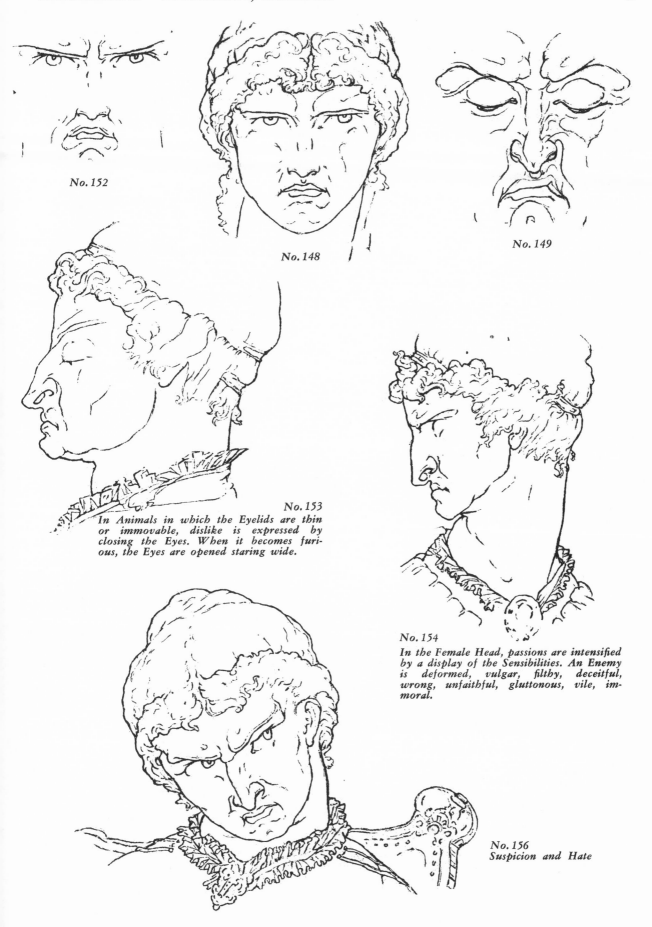

No. 152

No. 148

No. 149

No. 153

In Animals in which the Eyelids are thin or immovable, dislike is expressed by closing the Eyes. When it becomes furious, the Eyes are opened staring wide.

No. 154

In the Female Head, passions are intensified by a display of the Sensibilities. An Enemy is deformed, vulgar, filthy, deceitful, wrong, unfaithful, gluttonous, vile, immoral.

No. 156
Suspicion and Hate

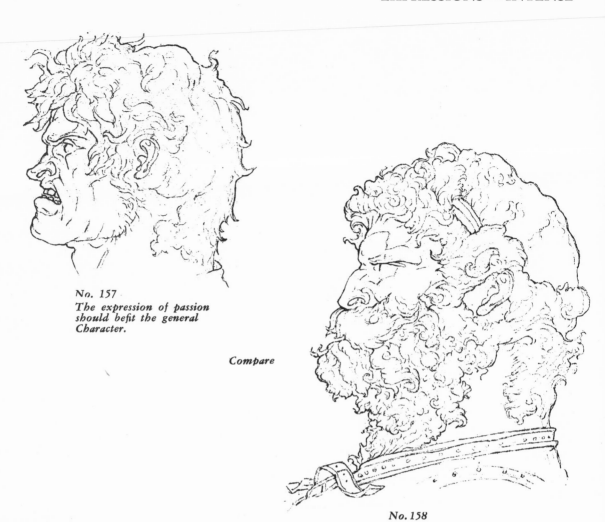

No. 157
The expression of passion should befit the general Character.

Compare

No. 158

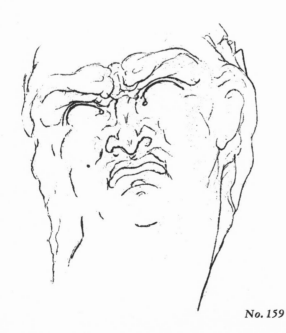

No. 159

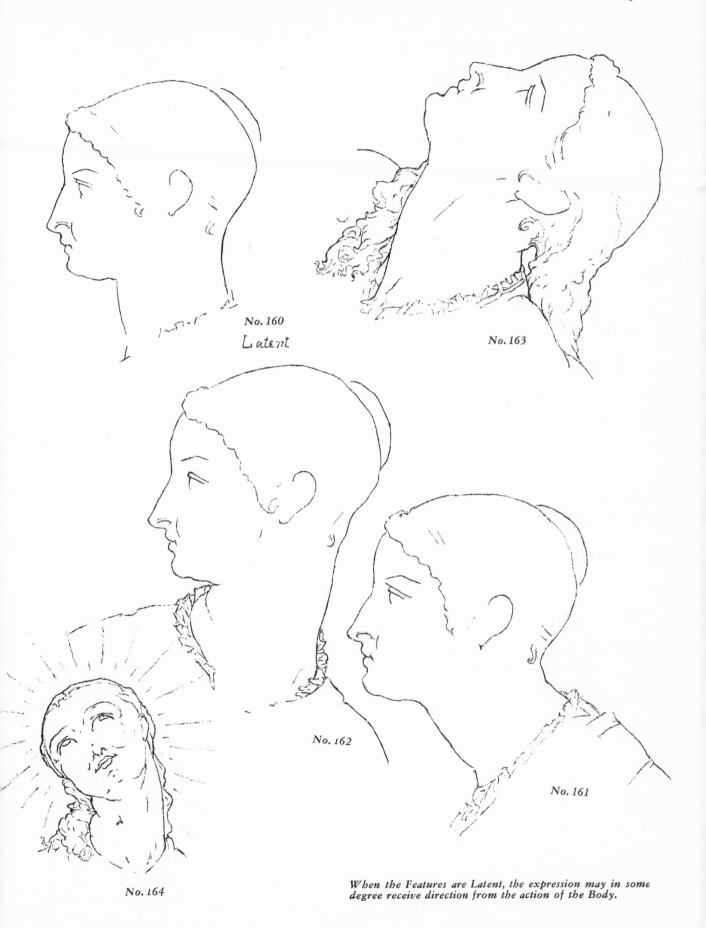

No. 160

Latent

No. 163

No. 162

No. 164

No. 161

When the Features are Latent, the expression may in some degree receive direction from the action of the Body.

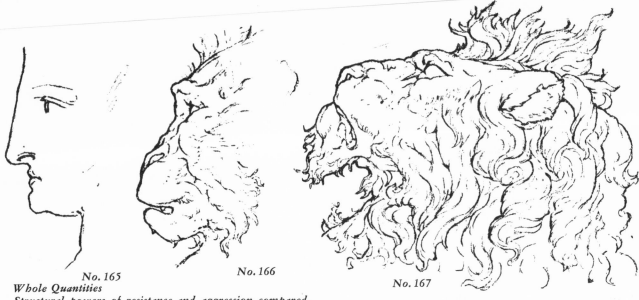

No. 165 No. 166
Whole Quantities
Structural powers of resistance and aggression compared.
Surroundings attach themselves to persons, and modes of life to types of Heads.

No. 167

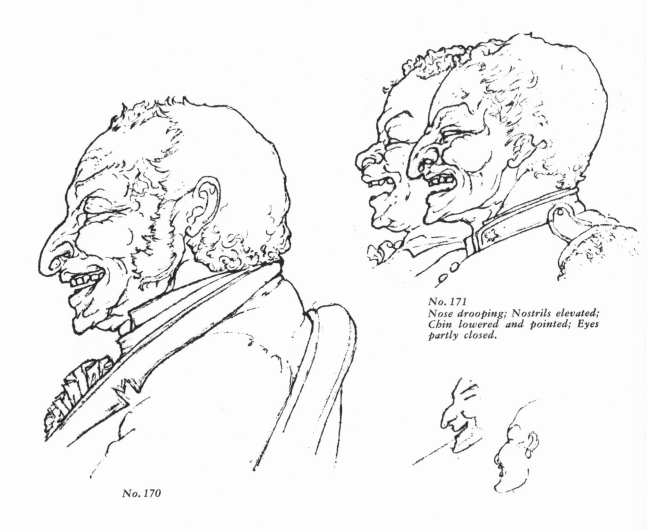

No. 171
Nose drooping; Nostrils elevated;
Chin lowered and pointed; Eyes
partly closed.

No. 170

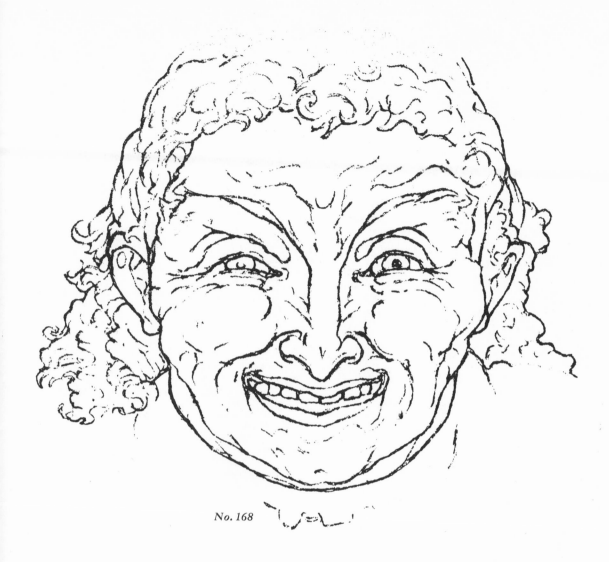

No. 168

Joy
Laughter
Content
Pleasure
Friendship

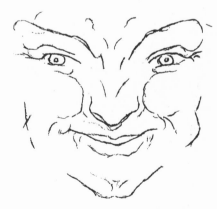

No. 169

Elevating, Pleasurable, and Friendly Emotions

The Eyebrows are elevated throughout, especially at their outer angles; the corners of the Mouth are drawn upward and outward toward the Ears in such a way as to press the flesh of the Cheeks toward the Malar Bones and against the under Eyelid in a circular fold; the Nostrils are expanded, and the outer corners of their Wings lifted; the outer corners of the Eyes elevated, and the Integument at the outer and lower portions of the Orbital Arch folded into wrinkles more or less numerous as the expression is more or less intense. The Features throughout are drawn away from the center of the Face toward the sides of the Head, at a point above the Ears. The general action is the reverse of that peculiar to the destructive energies, and means acceptance as the other means non-acceptance. The one, Attack or Attacked; the other, Attract or Attracted. The prevailing expression of Countenance denotes the prevailing temper of the Mind.

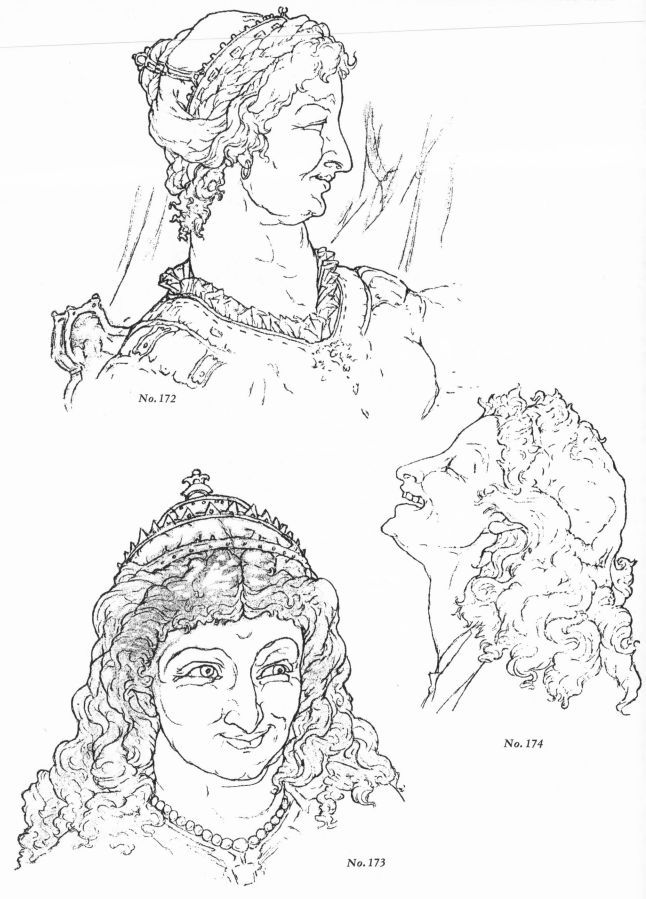

No. 172

No. 173

No. 174

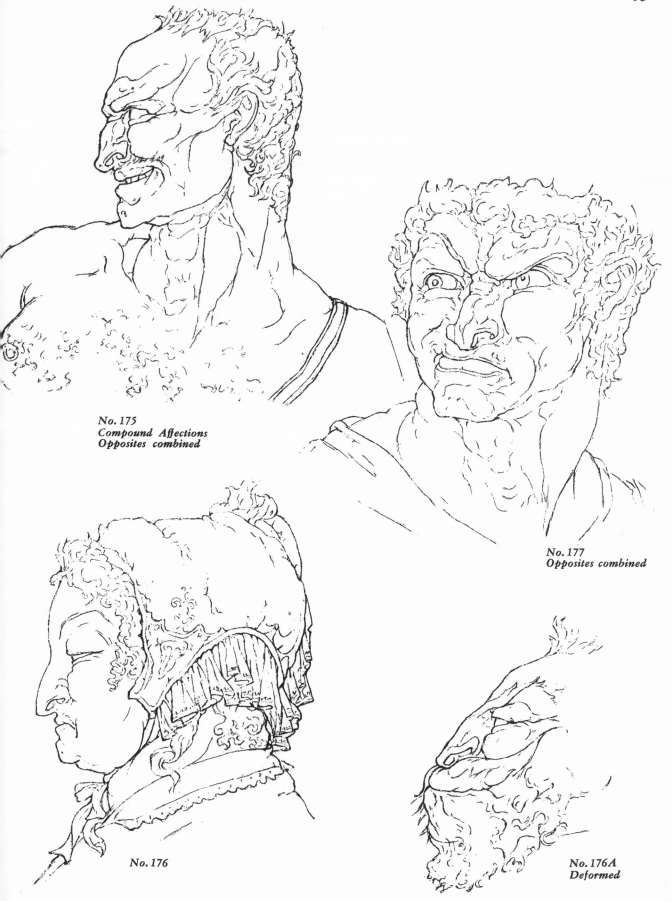

No. 175
Compound Affections
Opposites combined

No. 177
Opposites combined

No. 176

No. 176A
Deformed

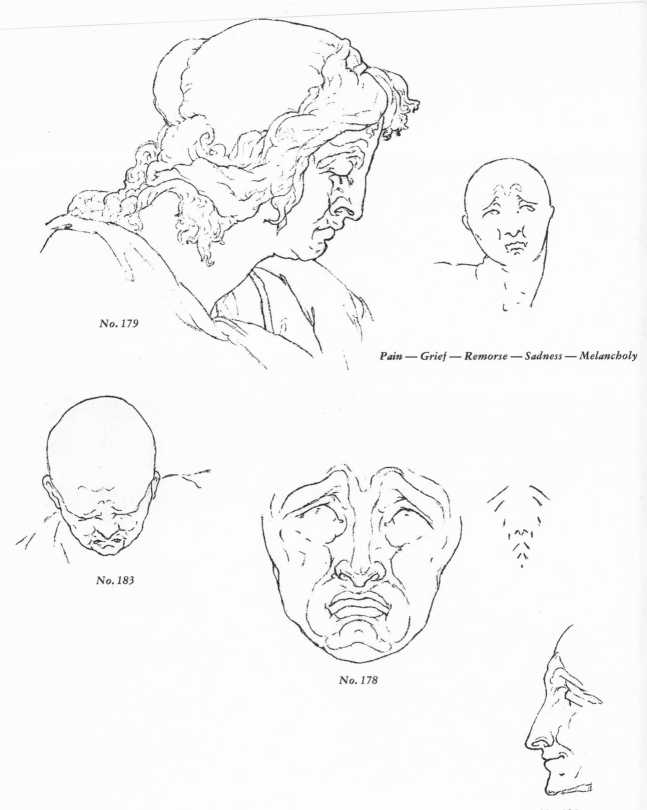

No. 179

Pain — Grief — Remorse — Sadness — Melancholy

No. 183

No. 178

No. 184
Opposites combined

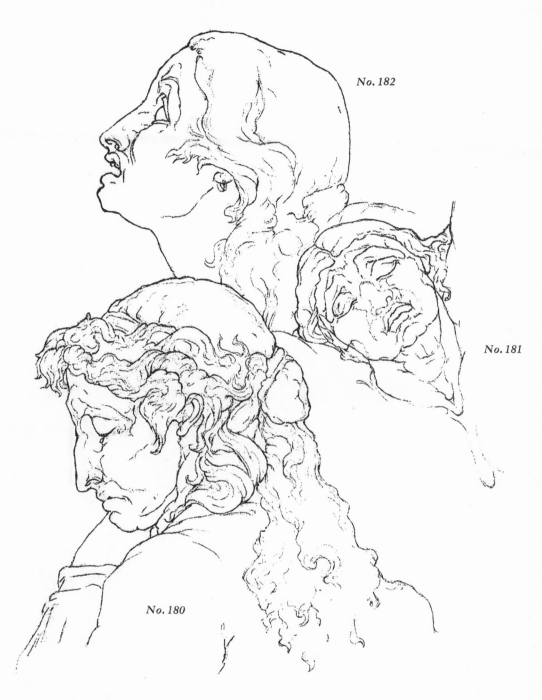

No. 182

No. 181

No. 180

Eyebrows elevated at the inner and depressed at the outer corners. Integument of the Arch, by action of the outer portion of the Eyebrows, pressed down upon the upper Lid, which in turn is pressed down upon the Ball of the Eye. Nostrils dilated and lowered at the inner angle. Mouth drawn upward in the region of the central Lobe, and outward and downward at the corners. Integument of the Mouth drawn upward and backward. Chin elevated in the middle and depressed at its angles. The Features throughout elevated in the center and depressed at the outer borders.

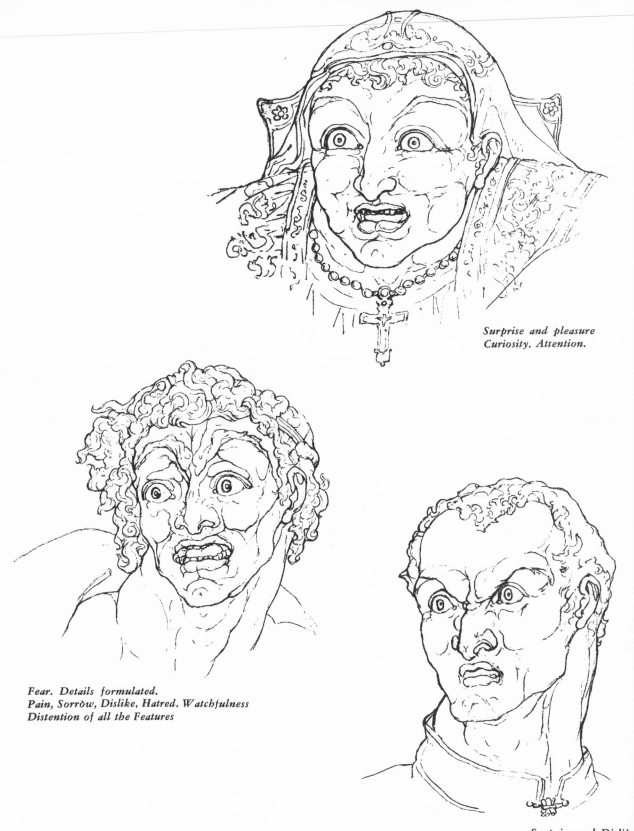

*Surprise and pleasure
Curiosity. Attention.*

*Fear. Details formulated.
Pain, Sorrow, Dislike, Hatred. Watchfulness
Distention of all the Features*

Surprise and Dislike

Figure numbers for the studies on these facing plates do not appear.

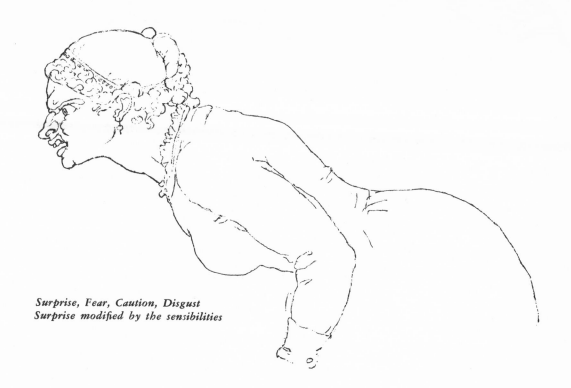

Surprise, Fear, Caution, Disgust
Surprise modified by the sensibilities

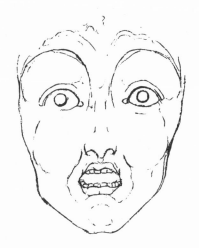

Surprise
Distention without Passion

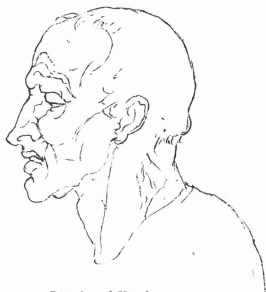

Despair and Hopelessness

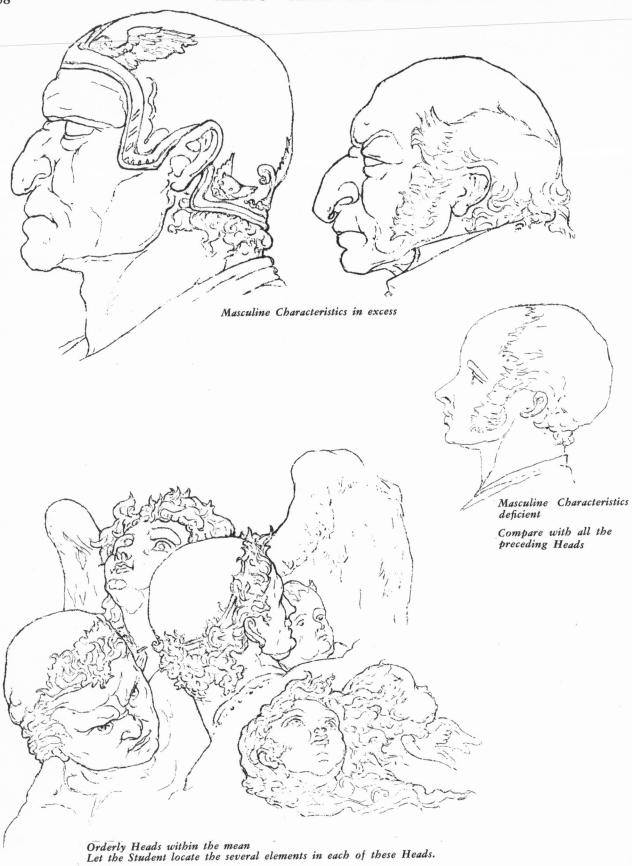

Masculine Characteristics in excess

*Masculine Characteristics
deficient*

*Compare with all the
preceding Heads*

Orderly Heads within the mean
Let the Student locate the several elements in each of these Heads.

Figure numbers for the studies on these facing plates do not appear.

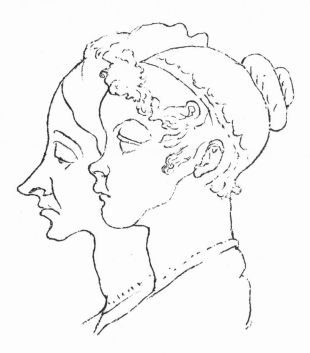

Feminine Characteristics in excess

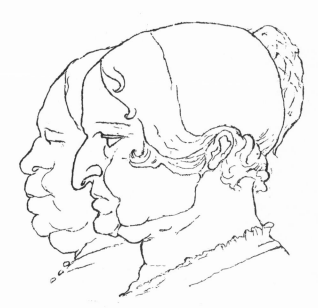

Feminine Characteristics deficient
Compare with all the preceding Heads of Women.

What are the distinguishing Characteristics of the Male and Female Head?

If all the proportions remain the same — that is, the measurement from part to part — the Heads will appear to be the same, even though the Features are different. The proportions must change as the Features and intellectual characteristics change, to avoid this form of mannerism. This does not mean that the same general type of Head may not be represented in every form of expression and character; but that circumstance does not favor us at any time or in any event with Men of the same individual characteristics in any thing. Neither does this refer to the tribal peculiarities of different races, but to the common differences in form existing among the individuals of every people.

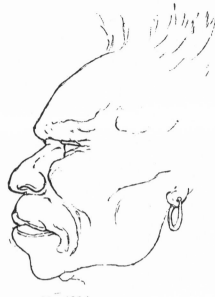

No. 185A
Massachusetts Indian

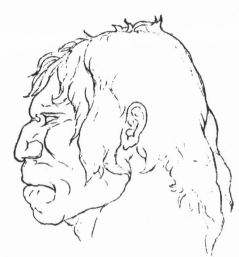

No. 185
Florida Indian

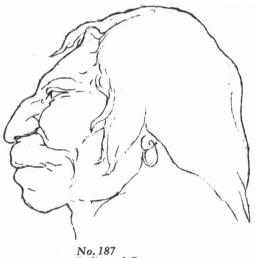

No. 187
Indian of Peru

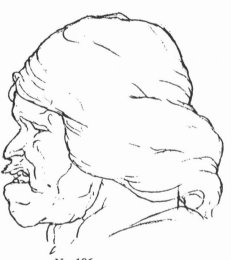

No. 186
Digger Indian,
California

American Indian
Retreating Chin. Nose hooked and more or less flat. Large
Malar Bones. Deep Jaws. Deep Mouth. Retreating Forehead.

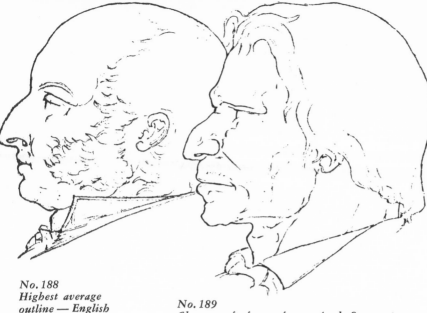

No. 188
*Highest average
outline — English*

No. 189
*Change of form from Anglo-Saxon to
Anglo-American, in which the propor-
tions change to the Indian form.*

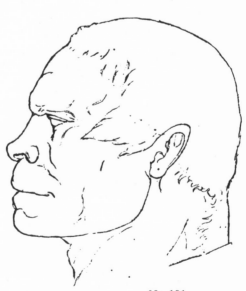

No. 188A
*Highest average outline —
American*

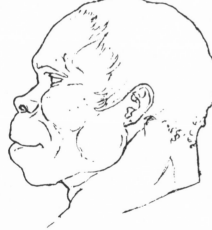

No. 190
Irish — Debased

Return to the Animal Form

*Heads of different Nations and Types differ less in
their highest Types than in their ordinary Heads or
in their debased Heads. As every race has a form of
Head peculiar to itself, so every race has a form of
debasement peculiar to itself. The Ideal is the repre-
sentative of the general character, and is impersonal:
Individual character is represented by individual forms,
and is personal. The Actual embraces every possible
modification of the Ideal within the limits prescribed by
the Constitution. The Individual Constitution, being the
representative of the general ancestry, is governed and
sustained by the Ideal or impersonal representing it.
Every part of the Body is subject to variation. Every
part of the Body has its highest and lowest point of
variation above and below the average of proportion.*

*The descent toward the Animal form in the Human
Head is toward the Animal in Human Nature, and not
toward the Animal as it exists in Animal nature. The
details of structure in the Human Head are always
Human — as the anatomy is Human. All actual decline
is toward one or another department of its own Animal
being, disease or death, and not toward the lower
Animals.*

No. 191
English — Debased

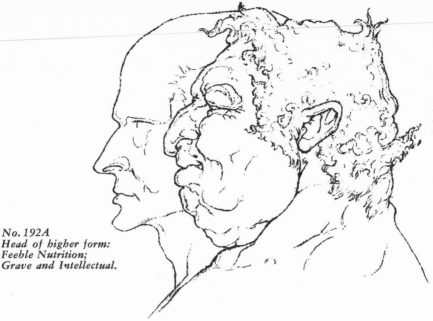

No. 192B
Lust and Gluttony;
Mirthful and Unintellectual;
Animal Passions constant.

No. 192A
Head of higher form:
Feeble Nutrition;
Grave and Intellectual.

Features Masculine to excess — Retreating Forehead — Re-
treating Chin — Cerebral Section small — Facial Section large
— Integument in the region of the lower Jaw in excess —
Neck large, muscular, and integumentary — Features coarse
and imperfectly formed. When the animal functions sup-
porting life are performed with unusual activity (the Head
being of the Animal Type), the Animal Appetites to which
they minister are supposed to be correspondingly active.
A coarse, massive Jaw is supposed, in any Head, to stand as
the representative of brutal and immoral instinct. The lower
races are in some instances more strongly marked in a Mascu-
line and Animal way than some of the higher races. If it
could be assumed that the Cerebral Section represented the
intellectual attributes; the Maxillary Section, the nutrient and
combative or carnivorous appetites; the Neck and Jaws com-
bined, the sexual appetites; the Nasal Section, Forehead, and
Chin, the sensibilities; the Eye, the purpose; the texture of the
Hair and condition of the Skin, the sensitiveness of the Con-
stitution to the activities of the Mind; — the Ideal Head repre-
senting the Ideal Character, and every departure from it a
departure toward one or other of the intellectual or animal
attributes — Physiognomy might be considered a Science
approximating in some degree to that kind of exactness found
in the Science of Physiology.
Individual Characteristics are represented in all races by the
same peculiarities of form, there being but one type of Struc-
ture and Character for all Mankind.

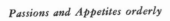

Passions and Appetites orderly

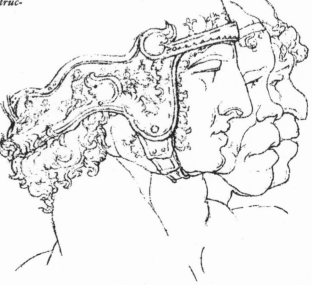

No. 195

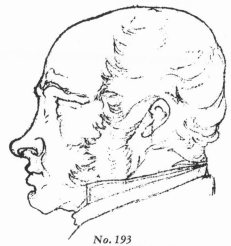

No. 193
Sensibilities active;
Animal Passions and Appetities
nervous and uncertain.

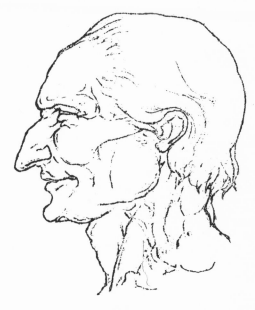

No. 194
Cunning, Rapacious, Treacherous,
Hypocritical, Fanatical.

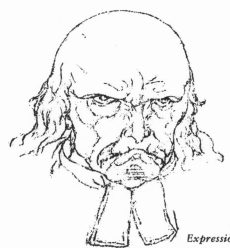

Expression Brutal and Monstrous

Find first and second planes in Nos. 192, 193, 194.

THE BODY

Number of Bones in the Body

**The entire Skeleton in an Adult consists of
204 distinct Bones: Vertebrae Column,
Sacrum, and Coccyx, 26; Cranium, 8;
Ossicula Auditus, 6; Face, 14; Os Hyoides,
Sternum, and Ribs, 26; Upper Extremities, 64;
Lower Extremities, 60.**

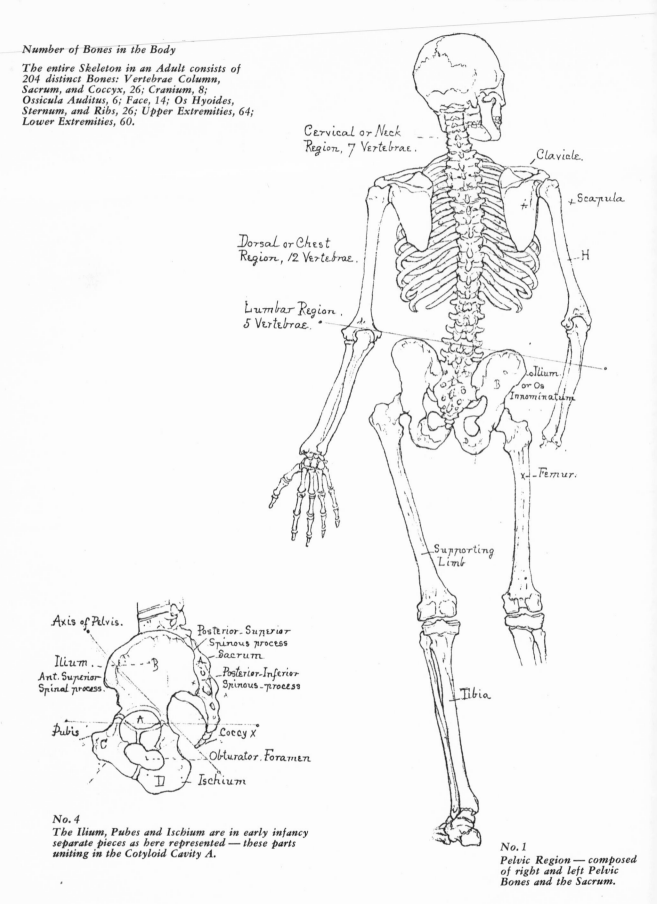

Cervical or Neck
Region, 7 Vertebrae.

Clavicle.

Scapula

H

Dorsal or Chest
Region, 12 Vertebrae.

Lumbar Region
5 Vertebrae.

Ilium
or Os
Innominatum

Femur.

Supporting
Limb

Tibia

Axis of Pelvis.

Posterior-Superior
Spinous process
Sacrum

Ilium
Ant. Superior
Spinal process.

Posterior-Inferior
Spinous-process

Pubis

Coccy x

Obturator. Foramen

Ischium

No. 4
**The Ilium, Pubes and Ischium are in early infancy
separate pieces as here represented — these parts
uniting in the Cotyloid Cavity A.**

No. 1
*Pelvic Region — composed
of right and left Pelvic
Bones and the Sacrum.*

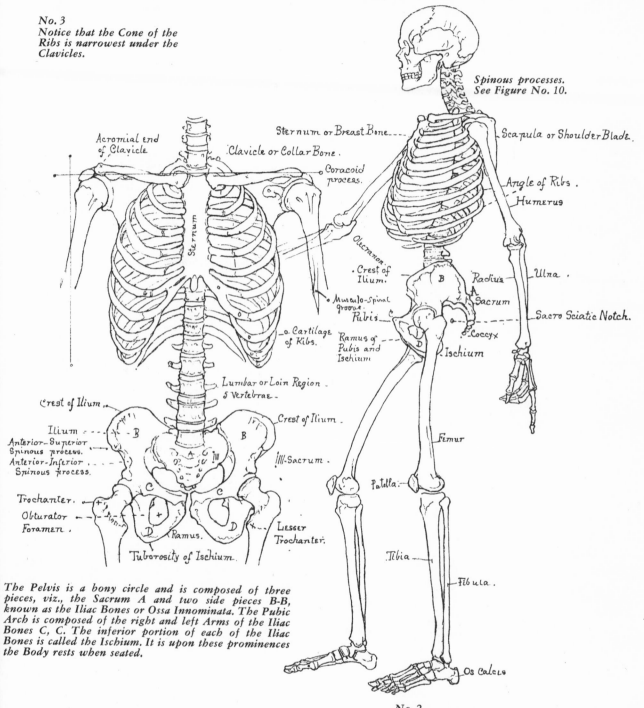

No. 3
Notice that the Cone of the
Ribs is narrowest under the
Clavicles.

Spinous processes.
See Figure No. 10.

Acromial end
of Clavicle

Sternum or Breast Bone.

Clavicle or Collar Bone.

Coracoid
process.

Scapula or Shoulder Blade.

Angle of Ribs.

Humerus

Sternum

Olecranon.

Crest of
Ilium.

Musculo-spinal
groove.

Pubis

Cartilage
of Ribs.

Ramus of
Pubis and
Ischium

Radius

Sacrum

Coccyx

Ischium

Sacro Sciatic Notch.

Ulna.

B

A

Lumbar or Loin Region
5 Vertebrae.

Crest of Ilium.

Crest of Ilium.

Sacrum.

Ilium

Anterior-Superior
Spinous process.

Anterior-Inferior
Spinous process.

Trochanter.

Obturator
Foramen.

Ramus.

Tuborosity of Ischium.

Lesser
Trochanter.

Femur

Patella.

Tibia

Fibula.

Os Calcis

The Pelvis is a bony circle and is composed of three
pieces, viz., the Sacrum A and two side pieces B-B,
known as the Iliac Bones or Ossa Innominata. The Pubic
Arch is composed of the right and left Arms of the Iliac
Bones C, C. The inferior portion of each of the Iliac
Bones is called the Ischium. It is upon these prominences
the Body rests when seated.

No. 2
The head of the Thigh Bone
rests in a cavity called the
Acetabulum or Cotyloid Cavity.
The right and left Arms of the
Pubis unit at a point called
the Symphysis Pubis.

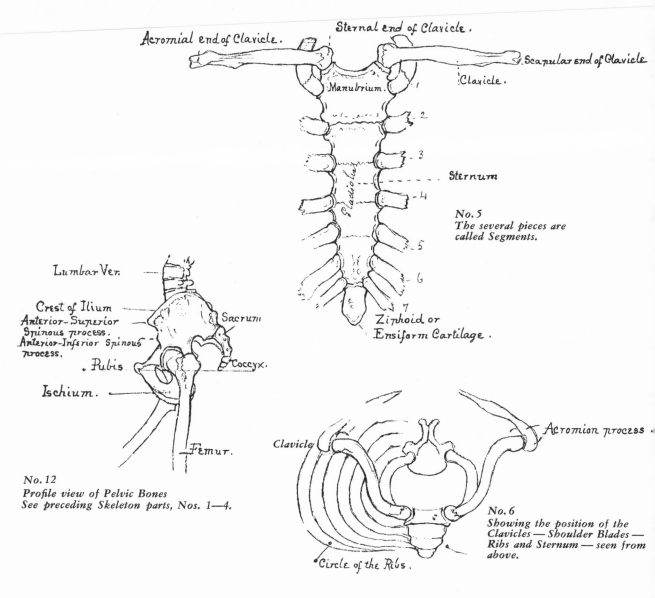

Acromial end of Clavicle.

Sternal end of Clavicle.

Scapular end of Clavicle

Clavicle.

Manubrium.

Sternum

No. 5
The several pieces are
called Segments.

Ziphoid or
Ensiform Cartilage.

Lumbar Ver.

Crest of Ilium
Anterior-Superior
Spinous process.
Anterior-Inferior Spinous
process.

Sacrum

Pubis

Coccyx.

Ischium.

Femur.

No. 12
Profile view of Pelvic Bones
See preceding Skeleton parts, Nos. 1—4.

Clavicle

Acromion process

Circle of the Ribs.

No. 6
Showing the position of the
Clavicles — Shoulder Blades —
Ribs and Sternum — seen from
above.

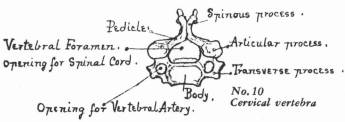

Pedicle.

Spinous process.

Vertebral Foramen.
Opening for Spinal Cord.

Articular process.

Transverse process.

Body.

No. 10
Cervical vertebra

Opening for Vertebral Artery.

Position of Acromion process
Acromial end of Spine
of Scapula

No. 8
Clavicles and top of Sternum
seen from above.

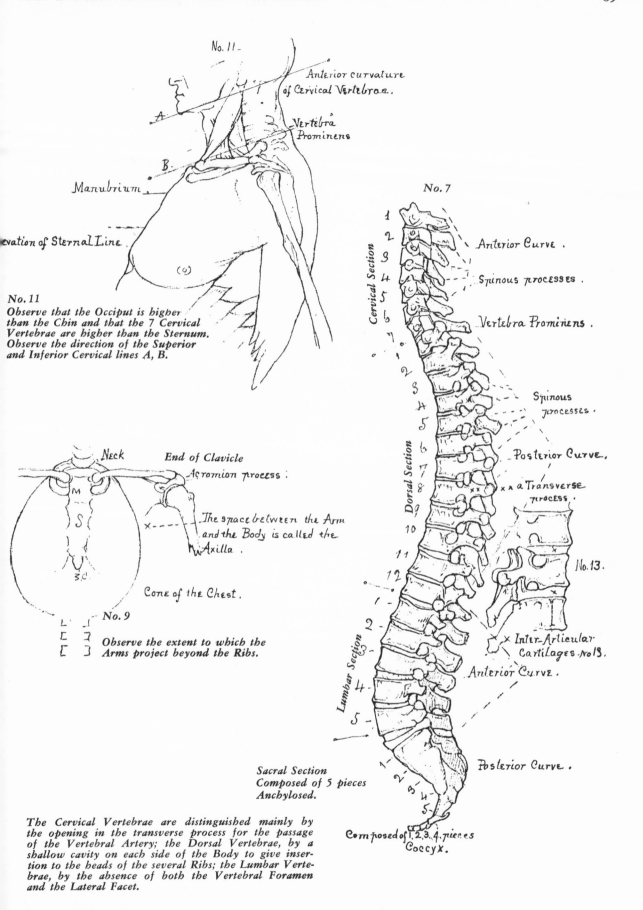

No. 11.

Anterior curvature
of Cervical Vertebrae.

Vertebra
Prominens

A

B

Manubrium.

evation of Sternal Line.

No. 11
*Observe that the Occiput is higher
than the Chin and that the 7 Cervical
Vertebrae are higher than the Sternum.
Observe the direction of the Superior
and Inferior Cervical lines A, B.*

No. 7

Cervical Section

Anterior Curve.

Spinous processes.

Vertebra Prominens.

Dorsal Section

Spinous
processes.

Posterior Curve.

x x a Transverse
process.

No. 13.

Inter-Articular
Cartilages No 13.

Anterior Curve.

Lumbar Section

Posterior Curve.

Neck

End of Clavicle

Acromion process.

The space between the Arm
and the Body is called the
Axilla.

Cone of the Chest.

No. 9

*Observe the extent to which the
Arms project beyond the Ribs.*

*Sacral Section
Composed of 5 pieces
Anchylosed.*

Composed of 1, 2, 3, 4, pieces
Coccyx.

*The Cervical Vertebrae are distinguished mainly by
the opening in the transverse process for the passage
of the Vertebral Artery; the Dorsal Vertebrae, by a
shallow cavity on each side of the Body to give inser-
tion to the heads of the several Ribs; the Lumbar Verte-
brae, by the absence of both the Vertebral Foramen
and the Lateral Facet.*

Alterable Sections

Lumbar Region extended .

x-x Alterable Section Abdominal space closed

No. 20

No. 21

Parts the form and measurement of which are changed by the motions of the Body.

Alterable Limit .

Unalterable Section .

Ribs .

Alterable Limit .

Unalterable Section .

Pelvis .

× Alterable Limit .

Space closed .

Space open

No. 14

Alterable Limit .

Alterable . Section .

Alterable Section .

No. 15

No. 19

Solid or Unalterable Sections — Parts the form and measurement of which are un- affected by the motions of the Body.

No. 13 is not included.

Anatomical Forms — Muscular Outlines

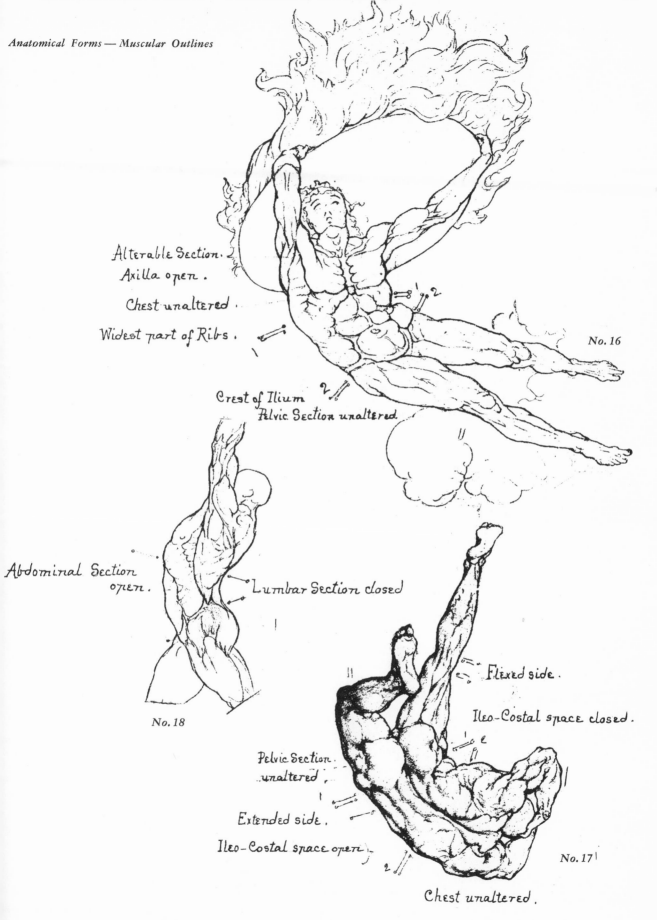

Alterable Section.
Axilla open.

Chest unaltered.

Widest part of Ribs.

No. 16

Crest of Ilium
Pelvic Section unaltered.

Abdominal Section
open.

Lumbar Section closed

No. 18

Flexed side.

Ileo-Costal space closed.

Pelvic Section
unaltered.

Extended side.

Ileo-Costal space open.

No. 17

Chest unaltered.

No. 31

Plan showing the position of the Clavicle when the arms are elevated above the horizontal, A. No. 31. The Clavicles may be forced into this position by throwing the weight of the Body upon the Hands, B. The position of the Clavicle when the Arm is at rest or its motions performed below the top of the Sternum, BA. Notice: In raising the Arm above the top of the Sternum, the Body is inclined to the opposite side. The principle underlying this motion is illustrated in every movement of the Body. An intellectual sense of equilibrium united to the instinctive sense in persons of taste gives grace and precision to the motions of the Body. The sense of proportion has much to do with the sense of equilibrium as we see it illustrated in those about us whose movements are controlled by the peculiarities of the Bodies. To pass from the Shoulders by graceful descent to fine and well-formed extremities indicates in the Masculine form the highest precision of motion and the finest sense of equilibrium. Narrow Shoulders and Pelvis and large Hands and Feet are inversions of the principles of mechanical uses or equilibrium in the Human Body. The motion of persons so made can never be other than awkward and inexact when put to extremist trial with one of opposite form. To discover this by contrast is the artist's endowment, whether the executive power accompanies it or not. What is most common is the sense of form. What is least common is the quickness of sensibility (which in these things is common sense) necessary to discover what it is that the sense of form should perpetuate.

No. 32
Scapular Section
Position of the Shoulder Blades when the Arms are elevated above the top of the Sternum. The higher the arms are elevated, the more the outer ends of the Clavicles will be elevated and the farther the inferior angle of the Scapular Bones will project beyond the line of the Ribs.

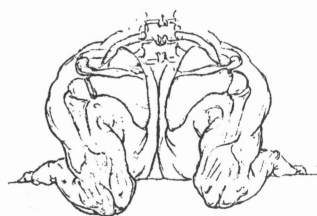

No. 33
Plan showing the place of the Scapular Bones when the arms are thrown back toward the Spinal Column.

No. 35

Figure Nos. 22-30 do not appea

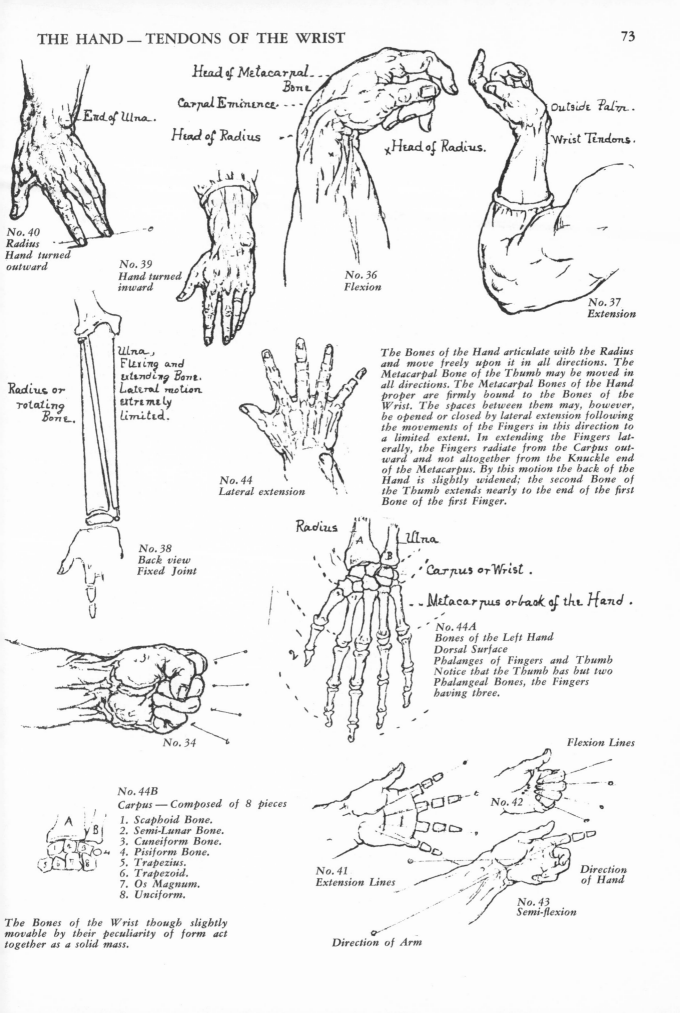

End of Ulna.

Head of Metacarpal Bone

Carpal Eminence.

Head of Radius

Head of Radius.

Outside Palm.

Wrist Tendons.

No. 40
Radius
Hand turned
outward

No. 39
Hand turned
inward

No. 36
Flexion

No. 37
Extension

Ulna, Flexing and extending Bone. Lateral motion extremely limited.

Radius or rotating Bone.

No. 38
Back view
Fixed Joint

No. 44
Lateral extension

The Bones of the Hand articulate with the Radius and move freely upon it in all directions. The Metacarpal Bone of the Thumb may be moved in all directions. The Metacarpal Bones of the Hand proper are firmly bound to the Bones of the Wrist. The spaces between them may, however, be opened or closed by lateral extension following the movements of the Fingers in this direction to a limited extent. In extending the Fingers laterally, the Fingers radiate from the Carpus outward and not altogether from the Knuckle end of the Metacarpus. By this motion the back of the Hand is slightly widened; the second Bone of the Thumb extends nearly to the end of the first Bone of the first Finger.

Radius

Ulna

Carpus or Wrist.

Metacarpus or back of the Hand.

No. 44A
Bones of the Left Hand
Dorsal Surface
Phalanges of Fingers and Thumb
Notice that the Thumb has but two
Phalangeal Bones, the Fingers
having three.

No. 34

No. 44B
Carpus — Composed of 8 pieces

1. Scaphoid Bone.
2. Semi-Lunar Bone.
3. Cuneiform Bone.
4. Pisiform Bone.
5. Trapezius.
6. Trapezoid.
7. Os Magnum.
8. Unciform.

The Bones of the Wrist though slightly movable by their peculiarity of form act together as a solid mass.

Flexion Lines

No. 42

No. 41
Extension Lines

Direction
of Hand

No. 43
Semi-flexion

Direction of Arm

The bones are seldom seen on the Palmar side of the hand. Notice at what points the several joints of each finger touch the finger beside it.

Receding line.

No. 45
Thumb — Three-quarters view

A B Dorsal Surface.
C
D E F G H

Palmar Surface

Metacarpal Bone
Phalange

Movable Section

No. 47
A. End of Ulna
B. Carpus
C. Head of Metacarpus
D. Knuckle
E. First Section of Finger
F. Skin of Joint
G.-H. Second and third Section of Fingers

Notice that the first joint of the finger in consequence of the length of the Palmar integument seems but a little longer than the second. Notice that the middle or transitional section extends across the hand and is composed of the head section of the several fingers. Notice that just above this section is another marked x — the line separating it from the other section of the hand becomes the boundary line of the transitional section of the junction of the web of the thumb and joint section of the forefinger. When the thumb is extended the outline is either in profile or three-quarters view. For the surface projection of the several parts of the outside of the palm of the hand, see Plan No. 45. For dorsal section, see Plan No. 49. For the form of the wrist in flexion and extension, see drawings on preceding page. Notice the form of the heel or outside section of the palm, the ball of the thumb and the joint section throughout.

No. 48
Profile view

No. 46
Thumb Head

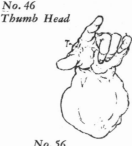

No. 56
Palm of the Hand partly closed

The flesh of the palm as is shown in this Plan extends beyond the knuckle joint nearly half-way to the joint below — the joint being D. The section marked I when the hand is closed belongs to the Palmar Surface of the fingers. When the hand is open to the Palmar Surface of the palm of the hand, flexion occurs at the fissure marked x. The Palmar Surface is longer than the Dorsal Surface when the hand is open — shorter when it is closed — measuring from the end of the middle finger to the knuckle joint. The fingers are longer than the Dorsum of the hand. The section between the vertical lines is the section of the carpal tendons.

Metacarpal Joint

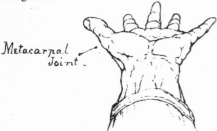

No. 53
Palmar elevation as seen from behind when the hand is extended directly and laterally

Study the wrist and hand carefully.

Tendons of Thumb and Flexor side of Wrist

Common Flexors

No. 55
Tendons of Thumb and Flexor side of Wrist

Extensor of the Metacarpal Bone of the Thumb.
xo Long Supinator -
xxo Flexor Carpi Radialis .
v Palmaris Longus Tensor of Palmer Fascia -

Supinator Longus .
o Flexor Carpi Radialis .
ε Palmaris Longus .

x Flexor Carpi Radialis
Annular Ligament .
End of Radius .

End of Ulna

Flexor Sublimis Digitorum No. 57
Flexor Tendons of Wrist — Palm side

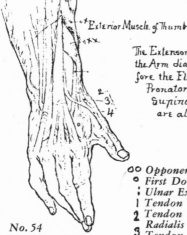

Exterior Muscle of Thumb

The Extensors and Flexors cross the Arm diagonally and therefore the Flexor Muscles are also Pronators the Extensors also Supinators the Supinators are also Flexors.

No. 54
Tendons of the back of the Wrist and Hand

oo Opponens of Thumb.
o First Dorsal Inter-osseous Muscle of Thumb.
: Ulnar Extensor.
1 Tendon of short Radial Extensor Carpi Radialis Brevior.
2 Tendon of long Radial Extensor — Extensor Carpi Radialis Longior.
3 Tendon of Extensor Brevior of the Thumb.
4 Dorsal Extensor of the Thumb-Conspicuous on the Dorsum of the Thumb.

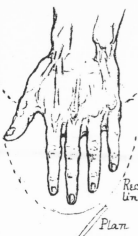

Palmar Integument or Web seen between the Fingers.

No. 49
Direction of Metacarpal Joints and Palmar Integument

Receding line

Plan

Natural form of extension in youthful hands when not stiffened by labor.

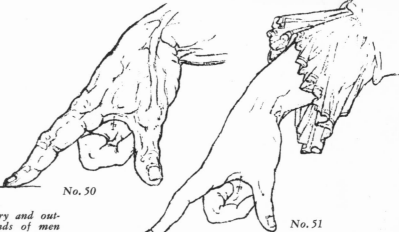

No. 50

No. 51

Male and Female Hands — Elementary and outline proportions compared. The hands of men are generally broader and thicker than are the hands of women. The outlines of the hands of men take their form from the bones and muscles of the several parts. The outlines of the hands of women take their form, as in the hands of children, from the fatty matter lying between the bones and muscles and the skin. The hands of women are more flexible than the hands of men; narrower in proportion to their length: of finer proportions in the animal scale and capable of greater exactness in their use. A small or weak hand is a great deformity. Every section of the hand should have the fullest length and width consistent with fine proportion. When the fingers are thick, short and large at the ends, the hand is beastlike. When the fingers are too long with loose joints and soft integument, the constitution is generally feeble. The hands as a whole like the foot, should be as large as exact fineness of general proportion will permit.

Male and Female Hands
Notice the integumentary web joining the thumb and forefinger.
See Nos. 50, 51, 55, & 56.

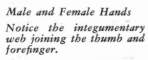

Carpal Section. Plan.
Cartilaginous at birth — Skeleton form.

Skeleton and Muscle proportions.

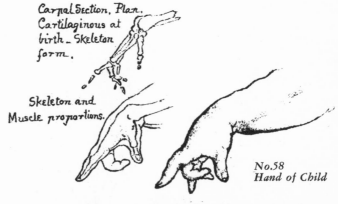

No. 58
Hand of Child

No. 52
The nail should never extend to the outline.

Outline altogether integumentary. The joints of extension represented by dimple cavities rather than by bony eminences or fold of skin. Outline convex — Phalangeal Sections short and generally imperfectly defined. Wrist bones obscured by folds of integument. No tendons seen. Joints susceptible of almost unlimited extension.

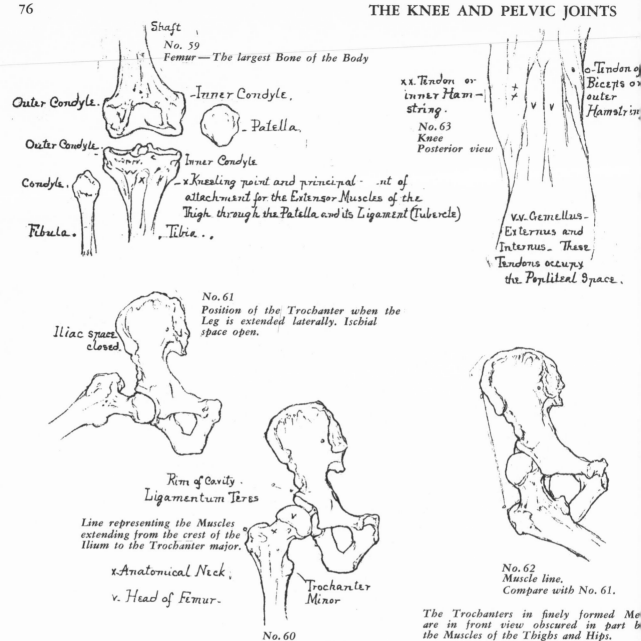

Shaft

No. 59
Femur — The largest Bone of the Body

Outer Condyle. Inner Condyle.

Outer Condyle. Patella.

Outer Condyle. Inner Condyle

Condyle. x Kneeling point and principal point of
attachment for the Extensor Muscles of the
Thigh through the Patella and its Ligament (Tubercle)

Fibula. Tibia.

x x. Tendon or
inner Ham-
string.

No. 63
Knee
Posterior view

o Tendon of
Biceps or
outer Hamstring

v.v Gemellus-
Externus and
Internus. These
Tendons occupy
the Popliteal Space.

No. 61
Position of the Trochanter when the
Leg is extended laterally. Ischial
space open.

Iliac space
closed.

Rim of Cavity.
Ligamentum Teres

Line representing the Muscles
extending from the crest of the
Ilium to the Trochanter major.

x Anatomical Neck.

v. Head of Femur.

Trochanter
Minor

No. 60
Trochanter Major

No. 62
Muscle line.
Compare with No. 61.

The Trochanters in finely formed Men
are in front view obscured in part by
the Muscles of the Thighs and Hips.

Plan. Sartorius Muscle
8 Vastus Internus Muscle
Tendon of Rectus (Common Tendon
of Extensor Muscles)

Tendon of
Vastus Externus
Muscle.

o. Patella.

External lateral
Ligament.

Head of
Fibula.

Tendon of Sartorius Muscle.
xx Tendon of the Aponeuroses of the Fascia Lata.
Ligamentum Patellae
w. Kneeling Point

No. 64

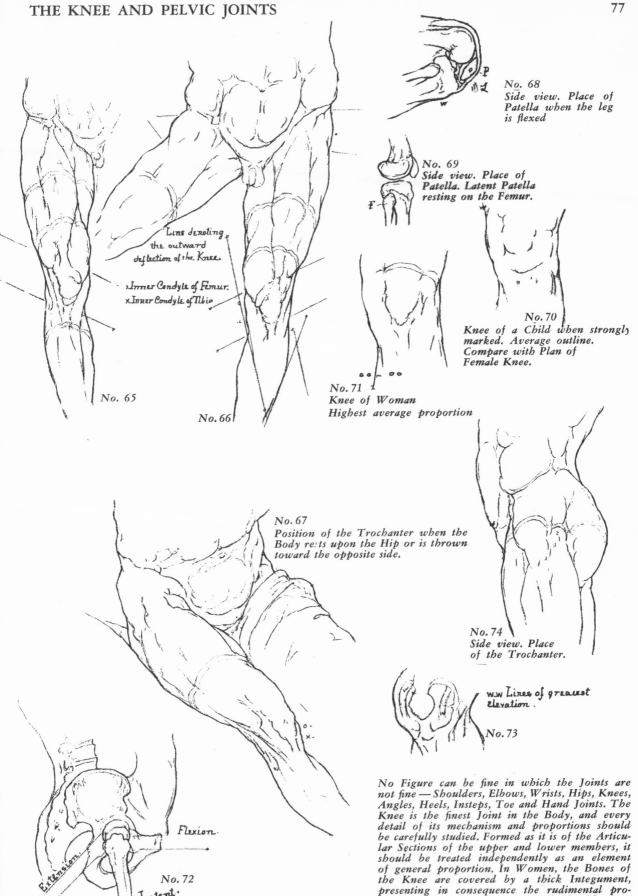

No. 68
Side view. Place of
Patella when the leg
is flexed

No. 69
Side view. Place of
Patella. Latent Patella
resting on the Femur.

Line denoting
the outward
deflection of the Knee.

∴ Inner Condyle of Femur.
x Inner Condyle of Tibio

No. 70
Knee of a Child when strongly
marked. Average outline.
Compare with Plan of
Female Knee.

No. 71
Knee of Woman
Highest average proportion

No. 65

No. 66

No. 67
Position of the Trochanter when the
Body rests upon the Hip or is thrown
toward the opposite side.

No. 74
Side view. Place
of the Trochanter.

w.w Lines of greatest
elevation.

No. 73

Flexion.

Extension.

No. 72

Latent.

No Figure can be fine in which the Joints are
not fine — Shoulders, Elbows, Wrists, Hips, Knees,
Angles, Heels, Insteps, Toe and Hand Joints. The
Knee is the finest Joint in the Body, and every
detail of its mechanism and proportions should
be carefully studied. Formed as it is of the Articu-
lar Sections of the upper and lower members, it
should be treated independently as an element
of general proportion. In Women, the Bones of
the Knee are covered by a thick Integument,
presenting in consequence the rudimental pro-
portions of early Infancy. A limb should never
be flat or angular.

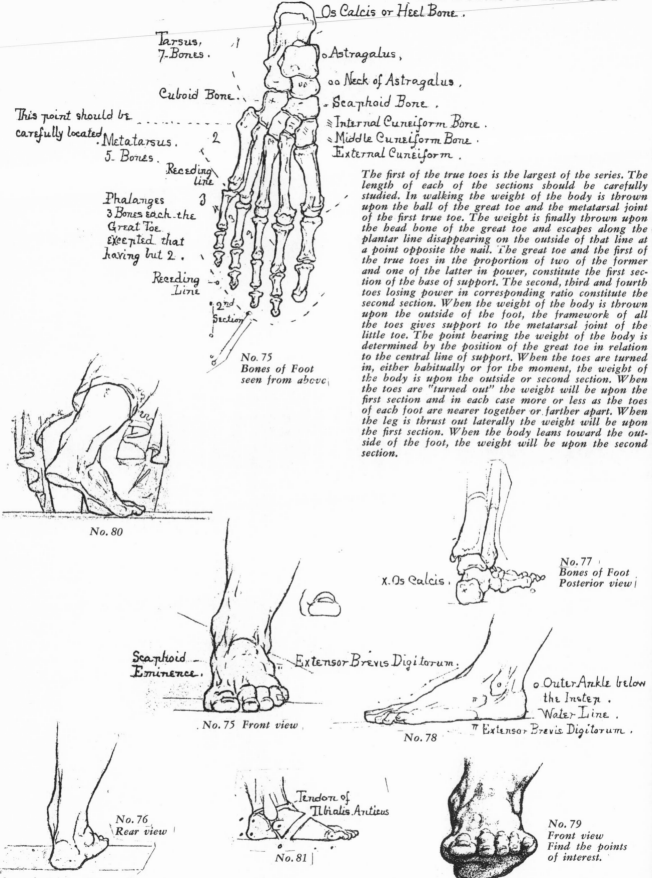

Os Calcis or Heel Bone.

Tarsus, 7 Bones.

o Astragalus,

oo Neck of Astragalus.

Cuboid Bone.

. Scaphoid Bone.

This point should be carefully located.

≈ Internal Cuneiform Bone.
≈ Middle Cuneiform Bone.
≈ External Cuneiform.

Metatarsus. 5 Bones. 2

Receding line 3

Phalanges 3 Bones each the Great Toe excepted that having but 2.

Receding Line

2nd Section

No. 75
Bones of Foot
seen from above

The first of the true toes is the largest of the series. The length of each of the sections should be carefully studied. In walking the weight of the body is thrown upon the ball of the great toe and the metatarsal joint of the first true toe. The weight is finally thrown upon the head bone of the great toe and escapes along the plantar line disappearing on the outside of that line at a point opposite the nail. The great toe and the first of the true toes in the proportion of two of the former and one of the latter in power, constitute the first section of the base of support. The second, third and fourth toes losing power in corresponding ratio constitute the second section. When the weight of the body is thrown upon the outside of the foot, the framework of all the toes gives support to the metatarsal joint of the little toe. The point bearing the weight of the body is determined by the position of the great toe in relation to the central line of support. When the toes are turned in, either habitually or for the moment, the weight of the body is upon the outside or second section. When the toes are "turned out" the weight will be upon the first section and in each case more or less as the toes of each foot are nearer together or farther apart. When the leg is thrust out laterally the weight will be upon the first section. When the body leans toward the outside of the foot, the weight will be upon the second section.

No. 80

X. Os Calcis.

No. 77
Bones of Foot
Posterior view

Scaphoid Eminence.

Extensor Brevis Digitorum.

o Outer Ankle below the Instep.
. Water Line.
π Extensor Brevis Digitorum.

No. 75 Front view

No. 78

No. 76
Rear view

Tendon of Tibialis Anticus

No. 81

No. 79
Front view
Find the points
of interest.

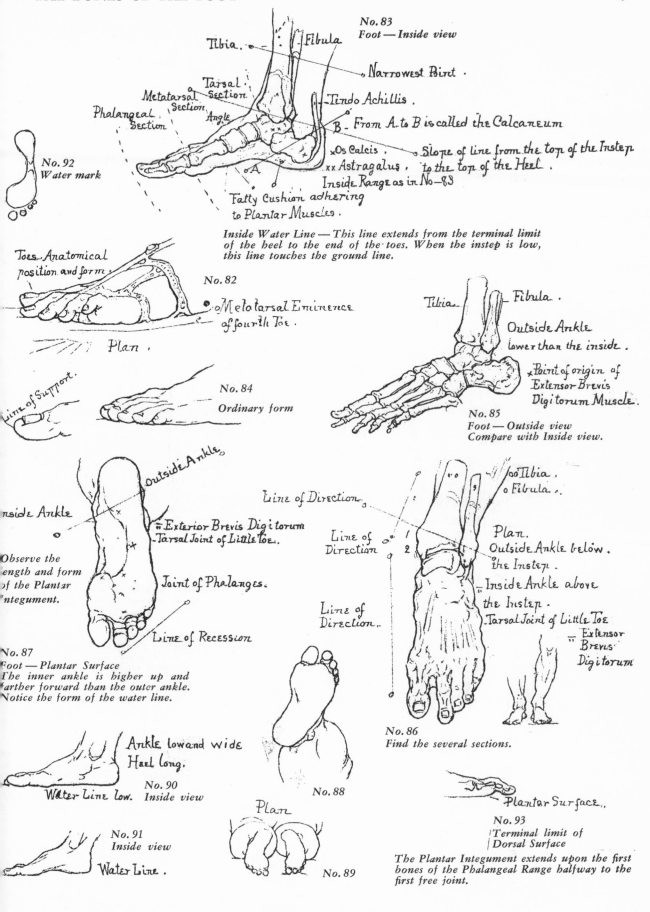

No. 83
Foot — Inside view

Tibia. Fibula
Narrowest Point.
Tindo Achillis.
B - From A. to B is called the Calcaneum
Tarsal Section
Metatarsal Section
Phalangeal Section
Angle
x Os Calcis.
xx Astragalus.
o A
Slope of line from the top of the Instep to the top of the Heel.
Inside Range as in No. 83
Fatty Cushion adhering to Plantar Muscles.

No. 92
Water mark

Inside Water Line — This line extends from the terminal limit of the heel to the end of the toes. When the instep is low, this line touches the ground line.

Toes Anatomical position and form

No. 82
Metatarsal Eminence of fourth Toe.

Plan.

Line of Support.

No. 84
Ordinary form

Tibia. Fibula.
Outside Ankle lower than the inside.
Point of origin of Extensor Brevis Digitorum Muscle.

No. 85
Foot — Outside view
Compare with Inside view.

Inside Ankle
Outside Ankle
Exterior Brevis Digitorum
Tarsal Joint of Little Toe.
Joint of Phalanges.
Observe the length and form of the Plantar Integument.
Line of Recession

No. 87
Foot — Plantar Surface
The inner ankle is higher up and farther forward than the outer ankle. Notice the form of the water line.

Line of Direction
Line of Direction
Line of Direction
Tibia. Fibula.
Plan.
Outside Ankle below the Instep.
Inside Ankle above the Instep.
Tarsal Joint of Little Toe
Extensor Brevis Digitorum

No. 86
Find the several sections.

Ankle low and wide
Heel long.

No. 90
Inside view
Water Line Low.

No. 91
Inside view
Water Line.

Plan

No. 88

Plantar Surface.

No. 93
Terminal limit of Dorsal Surface

The Plantar Integument extends upon the first bones of the Phalangeal Range halfway to the first free joint.

No. 89

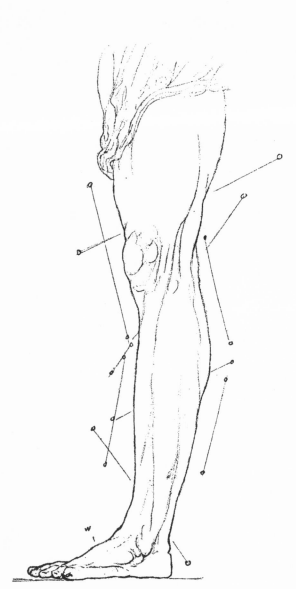

No. 94
Outside view — Ordinary

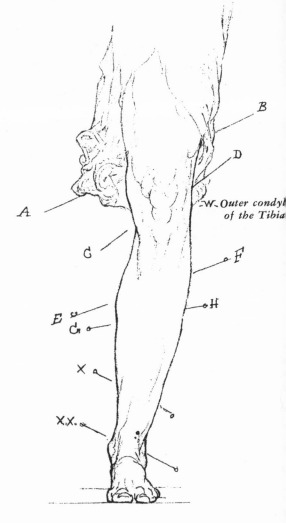

No. 95
*Average proportions — Unidealized
Points of interest*

*A to B. Line of direction from The Superior Eminenc[e]
of the Knee joint to the point above the Tendons a[t]
which the Vastus Externus muscle comes upon the ou[t]
line.*
*C to D. From the point at which the Gastrocnemiu[s]
disappears behind the bones of the Knee to narrowes[t]
point above the outer condyle of the Tibia.*
*E to F. The most prominent or Summit points of th[e]
inner and outer Sections of the calf of the leg.*
GH. to VX. Shank Sections.
*X to X.X. Section of the Tibia in which that bone come[s]
upon the outline. This Section is longer in proportio[n]
as the muscles are smaller or the integument thinne[r].
The Ankle should be thin and broad, the Shank lon[g]
and the Instep high. The highest average gives 6-1/[?]
times the length of the foot in the length of the <u>whol[e]</u>
body.*

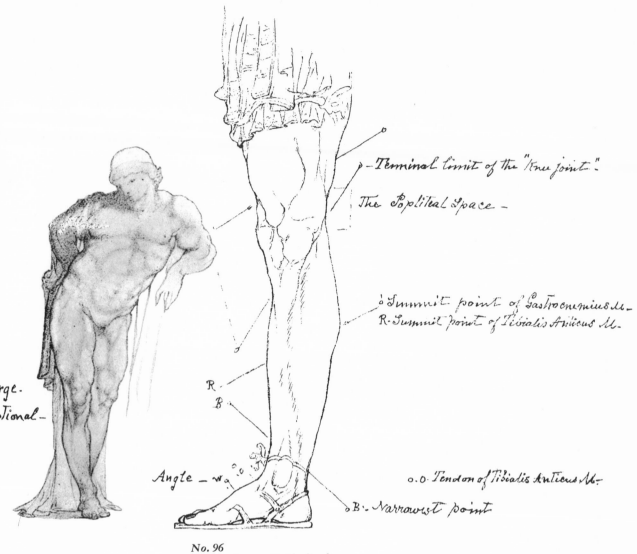

o —Terminal limit of the "Knee joint".

The Popliteal Space —

o Summit point of Gastrocnemius M.

R. Summit point of Tibialis Anticus M.

R.
B

Angle — *x*

o.o Tendon of Tibialis Anticus M.

o B. Narrowest point

No. 96
Inside view — Unidealized

—Plan—

x. *Fold of Integument above the Knee.*
R. *Fold of Integument below the Patella.*
T. *Central Tendon of Triceps.*
v. *Outer Condyle of Tibia.*
II. *Ligamentum Patellae.*
o. *Kneeling point.*

The fold of integument marked x is exhausted when the leg is bent.

No. 97

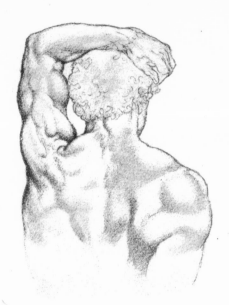

No. 98

When the arm is elevated, the Deltoid Muscle is turned to-
ward the Back. Its several limbs, viz., Clavical, Acromial,
and Scapular being distinctly visible. This section embracing
as it does the Acromion and the end of the Clavicle is the
boundary line between the upper attachments of the limbs
of the Deltoid and as much of the back as lies above the
Spine of the Scapula.

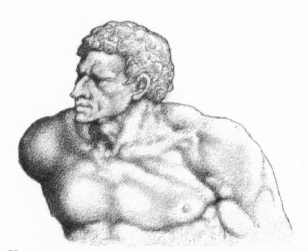

No. 99

See Skeleton Sections.

Shoulder joint, three-quarters view seen from above; Acromio-
Clavicular Circle; the boundary line between the muscles of
the Chest and Shoulder and those of the Cervical Section of
the Back. The lowest point of Clavicular depression is the
top of the Sternum.

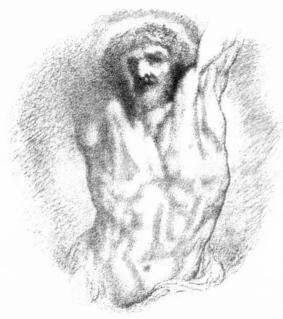

No. 100
Extension by Force. The Shoulder against the side of the Face; the Scapular limb of the Deltoid upon the outline; the Scapula upon the outline. The Trapezial Space closed; the Clavicle against the Neck; the Pectoral Muscle nearly vertical; the Ribs Extended.

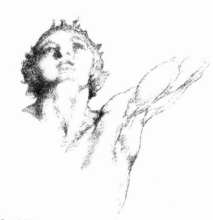

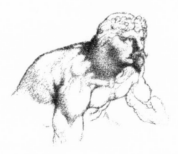

No. 102

No. 101
Clavicular limb of Deltoid covering the acromial end of the Clavicle; the acromial end of Deltoid upon the outline. In proportion as the Clavicle is elevated; the Shoulder must approach the Side of the Neck; the Trapezial Section being shortened and elevated.

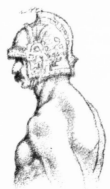

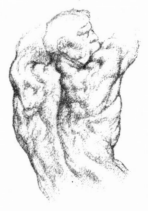

No. 103
Shoulder seen from above

No. 104
The apex from the outline

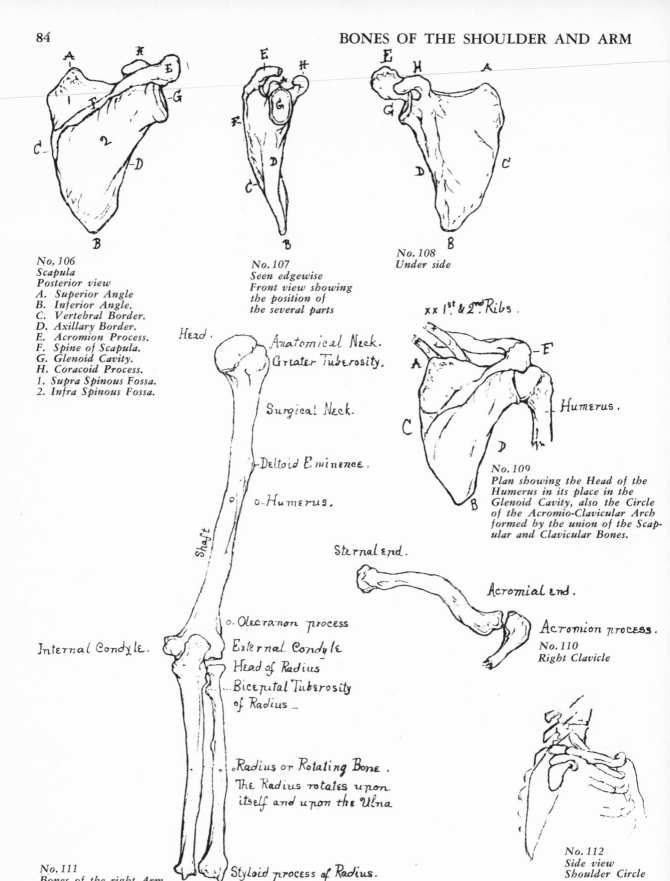

No. 106
Scapula
Posterior view
A. *Superior Angle*
B. *Inferior Angle.*
C. *Vertebral Border.*
D. *Axillary Border.*
E. *Acromion Process.*
F. *Spine of Scapula.*
G. *Glenoid Cavity.*
H. *Coracoid Process.*
1. *Supra Spinous Fossa.*
2. *Infra Spinous Fossa.*

No. 107
Seen edgewise
Front view showing
the position of
the several parts

No. 108
Under side

No. 109
Plan showing the Head of the
Humerus in its place in the
Glenoid Cavity, also the Circle
of the Acromio-Clavicular Arch
formed by the union of the Scap-
ular and Clavicular Bones.

No. 110
Right Clavicle

No. 111
Bones of the right Arm
Back view

No. 112
Side view
Shoulder Circle

Notice that the Humerus leans toward the Body;
that the inner Condyle is larger, higher up, and
sharper than the outer Condyle; that when the
Arm hangs latent by the side, the Radius and
Ulna turn from the Body.

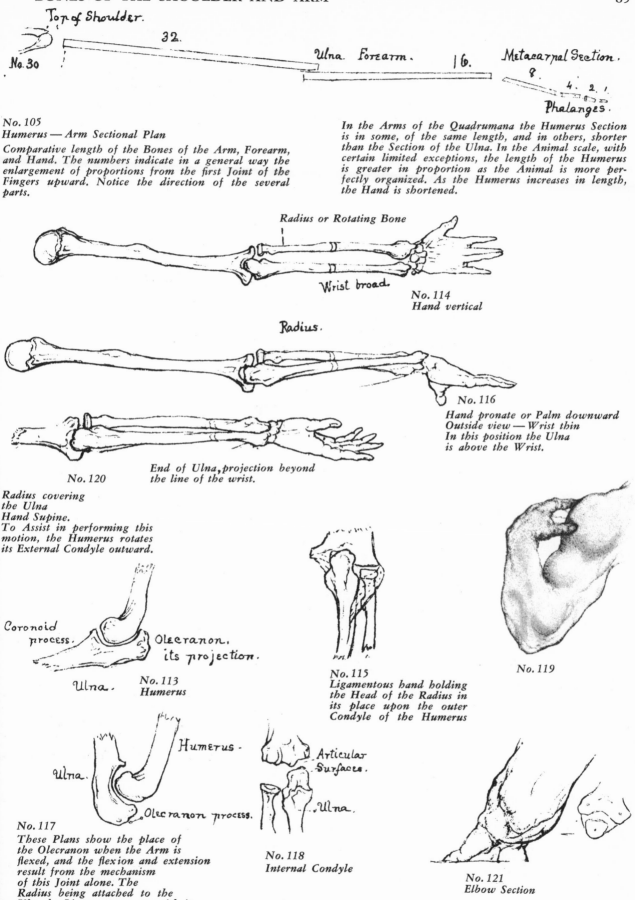

Top of Shoulder.

No. 30

32.

Ulna. Forearm.

16.

Metacarpal Section.

8.

4. 2. 1.

Phalanges.

No. 105
Humerus — Arm Sectional Plan
Comparative length of the Bones of the Arm, Forearm, and Hand. The numbers indicate in a general way the enlargement of proportions from the first Joint of the Fingers upward. Notice the direction of the several parts.

In the Arms of the Quadrumana the Humerus Section is in some, of the same length, and in others, shorter than the Section of the Ulna. In the Animal scale, with certain limited exceptions, the length of the Humerus is greater in proportion as the Animal is more perfectly organized. As the Humerus increases in length, the Hand is shortened.

Radius or Rotating Bone

Wrist broad.

No. 114
Hand vertical

Radius.

No. 116

Hand pronate or Palm downward
Outside view — Wrist thin
In this position the Ulna
is above the Wrist.

End of Ulna, projection beyond
the line of the wrist.

No. 120

Radius covering
the Ulna
Hand Supine.
To Assist in performing this
motion, the Humerus rotates
its External Condyle outward.

Coronoid
process.

Olecranon.
its projection.

Ulna.

No. 113
Humerus

No. 115
Ligamentous hand holding
the Head of the Radius in
its place upon the outer
Condyle of the Humerus

No. 119

Humerus.

Ulna.

Olecranon process.

No. 117
These Plans show the place of
the Olecranon when the Arm is
flexed, and the flexion and extension
result from the mechanism
of this Joint alone. The
Radius being attached to the
Ulna by Ligaments moves with it.

Articular
Surfaces.

Ulna.

No. 118
Internal Condyle

No. 121
Elbow Section

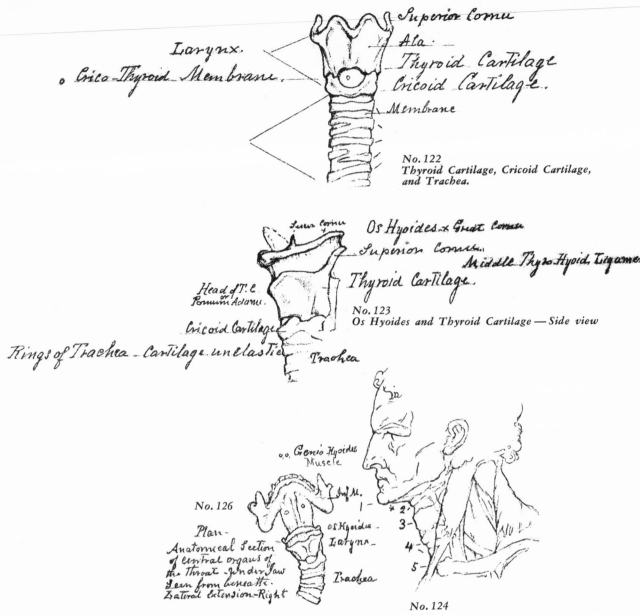

Superior Cornu

Larynx.

Ala:

Thyroid Cartilage

Crico-Thyroid Membrane.

Cricoid Cartilage.

Membrane

No. 122
Thyroid Cartilage, Cricoid Cartilage,
and Trachea.

Lesser Cornu

Os Hyoides × Great Cornu

Superior Cornu

Middle Thyro-Hyoid Ligament

Thyroid Cartilage.

Head of T. C. or Pomum Adami.

No. 123
Os Hyoides and Thyroid Cartilage — Side view

Cricoid Cartilage

Rings of Trachea — Cartilage unelastic

Trachea

o.o. Genio Hyoides Muscle

No. 126

Inf M.

Os Hyoides

Larynx

Plan —
*Anatomical Section
of central organs of
the Throat — under Jaw
seen from beneath.
Lateral Extension — Right*

Trachea

No. 124

Showing the place of the Thyroid Cartilage and parts associated
in the formation of the Neck.

1. Chin.
2. Os Hyoides.
3. Thyroid Cartilage.
4. Cricoid Cartilage and upper Trachea.
5. Tendon of Sterno-Cleido Mastoideus Muscle.

The Hyoid Bone marks the limits of the Sub-Maxillary
Section x on front and upon the sides of the Throat as
far back as the angle of the Jaw. The Sub-Maxillary
Section extends upon the Hyoid Bone. See No. 129,
No. 130.

Hyoid Bone. Anterior Surface.

Great Cornu

Lesser Cornu.

Body

No. 125
Hyoid Bone — Anterior Surface

No. 137
Thyroid cartilage as seen from above.
Notice the direction of its planes.

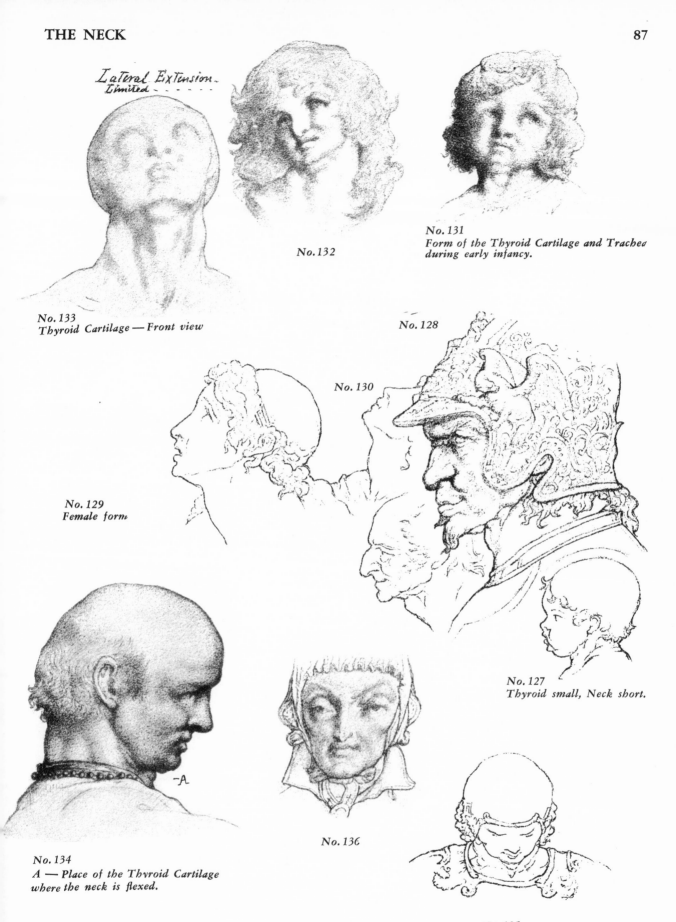

Lateral Extension.
Limited

No. 133
Thyroid Cartilage — Front view

No. 132

No. 131
Form of the Thyroid Cartilage and Trachea
during early infancy.

No. 128

No. 130

No. 129
Female form

No. 127
Thyroid small, Neck short.

No. 134
A — Place of the Thyroid Cartilage
where the neck is flexed.

No. 136

No. 135

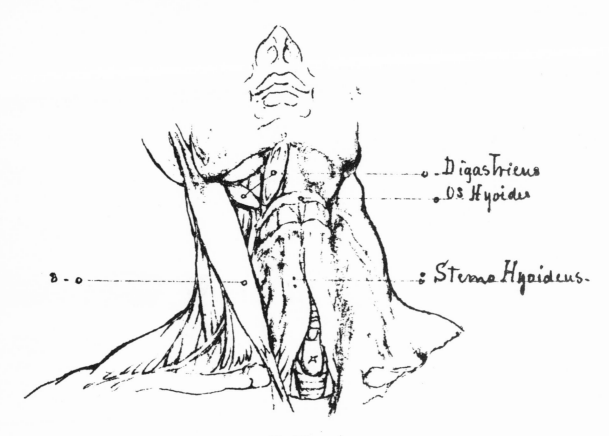

Digastricus
Os Hyoides

Sterno Hyoideus.

8 - o

No. 139
Anatomical Section — Front view

When the muscles are in action, the points of attachment
are brought together, more or less, in proportion as
the action is intense or the mechanism of the parts per-
mits. The point of origin is that toward the body; the
point of insertion is that toward the extremities. Ordi-
narily, the point of attachment moves toward the point
of origin. When the point of attachment becomes fixed,
the point of origin moves toward it. By the action of
the Sterno-Mastoid and associate muscles of the side
of the neck, the head is made to rotate upon the cervical
column toward the shoulder, on the side opposite that
on which the acting muscles are situated. Muscular ac-
tion sends the blood to the surface of the body. The
muscles are larger when in action than when at rest.
Thin muscles act in straight lines often in fibrous lines,
making the skeleton visible. In the Male body the in-
tegument is firm and closely adherent to the part beneath
when the muscles are fully developed. Flexion is more
forcible than Extension. Avoid skeleton outlines. Make
no display of technical anatomy. A work of art should
be something more than the solution of a problem in
science. For the bones of the neck, see Nos. 122-126.

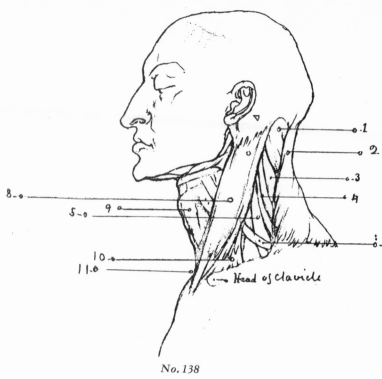

Mastoid process of
Temporal Bone

No. 138

8. *Sterno-Cleido-Mastoideus. Arises by two heads from the Sternum and Clavicle, and is inserted by a strong tendon into the outer surface of the Mastoid Process of the Temporal Bone.*

10. *The clavicular limb occupies the inner third of the upper border of the Clavicle.*

1. *Splenius. The External portion arises from the spinous processes of four or five dorsal and the seventh cervical vertebrae, and is attached to the external surface and posterior border of the Mastoid Process.*

2. *Trapezius, Cervical portion. Arises from the inner third of the Superior curved occipital line from the spinous processes of all the cervical vertebrae, and is attached to the outer third of the clavicle to the inner border of the Acromion process, and by its dorsal fibres to the superior border of the spine of the Scapula. See Skeleton Sections.*

3. *Levator-Anguli Scapulae. Arises from the transverse processes of the three or four superior cervical vertebrae, and is inserted into the superior angle of the Scapula.*

4. *Scalenus Posticus. From the first rib to the transverse processes of the six lowermost cervical vertebrae.*

5. *Scalenus Articus. From the first rib to the transverse processes of the third, fourth, fifth, and sixth cervical vertebrae.*

6. *Omo Hyoides. Arises from the superior border of the scapula behind the coracoid notch, and is inserted into the lower part of the body of the Os Hyoides externally to the Sterno Hyoid.*

9. *Sterno Hyoideus. Arises from the inner end of the clavicle behind the tendon (11) of the Sterno Mastoid (9) and is inserted into the Os Hyoides.*

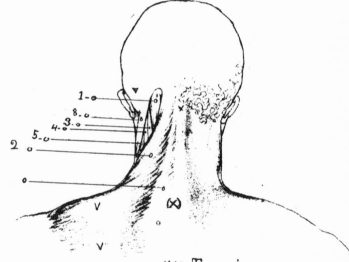

V.-V. Trapezius
°₀⊗-Trapezius Tendon

No. 140
Back view of the muscles of the neck. Muscular form. Integumentary form.

x. *Ligamentum Nuchae. A thin band of condensed cellulo-fibrous membrane, extending from the Occipital protuberance to the spinous process of the seventh cervical vertebra.*

(x) *Seventh cervical vertebra.*

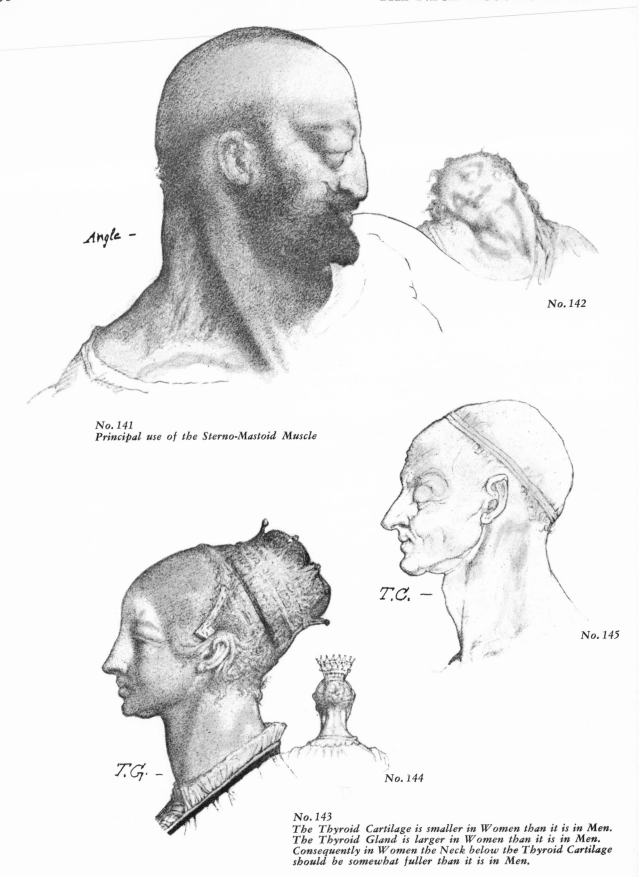

Angle –

No. 141
Principal use of the Sterno-Mastoid Muscle

No. 142

T.C. –

No. 145

T.G. –

No. 144

No. 143
The Thyroid Cartilage is smaller in Women than it is in Men.
The Thyroid Gland is larger in Women than it is in Men.
Consequently in Women the Neck below the Thyroid Cartilage
should be somewhat fuller than it is in Men.

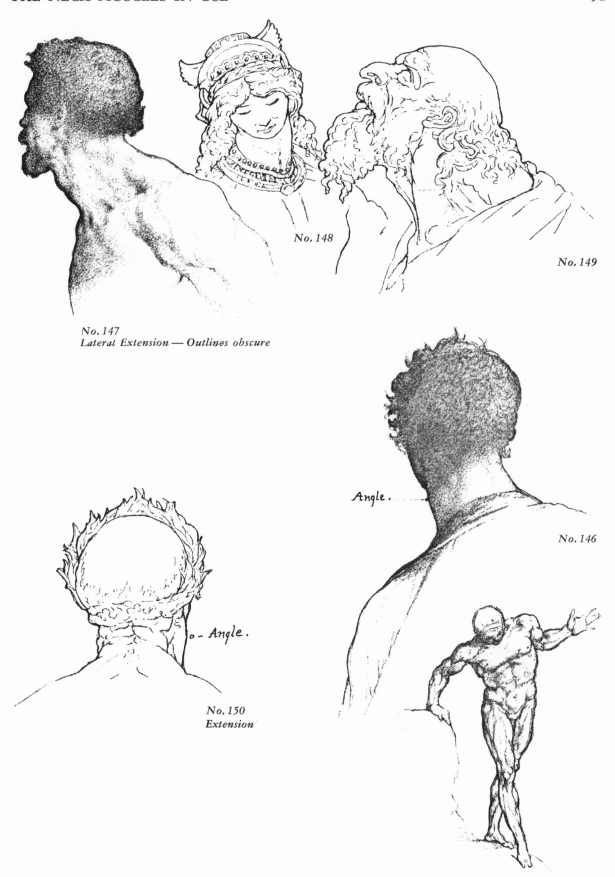

No. 148

No. 149

No. 147
Lateral Extension — Outlines obscure

Angle.

No. 146

o - Angle.

No. 150
Extension

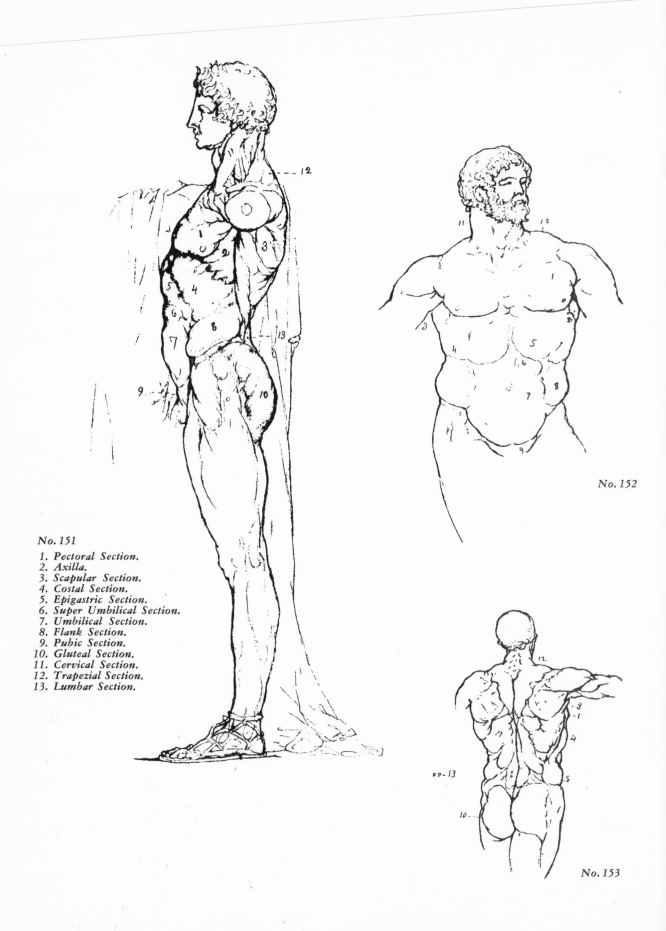

No. 152

No. 151

1. *Pectoral Section.*
2. *Axilla.*
3. *Scapular Section.*
4. *Costal Section.*
5. *Epigastric Section.*
6. *Super Umbilical Section.*
7. *Umbilical Section.*
8. *Flank Section.*
9. *Pubic Section.*
10. *Gluteal Section.*
11. *Cervical Section.*
12. *Trapezial Section.*
13. *Lumbar Section.*

No. 153

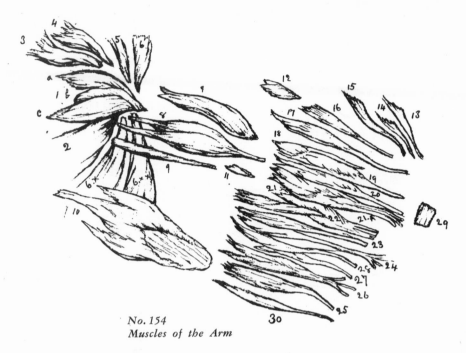

No. 154
Muscles of the Arm

1. Deltoid.
 a. Scapular Limb.
 b. Acromial Limb.
 c. Clavicular Limb.
2. Pectoralis Major.
3. Super Spinatus.
4. Infra Sinatus.
5. Teres Minor.
6. Teres Major.
6x. Subscapularis.
6xx. Latissimus Dorsi.
7. Brachialis Anticus.

8. Biceps.
9. Coraco Brachialis.
10. Triceps.
11. Subanconeous.
12. Anconeus.
13. Extensor Secundi Internii Pollocis.
14. Extensor Primi Internodii Pollicis.
15. Extensor Ossis Metacarpi Pollicis.
16. Extensor Carpi Radialis Longior.
17. Supinator Longus.
18. Supinator Brevis.
19. Flexor Longus Pollicus.

20. Extensor Carpi Radialis Brevior.
21. Flexor Profundus Digitorum.
21A. Flexor Sublimis Digitorum.
22. Pronator Radii Teres.
23. Flexor Carpi Radialis.
24. Palmaris Longus.
25. Flexor Carpi Ulnaris.
26. Extensor Communis Digitorum.
27. Extensor Minimi Digiti.
28. Extensor Carpi Ulnaris.
29. Pronator Quadratus.
30. Extensor Indicis.

In man the mechanism of the arm is complete. The bones increase in length and the muscles in size from the fingers upward. No part is covered by the proper integument of the side. The shoulder projects beyond the side of the body. Its movements are unrestrained. They are not subordinate to locomotion. The arm is an instrument of prehension; in it, flexion is unrestrained by any mechanical contrivance, and constitutes its principal use. Extension. is limited by special contrivances. Masculine proportions find strongest expression in the parts devoted to the movements of the arm, viz., the muscles of the Chest, the Shoulders, and the Back, the Clavicles, the Scapular and the Humeral Bones.*

**As in the lower animals.*

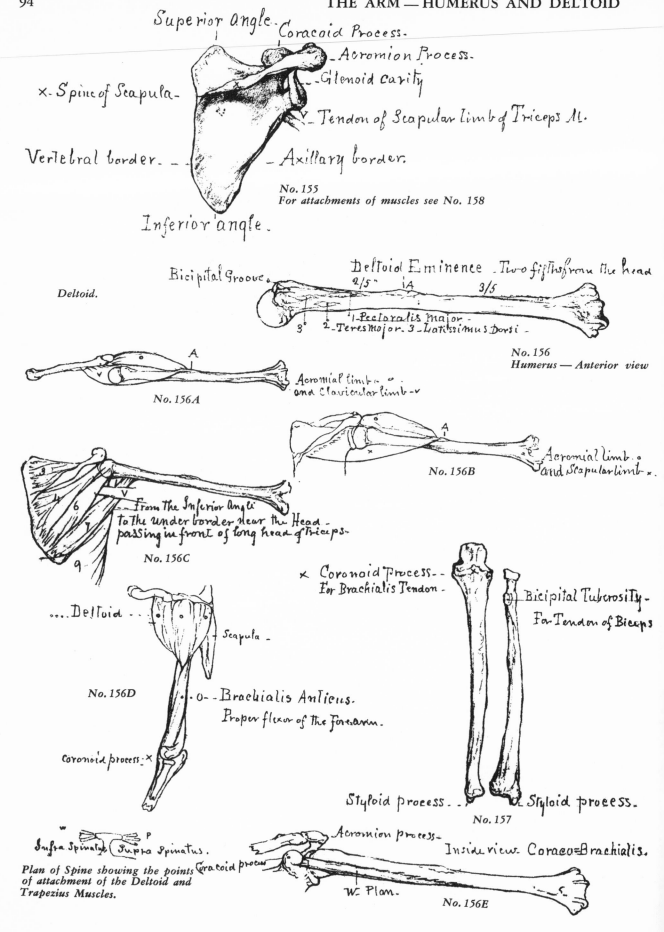

Superior Angle — Coracoid Process.

_ Acromion Process.

x - Spine of Scapula - _ Glenoid cavity

V _ Tendon of Scapular limb of Triceps M.

Vertebral border. _ _ _ Axillary border.

No. 155
For attachments of muscles see No. 158

Inferior angle.

Bicipital Groove. Deltoid Eminence . Two fifths from the head

Deltoid.

2/5" A 3/5

1- Pectoralis Major -
8° 2 - Teres Major. 3 - Latissimus Dorsi -

No. 156
Humerus — Anterior view

No. 156A

Acromial limb - o .
and Clavicular limb - v

No. 156B

Acromial limb. o
and Scapular limb. x

V _ From the Inferior Angle
to the under border near the Head _
passing in front of long head of Triceps -

No. 156C

x Coronoid Process - -
For Brachialis Tendon -

Bicipital Tuberosity -
For Tendon of Biceps

... Deltoid - -

Scapula -

No. 156D

. o- -Brachialis Anticus.
Proper flexor of the Forearm.

Coronoid process - x

Styloid process - . _ Styloid process.

No. 157

Infra Spinatus (Supra Spinatus.

*Plan of Spine showing the points
of attachment of the Deltoid and
Trapezius Muscles.*

Acromion process -

Coracoid procus

W. Plan.

Inside view. Coraco=Brachialis.

No. 156E

+x-Deltoid cavity

Regardless of the actual place of a muscle, it enters into the composition of the common mass to the extent to which it is seen from the point of view taken.

No. 158
Outline Plan of the Muscles of the Back of the Arm
1. *Acromial limb of Deltoid muscle.*
2. *Clavicular limb of Deltoid muscle. The Deltoid muscle has three limbs. It surrounds the Shoulder joint, covering it on its outer side, and in front and behind. It arises in front from the outer third of the clavicle, on the side from the Acromion process, and behind from the Spine of the Scapula. It terminates in a thick Tendon which is attached to the Humerus at the point A. See Fig. 156.*
3. *Supra Spinatus.* 6. *Teres Minor.*
4. *Infra Spinatus.* 7. *Teres Major.*
C. *Longhead or Scapular limb of Triceps. See V, No. 155. For points of origin and insertion, see No. 156C.*
8. *Latissimus Dorsi. See 3, No. 156.*

A. *Inner limb of Triceps.* B. *Outer limb of Triceps.*
D. *Tendon of Triceps (fourth limb, artistic classification).*
E. *Brachialis Anticus — O, No. 156D. Arises from the Humerus, at the insertion of the Deltoid, passes in front between condyles, and is attached to the Coronoid process of the Ulna, see x, No. 157. It is covered at the Elbow by the Biceps except upon the inner side above the Condyle — ⁝ No. 159. W, 156e — Coraco-Brachialis. From the Coracoid process to the middle of the Humerus lower border.*
O. *Acromial limb of Trapezius.*
X. *Acromion process.*
X. *Head of Humerus.*

Ligaments of the Shoulder joint.

Acromion process.

oo Coraco-Humeral Ligament

No. 158A
1. *Coraco-Clavicular Ligament*
2. *Coraco-Acromial Ligament*
3. *Acromio-Clavicular Ligament (Superior)*
4. *Capsular Ligament*

Humeral Tendon of Biceps from Bicipital Groove.

No. 156F

Biceps.

Brachialis Anticus

⁝ Brachialis Antˢ outer side.

T Tendon of Biceps

xx - Inner Limb of Triceps.
xx - First Section.
o - Biceps.

+ Inner Limb of Triceps.
second section.
⁝ Br. Antˢ Inner Side
Inner Condyle.
P.T. Pronator Teres.
S.L. Supinator Longus.
z - Flexors.

No. 159
Elbow — Front view

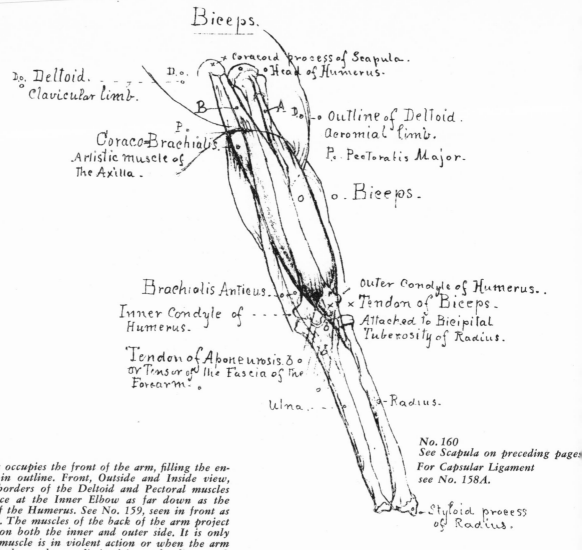

Biceps.

x Coracoid Process of Scapula.
o Head of Humerus.

Do. Deltoid.
o Clavicular limb.

D. o.

B

A. Do.

o Outline of Deltoid.
acromial limb.

P. Pectoralis Major.

P.

Coraco-Brachialis.
Artistic muscle of
The Axilla.

o. Biceps.

Brachialis Anticus.

Outer Condyle of Humerus.
x Tendon of Biceps.
Attached to Bicipital
Tuberosity of Radius.

Inner Condyle of
Humerus.

Tendon of Aponeurosis.
or Tensor of the Fascia of the
Forearm.

Ulna.

Radius.

No. 160
See Scapula on preceding pages
For Capsular Ligament
see No. 158A.

Styloid process
of Radius.

The Biceps occupies the front of the arm, filling the en-
tire space in outline. Front, Outside and Inside view,
from the borders of the Deltoid and Pectoral muscles
to the space at the Inner Elbow as far down as the
condyles of the Humerus. See No. 159, seen in front as
in No. 160. The muscles of the back of the arm project
beyond it on both the inner and outer side. It is only
when the muscle is in violent action or when the arm
is thin that the tendonous limit of it can be discovered.
The Integument of the Male arm is thin, thinner over
the Biceps than over the Triceps. The muscles are the
active organs of locomotion. In Men they give form to
all parts of the body excepting the joints and the middle
section of the field of the Abdomen. They are formed
of bundles of reddish fibers and are endowed with the
property of contractility. The names applied to the vari-
ous muscles have been derived:

1. From their situation, as the Tibialis, Radialis, Ul-
naris.
2. From their direction, as the Rectus abdominis, Ob-
liquus abdominis, Transversalis.
3. From their shape, as the Deltoid, Trapezius Pyra-
midalis.
4. From the number of their divisions, as the Triceps,
Biceps; from the number of their heads.
5. From their points of attachment, as the Clavicular
limb, the Sternal limb, the Sterno-Cleido-Mastoid,
etc.

The Tendons are white, glistening, fibrous cords, vary-
ing in length and thickness, sometimes round, sometimes
flat, and only slightly elastic. Aponeuroses are fibrous
membranes of a pearly white color, iridescent, glisten-
ing, and similar in structure to the Tendons. The mus-
cles are connected with the bones, cartilages, ligaments,
and skin, either directly or through the intervention of
fibrous sructures, called tendons or aponeuroses. The
Biceps of the arm is the finest muscle in all the body;
its contractile and tendonous portions are alike illus-
trative of the mechanism of the muscles themselves
throughout the body, and the way in which their forces
are applied. The muscles are enclosed in sheaths of
dense, inelastic, and unyielding fibrous membrane called
Fasciae. When a Tendon is broad and thin, it is styled
Aponeurotic. The Aponeuroses of investment form a
sheath for the entire limb as well as for each individual
muscle. See Femoral Fascia.

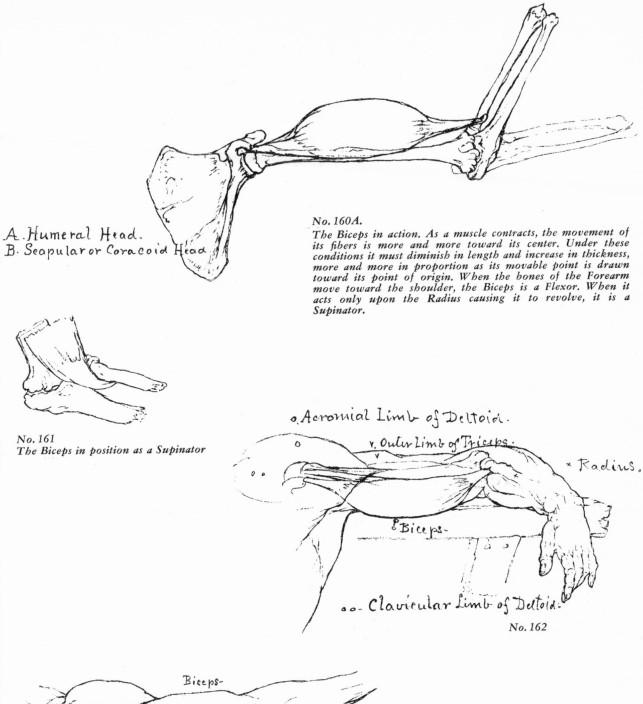

A. Humeral Head.
B. Scapular or Coracoid Head.

No. 160A.
The Biceps in action. As a muscle contracts, the movement of its fibers is more and more toward its center. Under these conditions it must diminish in length and increase in thickness, more and more in proportion as its movable point is drawn toward its point of origin. When the bones of the Forearm move toward the shoulder, the Biceps is a Flexor. When it acts only upon the Radius causing it to revolve, it is a Supinator.

No. 161
The Biceps in position as a Supinator

o. Acromial Limb of Deltoid.
v. Outer Limb of Triceps.
× Radius.
o Biceps.
oo. Clavicular Limb of Deltoid.

No. 162

Biceps.
× Inner Condyle.
o. Coraco-Brachialis.
v. Scapula. Latissimus Dorsi.

No. 163
The Biceps and the inner Condyle
The Axilla extends from the outer end of the Coraco-Brachialis Muscle to the tongues of the Serratus S.

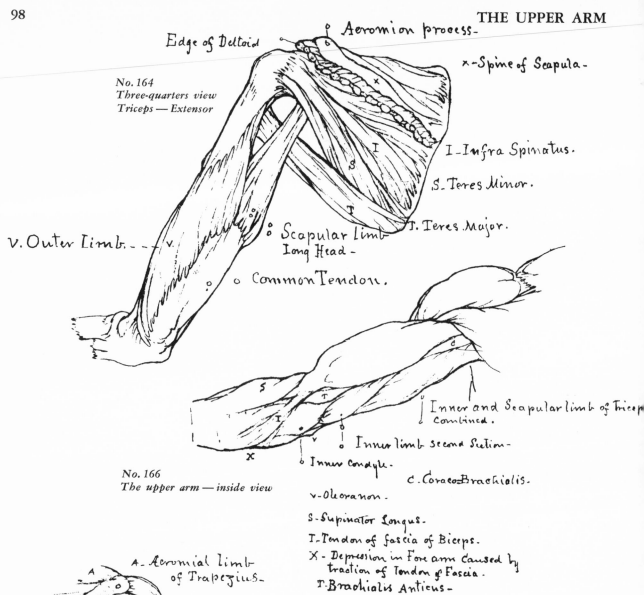

Edge of Deltoid

Acromion process.

x - Spine of Scapula.

No. 164
Three-quarters view
Triceps — Extensor

I - Infra Spinatus.

S. Teres Minor.

T. Teres Major.

v. Outer Limb.

o Scapular Limb
Long Head -

o Common Tendon.

Inner and Scapular limb of Triceps
Combined.

o Inner limb second Section -

No. 166
The upper arm — inside view

o Inner Condyle.

C. Coraco-Brachialis.

v - Olecranon.

S - Supinator Longus.

T - Tendon of fascia of Biceps.

X - Depression in Fore arm caused by
traction of Tendon of Fascia.

T - Brachialis Anticus -

A - Acromial limb
of Trapezius.

H - Humerus.

o Scapular Limb
of Triceps.

v Outer Limb.

Common Tendon
or fourth Limb.
artistic
o Classification-

No. 165
Back view

The Triceps is situated on the back of the arm, extend-
ing the entire length of the Humerus. It is of large
size, and is divided above into three parts named the
middle or long head, the external head, and the in-
ternal head. The middle head arises immediately below
the glenoid cavity of Scapula. See No. 165. The Teres
Major (posterior view as seen in No. 164), and, crossing
the space between the axillary border of the Scapula
and the Humerus, unites with the common tendon of
insertion o at the point ∵ . . The external head arises
from the posterior surface and external border of the
Humerus; its fibers unite with those of the common
tendon of insertion at its outer border, reaching to the
elbow. The inner head arises from the posterior surface
of the Humerus, below the groove for the Musculo-
Spiral nerve, and, extending upon the inner side of
the arm in the form and direction seen in the drawing
No. 166, terminates upon the inside border of the com-
mon tendon, the contractile fibers extending to the
elbow. See No. 148. The common tendon commences
about the middle of the back part of the muscle and is
inserted into the Ulna at the back part and upper sur-
face of the Olecranon process.

No. 167 The upper arm — outside view

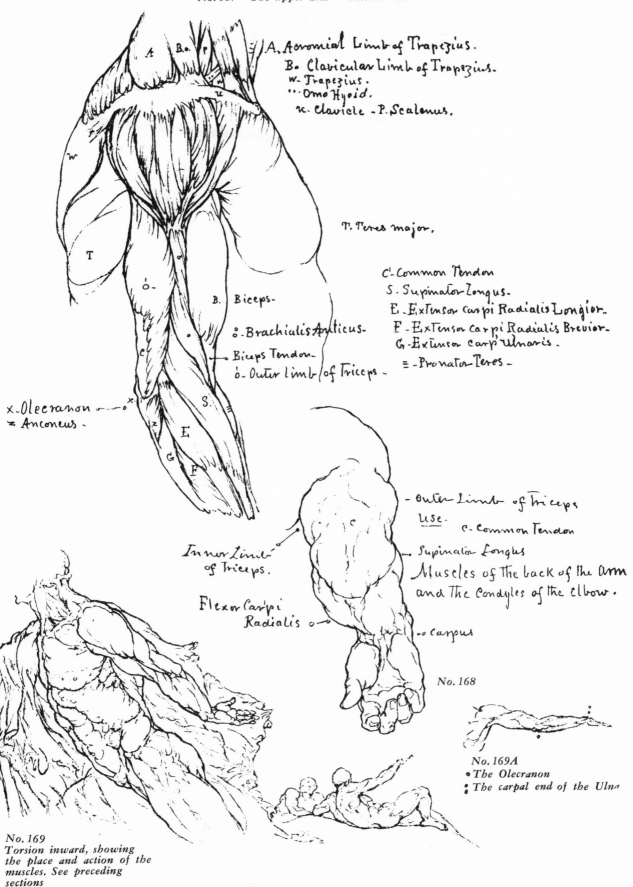

A. Acromial Limb of Trapezius.

B. Clavicular Limb of Trapezius.

W. Trapezius.

... Omo Hyoid.

K. Clavicle - P. Scalenus.

T. Teres major.

C. Common Tendon

S. Supinator Longus.

E. Extensor Carpi Radialis Longior.

F. Extensor Carpi Radialis Brevior.

G. Extensor Carpi Ulnaris.

= Pronator Teres

B. Biceps.

o. Brachialis Anticus.

Biceps Tendon.

o. Outer Limb of Triceps.

x. Olecranon

= Anconeus.

Inner Limb of Triceps.

Flexor Carpi Radialis o.

Outer Limb of Triceps

Use. C. Common Tendon

Supinator Longus

Muscles of the back of the Arm and The Condyles of the elbow.

o Carpus

No. 168

No. 169A
o The Olecranon
: The carpal end of the Ulna

No. 169
Torsion inward, showing the place and action of the muscles. See preceding sections

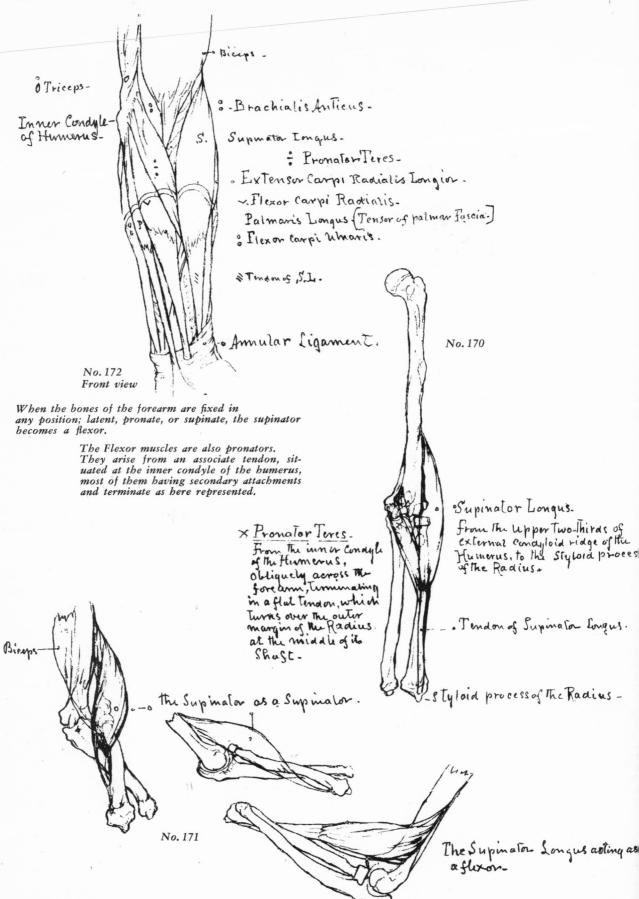

Biceps

Triceps

Inner Condyle of Humerus

Brachialis Anticus

Supinator Longus

Pronator Teres

Extensor Carpi Radialis Longior

Flexor Carpi Radialis

Palmaris Longus (Tensor of palmar Fascia)

Flexor Carpi Ulnaris

Tendon of S.L.

Annular Ligament

No. 170

No. 172
Front view

When the bones of the forearm are fixed in any position; latent, pronate, or supinate, the supinator becomes a flexor.

The Flexor muscles are also pronators. They arise from an associate tendon, situated at the inner condyle of the humerus, most of them having secondary attachments and terminate as here represented.

X Pronator Teres.
From the inner condyle of the Humerus, obliquely across the forearm, terminating in a flat Tendon, which turns over the outer margin of the Radius at the middle of its Shaft.

Supinator Longus.
From the upper Two-Thirds of external Condyloid ridge of the Humerus, to the Styloid process of the Radius.

Biceps

The Supinator as a Supinator.

Tendon of Supinator Longus.

Styloid process of the Radius.

No. 171

The Supinator Longus acting as a flexor.

S. Supinator Longus.

×. Extensor Carpi
Rad. Longior.

W. Extensor Communis
Digitorum.

†. Anconeus

× × Muscles of the
Thumb.

No. 174
Back view

Anconeus.

• — Transverse "line of quantity"
s. Supinator Longus.
○ Extensor Carpi Radialis Longior
¦ Tendon See Hand sections.
∴ Extensor Communis Digitorum.

∵ Extensor Carpi Radialis Brevior

Annular Ligament not described.

×.1 Extensor Ossis Metacarpi Pollicis.
×.2 Extensor Primi Internodii Pollicis.
×.3 Extensor Secundi Internodii Pollicis.

outer Condyle

No. 173
Outside view

+ Supinator Long⁵ +

○ Flexor Carpi Ulnaris.

∽ Condyle of ulna.

No. 175
Inside view

No. 176
Use of the muscles as elements of proportion.
Details of structure, accented and unaccented, illustrated

Accented

Unaccented.

Accented.

: : *Acromial Limb of Trapezius.*
x *Longhead of Triceps.*
. *Teres Minor.*
: *Teres Major.*
:. *Infra Spinatus.*

Muscles

10. *Rhomboideus. This muscle arises from the spinous processes of the seventh cervical and five superior dorsal vertebrae, and is inserted into all that part of the vertebral border of the Scapula situated below its spine. It is covered, except at its lower third, by the Trapezius. It is the artistic muscle of the Scapular field, as the Coraco-Brachialis is of the Brachial field on the pectoral side of the arm. An important outline of its vertebral border may be seen, in persons in whom the muscles of the back are much developed, through the body section of the Trapezius muscle. The superior angle of the Scapula and its vertebral border are also visible through the Trapezius at points suited to their anatomical rela-*

tions, and the movements of their parts.

9. *Serratus Magnus arises by nine fleshy digitations from the upper border of the eight upper ribs, and is inserted into the whole length of the vertebral border of the Scapula upon the under side of that bone. It is divided into three parts. Its lower third is attached to the inner surface of the inferior angle of the Scapula by an attachment which is partly tendinous and partly muscular. This limb falls below the angle of the Scapula and is covered by the Latissimus Dorsi through which, notwithstanding the thickness of that muscle, its form is distinctly visible.*

Muscles, Tendons, and Bones

1. *Acromial limb of Trapezius.*
2. *Wings of Trapezius.*
3. *Shoulder of Trapezius.*
3a. *Body of Trapezius.*
4. *Acromial limb of Deltoid.*
5. *Scapular limb of Deltoid.*
6. *Infra Spinatus.*
7. *Teres Major.*
8. *Teres Minor.*
10. *Superficial portion of Rhomboideus.*

11, 11d. *Latissimus Dorsi. Arises from the spinous processes of the sixth inferior dorsal, from those of the sacral and lumbar vertebrae, from the posterior third of the crest of the ilium, see Skeleton Sections, and from the last four ribs, and is inserted by a strong tendon into the lower part of the inner border of the bicipital groove of the humerus. From its upper border limit it passes outward along the inferior edge of the Rhomboideus, over the inferior angle of the scapula, and the lower third of the Teres major, to disappear, in posterior view, behind the upper third of that muscle. Its contractile fibers rise upon the outer border of the muscles of the loins and sacrum,*

and, ascending in the manner represented above, cover the flank section of the External Oblique Muscle, and come upon the outline at 11d, 11a. Its tendon of origin is Aponeurotic; and, in passing outward from the spinal column, it covers and forms a sheath for, the muscles of the Loins and Sacrum, viz., Sacro Lumbalis, 12.

13. *Flank Section of the External Oblique Muscle.*
14. *Pelvic Tendon of Latissimus Dorsi.*
15. *Space separating the External Oblique from the crest of the Ilium.*
16. *Crest of the Ilium.*
§ *The Ribs.*

Muscular Form

Integumentary Form

No. 177

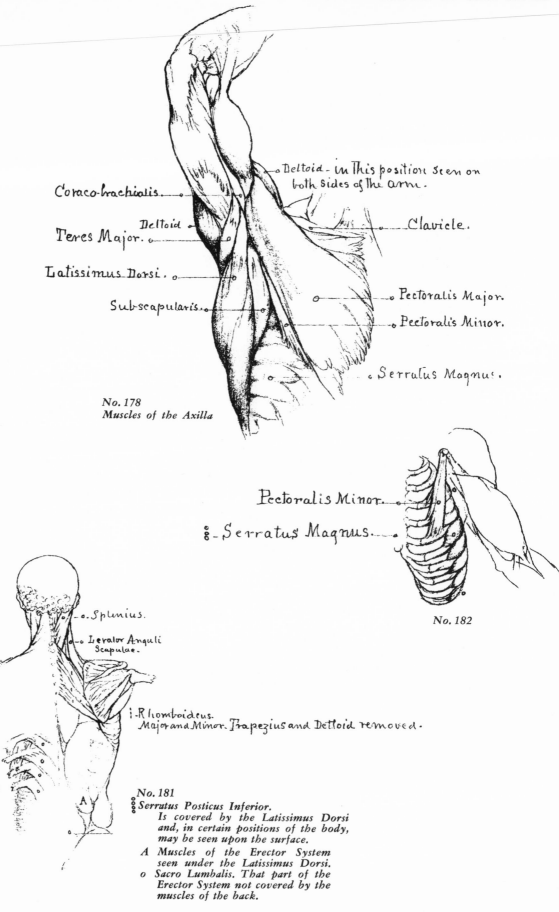

Coraco-brachialis.

Deltoid - in this position seen on both sides of the arm.

Deltoid

Teres Major.

Clavicle.

Latissimus Dorsi.

Subscapularis.

Pectoralis Major.

Pectoralis Minor.

Serratus Magnus.

No. 178
Muscles of the Axilla

Pectoralis Minor.

Serratus Magnus.

No. 182

Splenius.

Levator Anguli Scapulae.

Rhomboideus. Major and Minor. Trapezius and Deltoid removed.

9ᵗʰ
10ᵗʰ
11ᵗʰ
12ᵗʰ

A

No. 181
Serratus Posticus Inferior.
 Is covered by the Latissimus Dorsi
 and, in certain positions of the body,
 may be seen upon the surface.
A Muscles of the Erector System
 seen under the Latissimus Dorsi.
o Sacro Lumbalis. That part of the
 Erector System not covered by the
 muscles of the back.

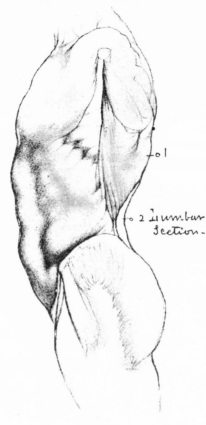

Latissimus Dorsi — Side view
Serratus Magnus Cutaneous Section.

The exposed portion of the serratus consists of three tongues — upper, lower, and middle. Sometimes the end of a fourth may be discovered projecting a little beyond the edge of the Latissimus Dorsi. Great care should be taken to give these tongues a softened outline. On the side of the body the Latissimus Dorsi ascends in a straight line from the eighth rib to the Humerus. When large, it nearly fills the upper part of the Axilla. When the Latissimus Dorsi is large, the muscles of the Scapula are large. It gives width to the side and thickness of the back. It is the principal muscle of the upper arm.

No. 179

The Erector Spinae, and its prolongations in the dorsal and cervical regions, fill up the vertebral groove on each side of the Spine. This large muscular and tendinous mass varies in size and structure at different parts of the Spine. In the Sacral region, the Erector Spinae is narrow and pointed, and its origin chiefly tendinous in structure (its lower third is covered by the Gluteus Magnus). In the lumbar region, it becomes enlarged, and forms a large fleshy mass. This is the Lumbar Section of art anatomy, and is named Sacro Lumbalis because it occupies the Sacral and Lumbar portions of the back. That portion of the Erector System called the Spinalis Dorsi may be seen through the Latissimus Dorsi on the extended side when the body is flexed. The limbs, Longissimus Dorsi, and Sacro Lumbalis may be seen through the Latissimus Dorsi. See A, No. 181.

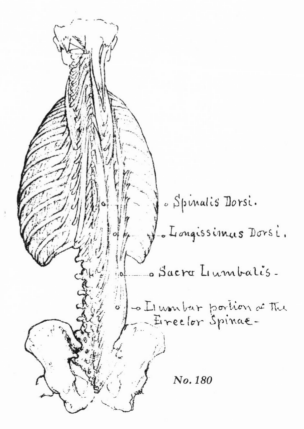

No. 180

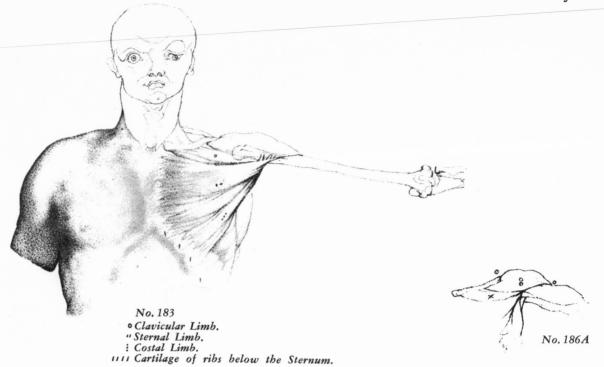

No. 183
o *Clavicular Limb.*
" *Sternal Limb.*
: *Costal Limb.*
ıııı *Cartilage of ribs below the Sternum.*

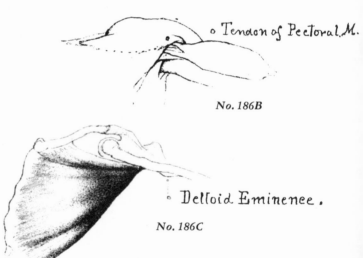

No. 186A

o *Tendon of Pectoral. M.*

No. 186B

o *Delloid Eminence.*

No. 186C

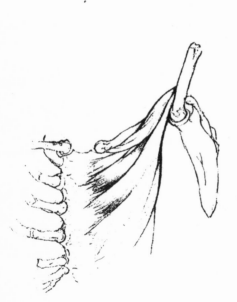

No. 186

No. 187

The Pectoralis Major is a broad, thick, triangular mus-
cle, situated at the upper and fore part of the Thorax
and Axilla. It arises from the anterior border of th[e]
Clavicle and the anterior surface of the Sternum, from
the cartilages of the second, third, fourth, and, mor[e]
particularly, those of the fifth and sixth ribs, and i[s]
inserted into the anterior margin of the bicipital groov[e]
of the humerus. To reach its point of attachment i[t]
passes over and beyond the heads of biceps. See o[n]
No. 186B. It passes under the Deltoid, nearly midwa[y]
between the Acromion and the Deltoid eminence. Se[e]
No. 186A. Where the sternal ends of the ribs are
prominent, the sternal limb is separated into bands
as represented in No. 186 and 186C. The Pectoralis is [a]
flexor when all the limbs act together. When the cla[-]
vicular limb, only, is in action, the arm is drawn upwar[d]
toward the face. When the costal limb, only, is in action[,]
the humerus is depressed, and the elbow, at the poin[t]
of extremest tension is resting upon the Navel. That par[t]
of the Pectoral muscle covering Axilla is called th[e]
Axillary Section. See No. 183 Cutaneous Side, No. 184
and No. 187x.

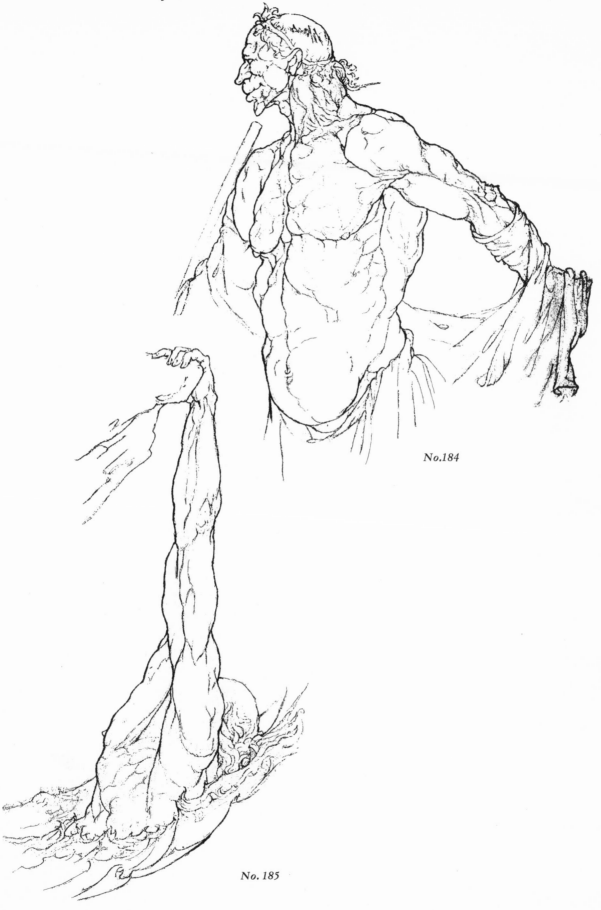

No.184

No. 185

In some men, the muscles are thin and fibrous. In these the skeleton comes upon the outline. In others, they are large and rope-like, with cavernous depression. between them. In these, the outline is a combination of the muscular and the bony. In others, they are full to such an extent that they rise in circular folds from their points of attachment and from the closure of their spaces come altogether upon the outline, except a, points where muscles are not found. When the muscles are full, the integument is full. When the muscles are thin, the integument is thin. (Male proportions.)

From the peculiar manner of arrangement and distribution of the instruments of muscular force, one could almost imagine that the bones were made first for certain immediate uses of their own, and that the muscles were attached afterward by ingenious contrivance as room might offer or convenience suggest. This in a common and purely mechanical way, and always in the best way, though by no means in the only way. Braces, being put upon those which from the poor advantage offered for their attachment were likely to slip out of place when in action; braces here, bands there, and fasciae, reinforcing tendons, binding aponeuroses, and synovial membranes, wherever an unerring infallible foresight could perceive necessity for their use. From what is here spoken of, it will be seen that but few muscles can be rectilinear in form, and therefore direct in action; that most of them must, to a certain extent, twist upon themselves from the direction of their fibers in their relation to the direction of their tendons, from their place upon the bones, their relation to one another at the time of action, and from the position of the bones as they are in the act of performing their own duty to which somehow their uses must conform.

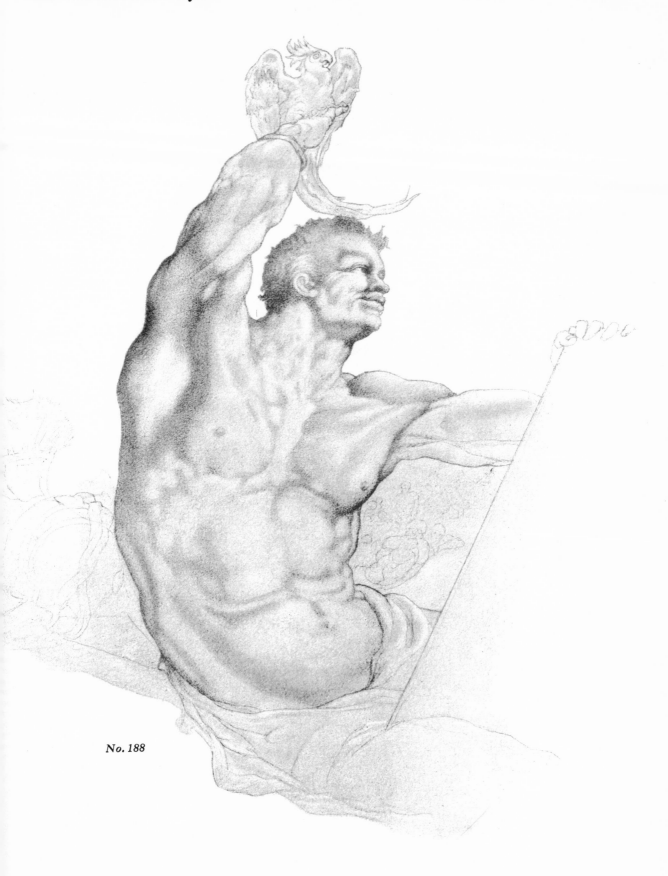

No. 188

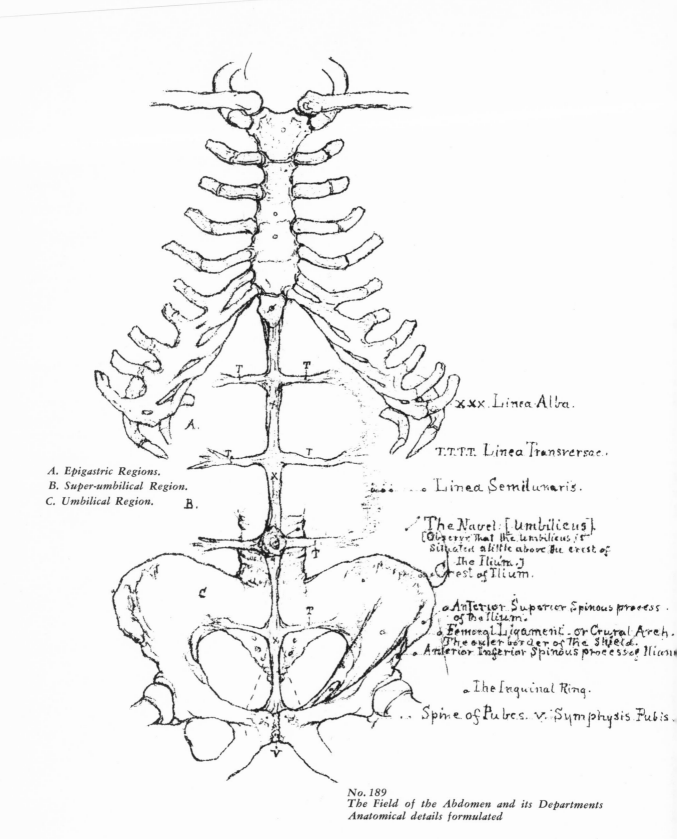

A. Epigastric Regions.
B. Super-umbilical Region.
C. Umbilical Region.

xxx. Linea Alba.

T.T.T. Linea Transversae.

Linea Semilunaris.

The Navel [Umbilicus]
[Observe that the umbilicus is
situated a little above the crest of
the Ilium.]
Crest of Ilium.

Anterior Superior Spinous process.
of the Ilium.
Femoral Ligament - or Crural Arch.
The outer border of the shield.
Anterior Inferior Spinous process of Ilium.

The Inguinal Ring.

Spine of Pubes. v. Symphysis Pubis.

No. 189
The Field of the Abdomen and its Departments
Anatomical details formulated

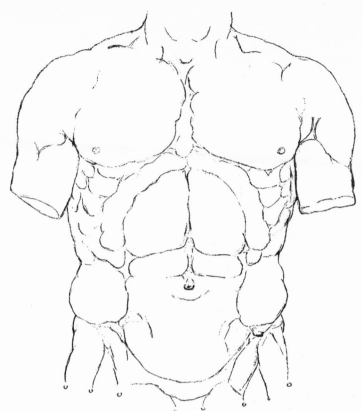

No. 190
The Epigastric, Super-umbilical, and Umbilical
sections form the "Abdominal Shield."

The Epigastric section extends from the ribs and ensi-
form cartilage to a point of flexure below, determined
by the size and form of the epigastric field. The Umbili-
cal Section extends from the superior border of the
Umbilicus to the Pubis. Its size is determined by the size
of the pelvic opening. The Super-umbilical Section rep-
resents the Lumbar opening and its uses. As flexion and
extension, lateral and direct, are accomplished mainly
in the Lumbar region, the Super-umbilical Section,
which corresponds to it, must be subject to greater
modifications of its original form than either of the
other sections.

The parietes of the abdomen are partly aponeurotic
and partly muscular: the muscular portions are situated
at the sides of the abdomen, beyond the semilunar lines;
the aponeurotic portions occupy the central regions of
the abdomen and constitute the proper sheaths of the
Recti muscles. See No. 191 and No. 189A. The Linea
Alba is composed of the joined fibers of the sheaths
of the Recti muscles and may be regarded as a tendinous
raphe, extending from the Ensiform Cartilage to the
Symphysis Pubis. It constitutes the median line of the
abdomen. The transverse fibrous bands called the Lineae
Transversae are similar in structure to the Linea Alba,
and might, with propriety, be called the reinforcing
tendons of the Recti muscles. They are from three to
five in number. The semilunar line ooo gives attach-
ment to the Obliquus Externus muscle. All these lines
may be distinctly seen upon the surface when the mus-
cles are in action. But though they conform in a meas-
ure to the borders of the three great regions of the
abdomen, they do not determine their limits.

No. 189A
Aponeurotic sheaths of Recti muscles —
Transverse section

The *Rectus Abdominis* is a long, flat muscle which extends from the crest of the Os Pubis to cartilages of the fifth and sixth ribs. It is separated from the muscle of the opposite side by the Linea Alba, and is enclosed in a sheath formed by the aponeuroses of the Oblique and Transversalis muscles. In art anatomy, the Recti muscles constitute a single body, the use of which is to cover the abdominal opening and conform to the movements of the viscera lying behind its wall. The Recti muscles are without expression.

The *External Oblique Muscle* — B, No. 191 — arises from the external surfaces and lower borders of the seven or eight inferior ribs, and is inserted into the anterior half of the external lip of the crest of the Ilium and into the external edge of the anterior aponeurosis. The upper or costal attachments consist of seven or eight angular tongues, or digitations, fleshy and tendinous in their structure, and arranged in an oblique line, running downward and backward. The Flank section, in art anatomy called the section of the Internal Oblique, viz., that portion of the muscles of the side situated between the lower border of the cone of the chest and crest of the ilium, is composed of the external oblique, internal oblique, and transversalis, and is the principal artistic section of the body.

No. 192
From A to B—first plane
of Umbilical Section.
From B to C—second plane
of Umbilical Section.

T. Ziphoid Cavity.

u. Umbilicus.

No. 191
Rectus Abdominis
Obliquus Externus

The *Femoral Ligament* or *Crural Arch* is that portion of the aponeurosis which extends between the anterior superior process of the Ilium and the spine of the. Os Pubis. It defines the limit of the abdomen at its inferior border. Seen through the integument, the femoral ligaments constitute the lower border of the abdominal shield.

The greatest attention should be given to the form and uses of the flank muscles. In the higher states of physical health and muscular power, they press beyond and overhang the crest of the ilium. They yield to every movement of the body. In the feeble, they are often concave.

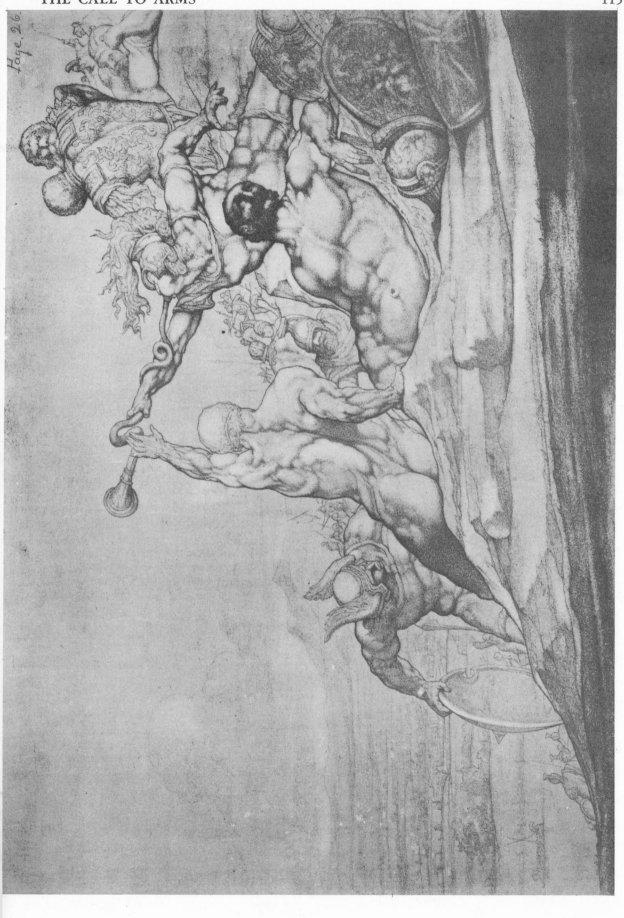

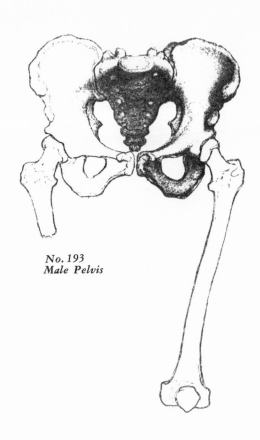

No. 193
Male Pelvis

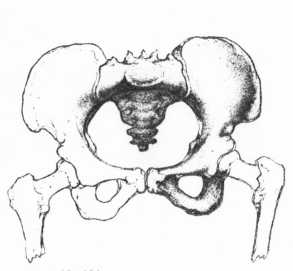

No. 194
Female Pelvis

*The female pelvis exceeds the male in
its horizontal diameters; the male pelvis
exceeds the female in its vertical diameters.*

*Compared with the male pelvis,
the female pelvis is drawn too
large.*

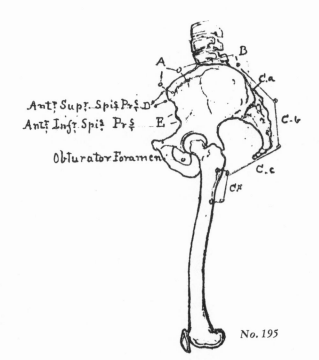

*A. Point of origin of the Tensor
Vaginae Femoris.
From A to B for visible portion of
Gluteus Medius.
From B to Ca upon the posterior
third of crest of Ilium.
From Ca to Cc upon the Sacrum.
From top to bottom of Line Cx
for Gluteus Maximus.
D. Sartorius.
E. Point of origin of Rectus
Femoris.*

No. 195

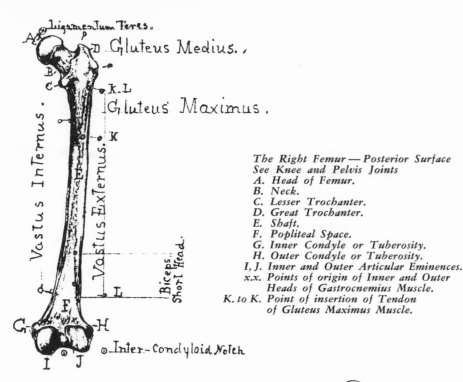

Ligamentum Teres.

D Gluteus Medius.

K.L
Gluteus Maximus.

K

Vastus Internus.

Vastus Externus.

Biceps.
Short Head.

L

G F H

Inter-Condyloid Notch.

I J

No. 196

The Right Femur — Posterior Surface
See Knee and Pelvis Joints
A. Head of Femur.
B. Neck.
C. Lesser Trochanter.
D. Great Trochanter.
E. Shaft.
F. Popliteal Space.
G. Inner Condyle or Tuberosity.
H. Outer Condyle or Tuberosity.
I, J. Inner and Outer Articular Eminences.
x.x. Points of origin of Inner and Outer
 Heads of Gastrocnemius Muscle.
K. to K. Point of insertion of Tendon
 of Gluteus Maximus Muscle.

Anterior Surface.

Cruræus.

For the anterior portion of the extensor
muscles of the thigh.

The Patella rests
upon the Femur.

Patella

No. 197

The center of the Femur is marked by an irregular ridge called the Linea Aspera. A little above the center of the shaft (at E) this crest divides into three lines: the most external one ascends to the base of the Great Trochanter; the middle one ascends to the base of the Trochanter Minor; and the internal one is lost above in spiral line of the femur. Below the point E, the ridge divides to the right and left, as represented in the drawing, descending upon the inner and outer borders of the popliteal field to disappear upon the outline. To the inner lip of the Linea Aspera, its whole length, is attached the Vastus Internus; and to the whole length of the outer lip, the Vastus Externus. The slightly elevated edges of this rough field are styled lips. The Adductor Magnus is attached to the Linea Aspera throughout its entire length, being connected with the outer lip above and its inner lip below. (Unimportant particulars omitted.) The neck of the Femur varies in length in different persons: in males it forms an obtuse angle with the body of the Femur; generally in females, an acute angle, being one of the causes of the prominence in them of the Great Trochanter. The bone inclines toward the median line sufficiently to bring the Inner Condyle nearly under the innermost edge of the Obturator Foramen.

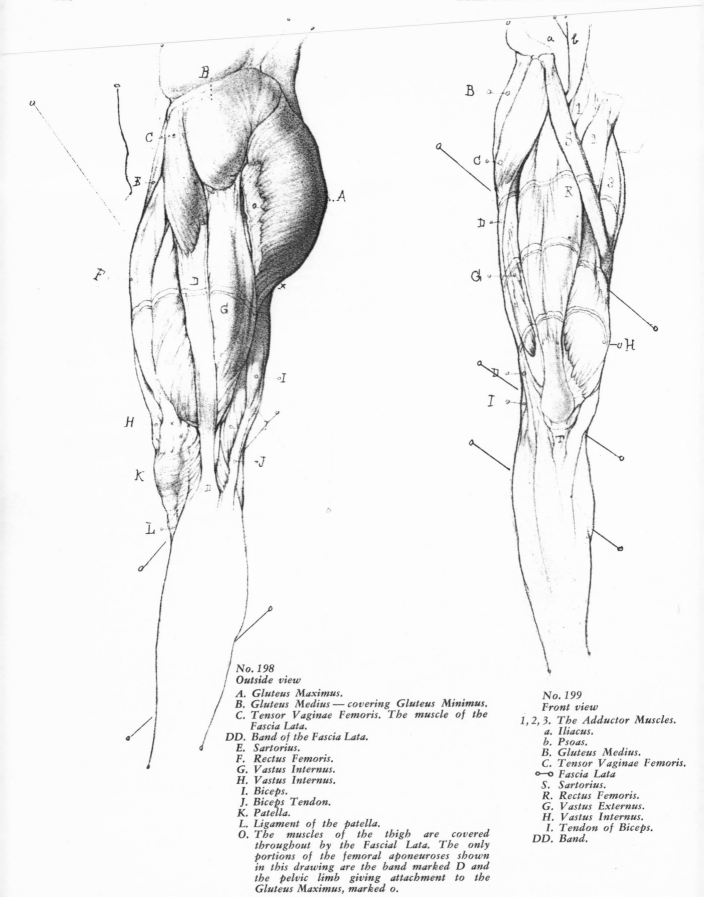

No. 198
Outside view

A. *Gluteus Maximus.*
B. *Gluteus Medius — covering Gluteus Minimus.*
C. *Tensor Vaginae Femoris. The muscle of the Fascia Lata.*
DD. *Band of the Fascia Lata.*
E. *Sartorius.*
F. *Rectus Femoris.*
G. *Vastus Internus.*
H. *Vastus Internus.*
I. *Biceps.*
J. *Biceps Tendon.*
K. *Patella.*
L. *Ligament of the patella.*
O. *The muscles of the thigh are covered throughout by the Fascial Lata. The only portions of the femoral aponeuroses shown in this drawing are the band marked D and the pelvic limb giving attachment to the Gluteus Maximus, marked o.*

No. 199
Front view

1, 2, 3. *The Adductor Muscles.*
 a. *Iliacus.*
 b. *Psoas.*
 B. *Gluteus Medius.*
 C. *Tensor Vaginae Femoris.*
o—o *Fascia Lata*
 S. *Sartorius.*
 R. *Rectus Femoris.*
 G. *Vastus Externus.*
 H. *Vastus Internus.*
 I. *Tendon of Biceps.*
DD. *Band.*

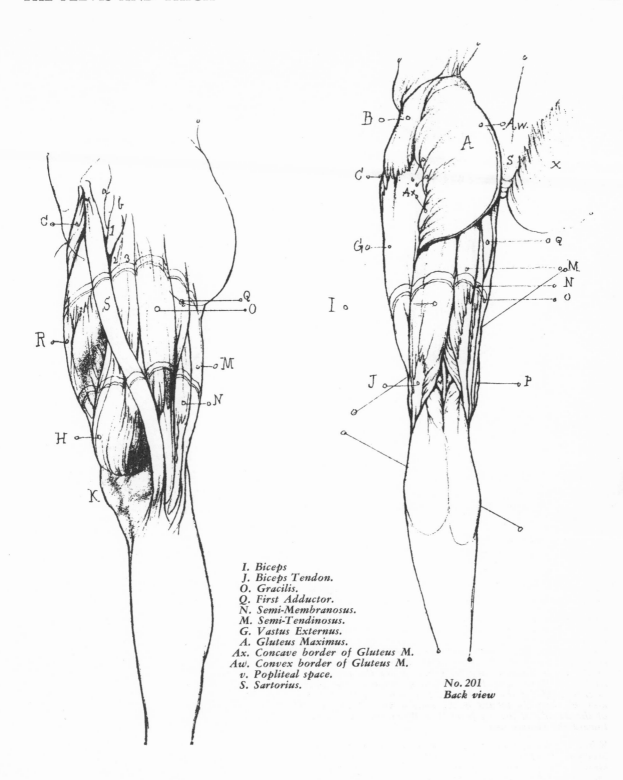

I. Biceps
J. Biceps Tendon.
O. Gracilis.
Q. First Adductor.
N. Semi-Membranosus.
M. Semi-Tendinosus.
G. Vastus Externus.
A. Gluteus Maximus.
Ax. Concave border of Gluteus M.
Aw. Convex border of Gluteus M.
v. Popliteal space.
S. Sartorius.

No. 201
Back view

No. 200
Inside view

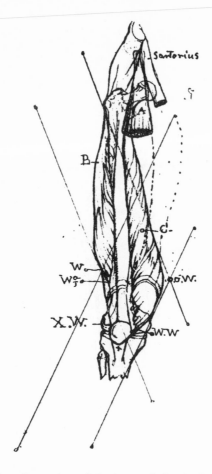

No. 203
Transverse section — outline
R. Flexors.
S. Sartorius.
V. Vastus externus.
A. Adductors.
B, B. Flexors.
X. Ligament of patella, see No. 202.

No. 202

Plan showing the torsion of the front of the thigh.

A. Upper portion of Rectus. The Rectus Femoris arises by its external or straight tendon, A, from the anterior inferior spinous process of Ilium, and is attached to the Patella by a tendon common to the several limbs of the Triceps Femoris.

B. Vastus Externus. Arises at the base of the great Trochanter, and terminates upon the outline at W and upon its portion of the common tendon at Wa within the outline.

C. Vastus Internus. Arises from the inner side of the neck of the femur, and, passing downward and inward, at highest stage of development, terminates upon the outline at the point marked o.o.W. Whence, turning outward, it crosses the inner outline of the Femur at the upper border of the Inner Condyle, and terminates upon the common tendon at W.W. The line of torsion terminates at the inferior angle of the Patella, X. The bones of the Knee must be carefully defined in the male figure. The surface of the outside of the leg from B to W inclines backward toward the median line.

When the body is in energetic motion, fineness must be produced by preserving the lengths, and giving to the muscles an expression of strength. The joints appear smaller and finer when the body is in motion than when it is at rest. When the body is at rest, the accent of muscles in motion should be carefully avoided.

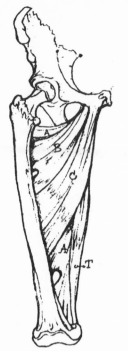

No. 204
Adductor System

A. Adductor Magnus. Tendon of AM.
B. Adductor Brevis.
C. Adductor Longus.

These muscles compose the fleshy and
yielding mass on the inside of the
thigh, marked A in No. 203. See Nos.
199, 200, 201.

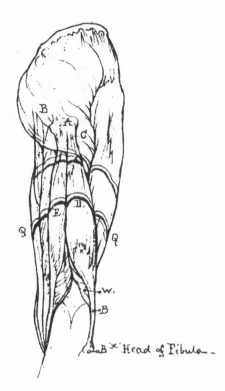

No. 205

A. *Tuberosity of Ischium. To the Ischium are*
attached, besides many deep-seated muscles,
the Biceps, Semi-tendinosus, Semi-membrano-
sus, and the Adductor Magnus.

D. *Biceps. The Biceps arises by two heads; that*
giving form to the superficial limb of the
muscle arises from the tuberosity of the Ischi-
um by a tendon common to it and the semi-
tendinosus, and becoming tendinous at the
·point x, descends as here represented (x Biceps
tendon) upon the outline to be inserted into
the outer side of the head of the Fibula.

W. *Visible portion of the short head of Biceps.*
The tendon of this muscle forms the outer
Hamstring.

E. *Semi-tendinosus. Arises from the tuberosity of*
the Ischium, and is inserted into the upper part
of inner surface of the Tibia. The tendons of
the Semi-tendinosus and Semi-Membranosus
constitute the inner Hamstring. The muscles
of the back and inner side of the leg are cov-
ered by a thick integument. The line of quan-
tity, QQ, shows the transverse elevation of the
parts described. The limbs, in every section,
are larger in the center than above or below,
and always larger at the end where the muscles
have their rise than where they terminate.

No. 206
Formulated detail of the
parts forming the knee joint.
The patella face is turned
toward the outside of the leg.

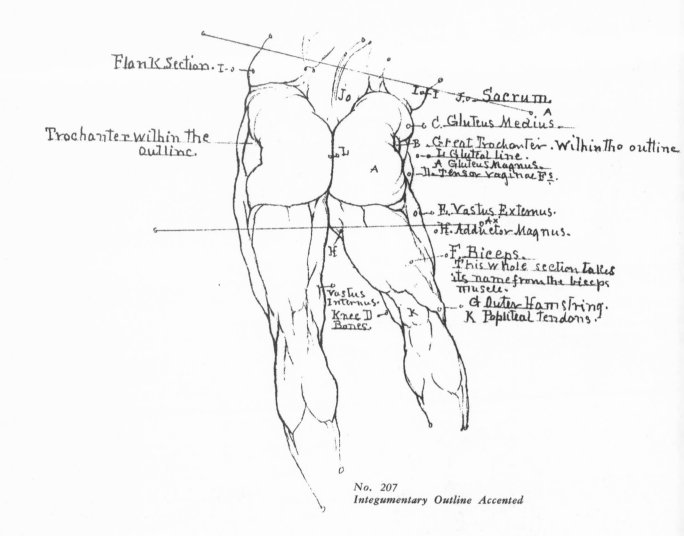

Flank Section. I.

Trochanter within the outline.

J.₀ = Sacrum.
C. Gluteus Medius.
B. Great Trochanter. Within the outline
L. Gluteal line.
A. Gluteus Magnus.
D. Tensor vaginae Fs.
E. Vastus Externus.
H. Adductor Magnus.
F. Biceps.
This whole section takes its name from the biceps muscle.
G. Outer Hamstring.
K. Popliteal tendons.

Vastus Internus.
Knee D Bones.

No. 207
Integumentary Outline Accented

No. 208
*In giving movement to
the muscles attached to
the pelvis, care should
be had that its proportions
are not obscured.*

No. 209
*Form of the pelvis
at maturity*

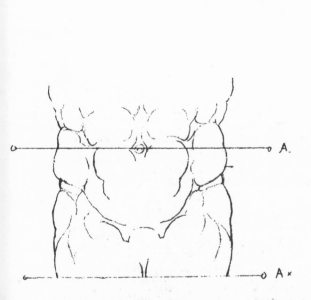

Important

No. 211

No. 210
*The pelvis and parts
having pelvic relations*

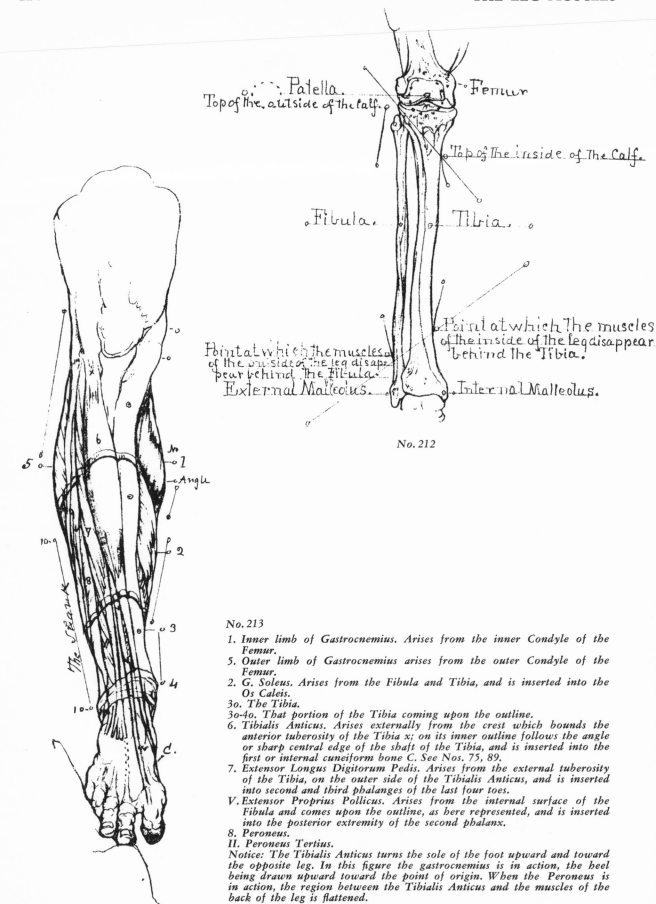

No. 212

No. 213

1. *Inner limb of Gastrocnemius. Arises from the inner Condyle of the Femur.*
5. *Outer limb of Gastrocnemius arises from the outer Condyle of the Femur.*
2. *G. Soleus. Arises from the Fibula and Tibia, and is inserted into the Os Caleis.*
3o. *The Tibia.*
3o-4o. *That portion of the Tibia coming upon the outline.*
6. *Tibialis Anticus. Arises externally from the crest which bounds the anterior tuberosity of the Tibia x; on its inner outline follows the angle or sharp central edge of the shaft of the Tibia, and is inserted into the first or internal cuneiform bone C. See Nos. 75, 89.*
7. *Extensor Longus Digitorum Pedis. Arises from the external tuberosity of the Tibia, on the outer side of the Tibialis Anticus, and is inserted into second and third phalanges of the last four toes.*
V. *Extensor Proprius Pollicus. Arises from the internal surface of the Fibula and comes upon the outline, as here represented, and is inserted into the posterior extremity of the second phalanx.*
8. *Peroneus.*
II. *Peroneus Tertius.*
Notice: The Tibialis Anticus turns the sole of the foot upward and toward the opposite leg. In this figure the gastrocnemius is in action, the heel being drawn upward toward the point of origin. When the Peroneus is in action, the region between the Tibialis Anticus and the muscles of the back of the leg is flattened.

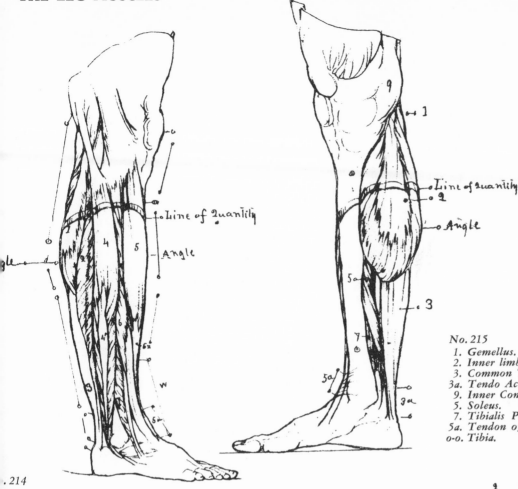

No. 215

1. Gemellus.
2. Inner limb of Gastrocnemius.
3. Common Tendon.
3a. Tendo Achillis.
9. Inner Condyle.
5. Soleus.
7. Tibialis Posticus.
5a. Tendon of Tibialis Anticus.
o-o. Tibia.

. 214

Gastrocnemius
Soleus.
Tendon.
Peroneus Longus. Arises exter-
nally from the outer and anterior
part of the head of the Fibula and,
passing in the manner here repre-
sented behind the outer ankle, is
inserted into the head of the first
metatarsal bone.
Tibialis Anticus.
Tendon of Tibialis Anticus con-
necting the outline of the leg with
the outline of the foot.
Extensor Longus Digitorum Pedis.
Peroneus Tertius. The planes and
point of elevation of the several
localities should be studied care-
fully.

No. 216 A
Gastrocnemius
and Soleus

No. 216
Posterior view

1. Popliteal space.
2-2. Inner and outer Gemellus.
3-3. Inner and outer central tendon. When
 the Gastrocnemius is in action, these
 tendons flatten the sides of the calf of
 the leg.
o-o. Common tendon. Tendon of Gastro-
 cnemius and Soleus muscles.
5-5. The free portion of the common ten-
 don, Tendo Achillis.
4-4. Fibers of the Soleus muscle extending
 on the sides of the leg beyond the
 common tendon.
6. Peroneus.

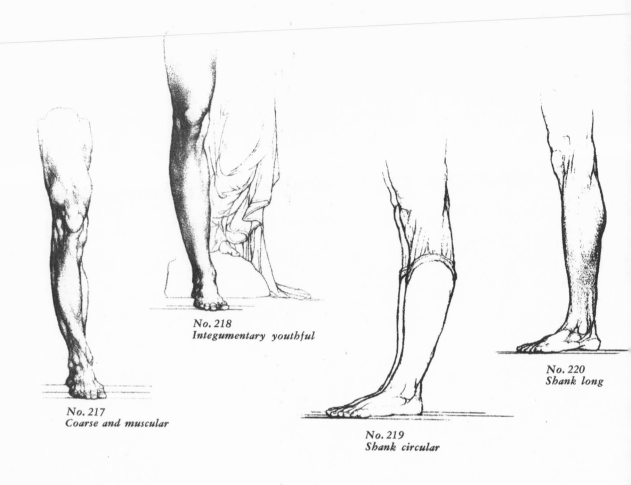

No. 218
Integumentary youthful

No. 217
Coarse and muscular

No. 219
Shank circular

No. 220
Shank long

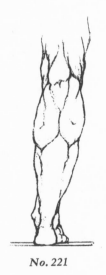

No. 221

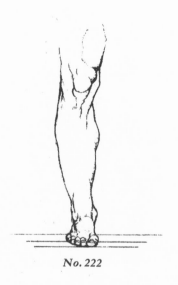

No. 222

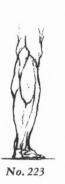

No. 223

No. 224
Shank circular

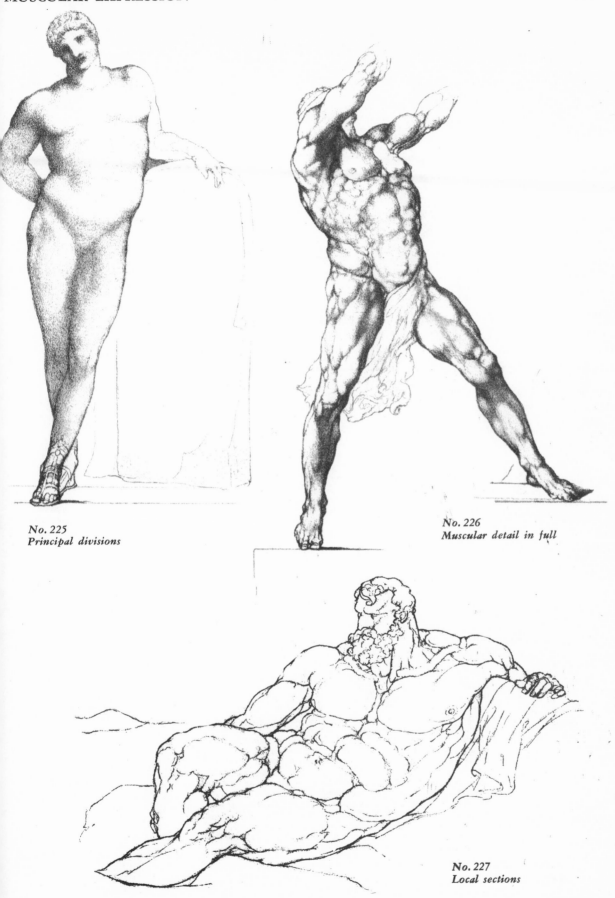

No. 225
Principal divisions

No. 226
Muscular detail in full

No. 227
Local sections

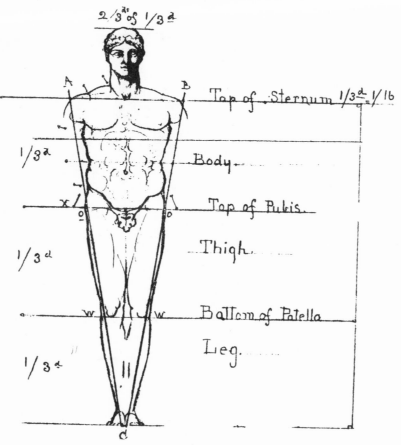

No. 228
Nonpersonal
The ultimate

When the Body, Thigh, and Leg are of equal length, the individualization of the local sections is complete. The chest may occupy the entire space of its division as in No. 229, or only a portion of it as in No. 228. The greatest possible length of the leg and thigh sections consistent with the greatest possible width of the shoulder section locates the pubis at x and the trochanters at oo on the lines AB. Masculine proportions can be represented only in their primitive relations by diverging lines. Every local section should be convex rather than concave, thus placing the bony attachments of the muscular body within the general outline. The station points A, B, oo, and ww are only fixed insofar as they relate to the principles of structure here described. They have no mechanical properties, and may be moved under the guidance of the sensibilities whenever, in changing the details or representing the different stations of natural life, better ones can be discovered.

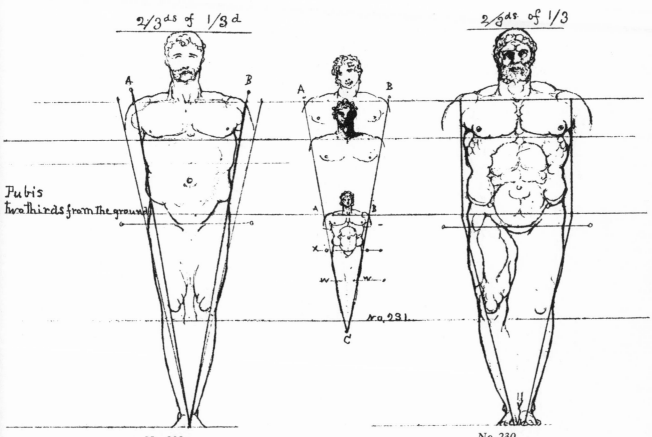

No. 229
Nonpersonal with personal
modifications. Transitional.
See No. 228.

No. 230
Personal. An orderly
divergence from the ideal.
See No. 228.

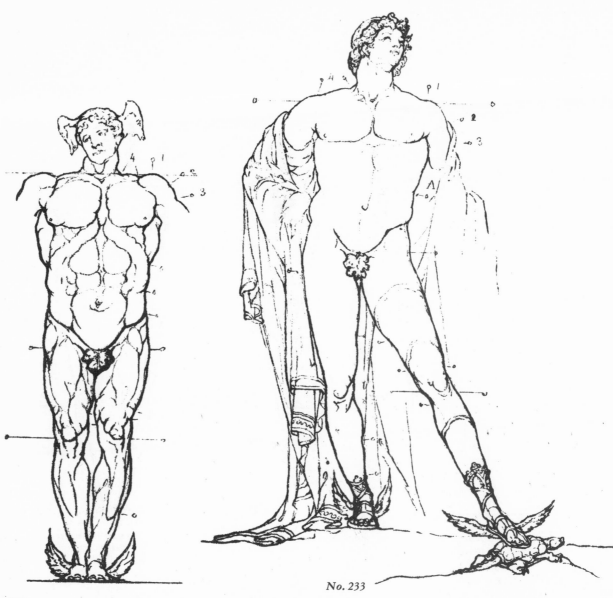

No. 232

No. 233

Shoulders high. Ribs narrow. Body long. Epigastric section narrow. Muscles large and pendulous. Thighs short and thick. Knees large and coarse. Legs twisted. Cartilage of ribs outstanding. Shoulders heavy. Sides flat. Muscular indentations abrupt and excessive. Large feet and hands. Muscular and local sections distinctly but widely defined. Proportions disorderly throughout. Compare with Nos. 233 and 235.

Points of interest, when moved, affect remotest proportions and points of interest more than points of interest in their immediate vicinity. It should be remembered that points of interest and boundaries of local sections should be assumed only in support of the kind of primitive form determined upon.

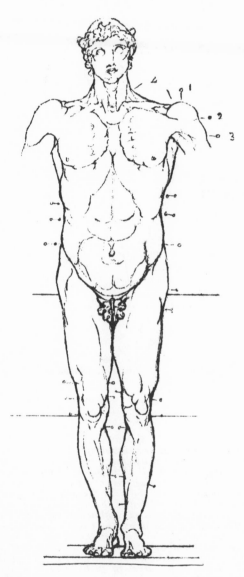

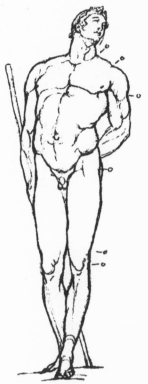

No. 235
Short flank. Orderly form. Body thrown back.

No. 234
*Common. Outline concave. Trapezius and Pectoral
muscles small. Local sections undefined. Epigastric sec-
tion narrow. Legs twisted and short. Hips wide. Axillary
portion of Pectoral muscle thin and concave. Compare
with No. 228 and the points of interest with the points
of interest in all the other figures in this division.*

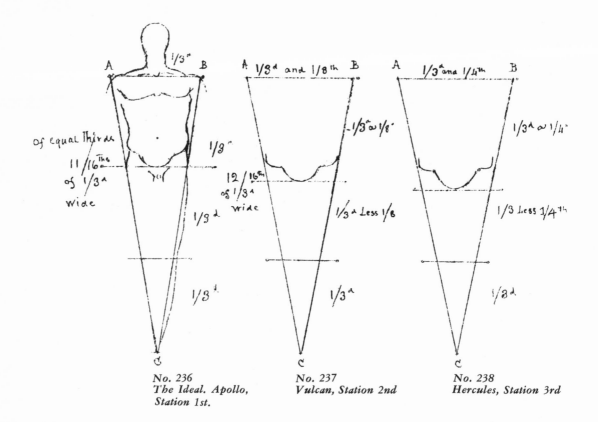

No. 236
The Ideal. Apollo,
Station 1st.

No. 237
Vulcan, Station 2nd

No. 238
Hercules, Station 3rd

In orderly forms, as the shoulders widen, the body widens throughout. Whatever the station, the local sections must through all their details conform to the outline Ideal. In the majority of men as against the Ideal, the body is long; the sides flat under the arms or thin and hollow at the flanks; the hips wide; the abdomen pendulous below and hollow at the pit of the epigastrium; the thighs short; the knees coarse or thick; the legs flat, twisted, or bent at the shank; the ankle joint low or broad; the heel wide or projecting; the feet flat and broad or thick, and animal-like. In thin men the joints seem large. In fleshy men their forms are obscured by the thickness of the integument. Solid, well-formed shoulders, full chest and epigastric sections, small waists, fine flanks, long thighs, round straight limbs, well-defined joints, and well-formed hands and feet are peculiarities of form to be found associated in but very few persons. Very large men . are sometimes well formed but seldom finely formed. The sense of weight in the appearance of the body is rarely equalled by an appearance of strength and activity such as is found in smaller men. Very small men often have heads of the average size and features resembling those of children or of such concentrated masculinity of form and expression as to compensate in the element of character for what is absent in the element of size.

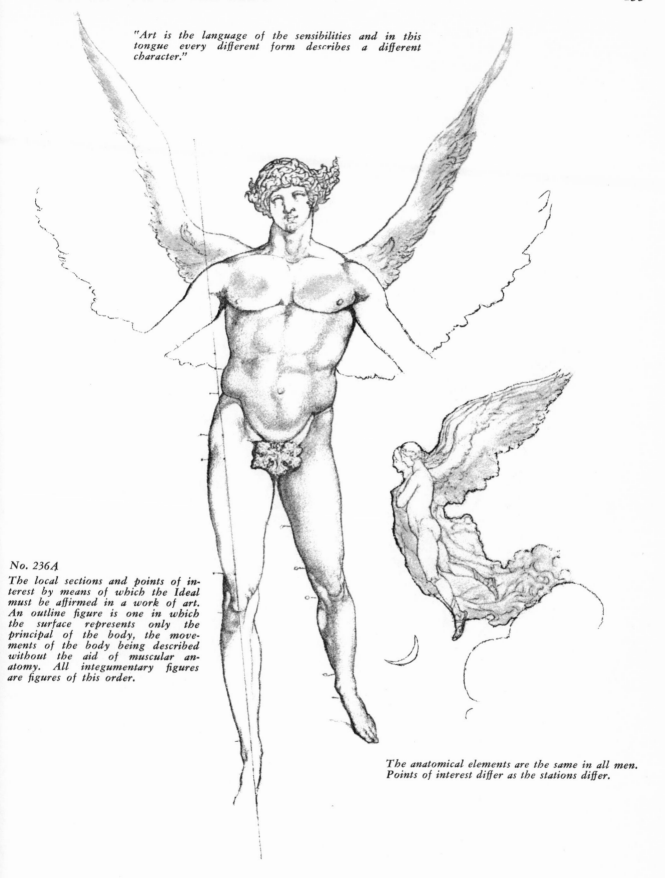

"*Art is the language of the sensibilities and in this tongue every different form describes a different character.*"

No. 236A

The local sections and points of interest by means of which the Ideal must be affirmed in a work of art. An outline figure is one in which the surface represents only the principal of the body, the movements of the body being described without the aid of muscular anatomy. All integumentary figures are figures of this order.

The anatomical elements are the same in all men. Points of interest differ as the stations differ.

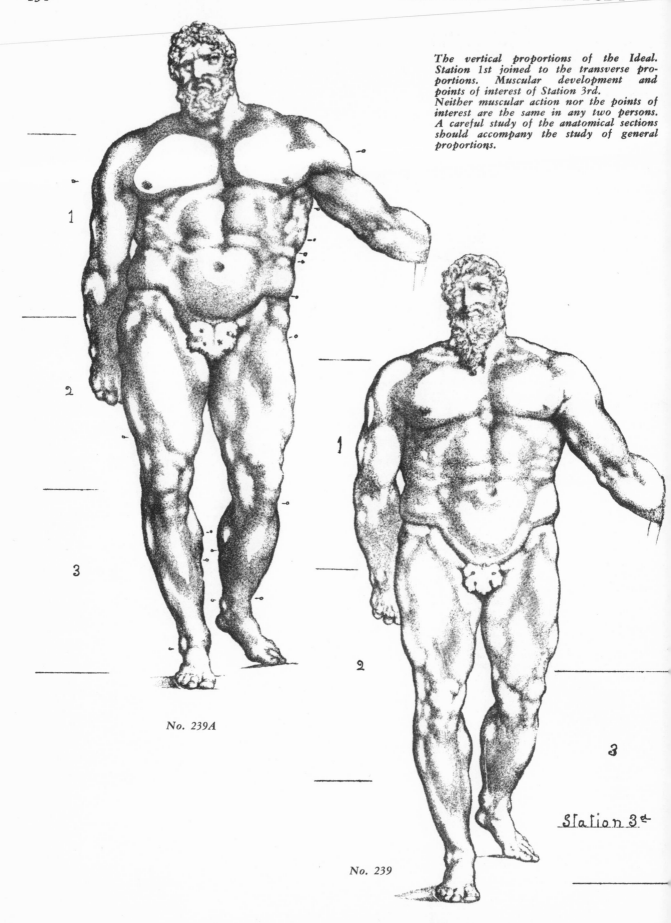

The vertical proportions of the Ideal.
Station 1st joined to the transverse pro-
portions. Muscular development and
points of interest of Station 3rd.
Neither muscular action nor the points of
interest are the same in any two persons.
A careful study of the anatomical sections
should accompany the study of general
proportions.

No. 239A

No. 239

Station 3rd

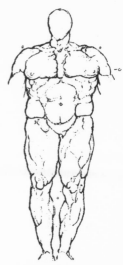

A. Broad pectoral
 Low trochanters

B. High trapezius
 High waist

C. Low trapezius
 Narrow flank

D. Sloping trapezius

E. Broad and deep
 pectorals only possible
 in very large men.

No. 240 Points of interest in the proportions of ordinary men

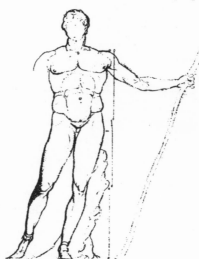
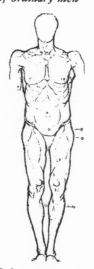
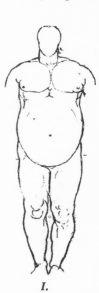

F. Deep pectorals

G.

H. Skeleton proportions

I.

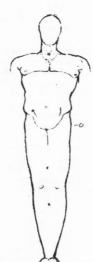

J. Narrow chest
 Wide hips

K. Short, broad chest
 Narrow pelvis, Low trapezius.

L. Square sides
 High shoulders

M. Circular shoulders,
 body, and flanks.

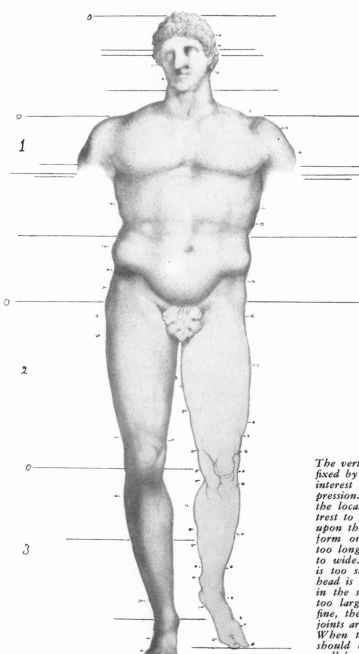

1

2

3

Station · 1st · No. 241

The vertical elements are elements of proportion
fixed by natural law. They govern the points of
interest and determine their strength and ex-
pression. The transverse elements through all
the local sections of the body are points of in-
trest to the extent to which they may be moved
upon the primitive outline without changing its
form or proportions. When the body appears
too long, it is too narrow; when too short, it is
to wide. When the body is too large, the head
is too small. When the body is too small, the
head is too large. A line too much or too little
in the shoulders will make the feet that much
too large or too small. When the features are
fine, the extremities should be fine. When the
joints are broad, the extremities should be broad.
When the neck is short, the fingers and toes
should be short. When the eyes are large and
well formed, the mouth, chin, and nostrils should
be well formed. When the flanks are too high,
the body in side view will appear too short, and
the loins, gluteal section, and legs too long.

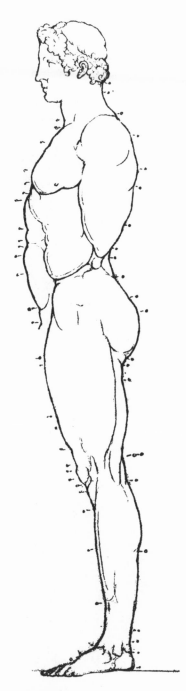

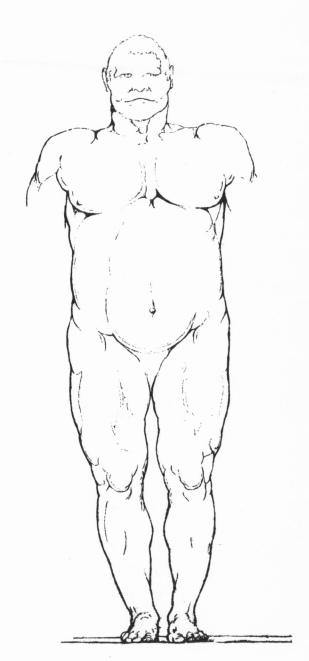

No. 242
Profile view,
details accented.

No. 243
In animal-like men the details of structure peculiar
to men of the higher forms are never fully developed.

No. 244

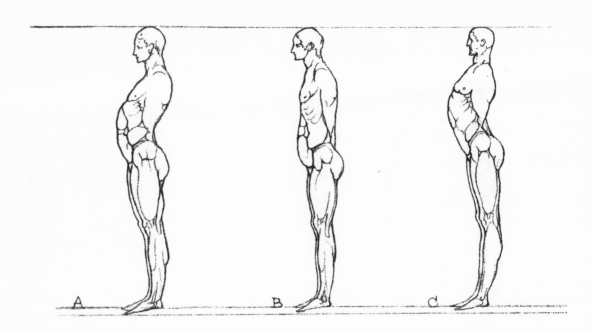

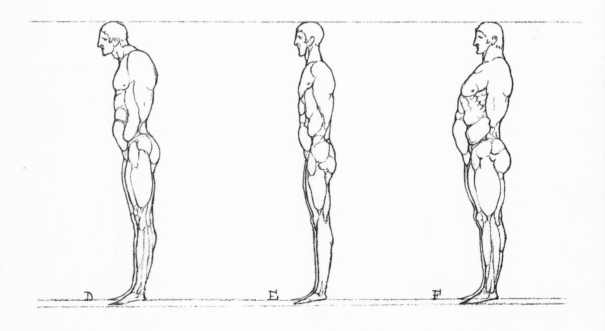

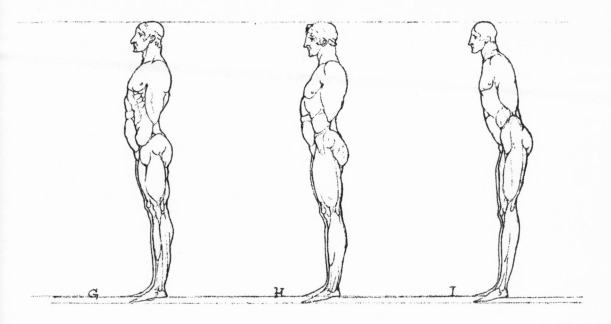

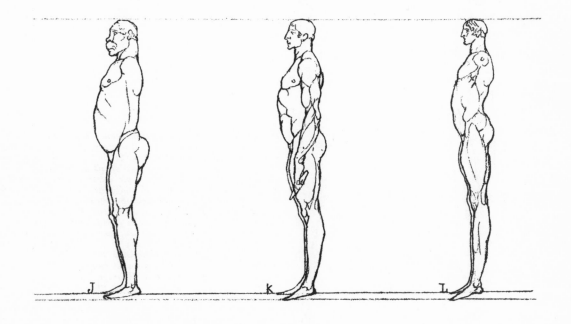

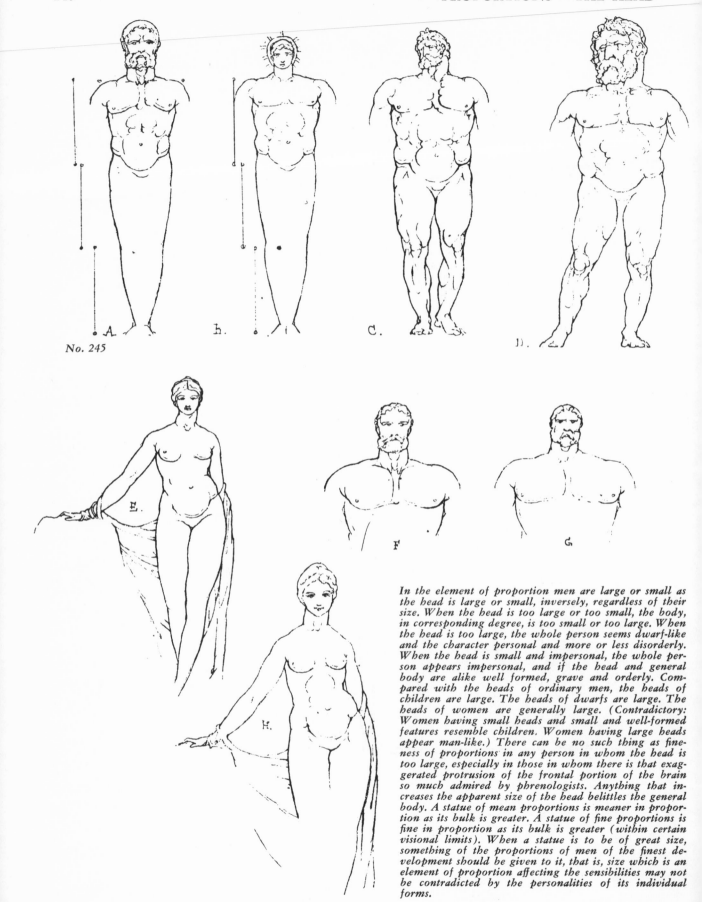

No. 245

In the element of proportion men are large or small as the head is large or small, inversely, regardless of their size. When the head is too large or too small, the body, in corresponding degree, is too small or too large. When the head is too large, the whole person seems dwarf-like and the character personal and more or less disorderly. When the head is small and impersonal, the whole person appears impersonal, and if the head and general body are alike well formed, grave and orderly. Compared with the heads of ordinary men, the heads of children are large. The heads of dwarfs are large. The heads of women are generally large. (Contradictory: Women having small heads and small and well-formed features resemble children. Women having large heads appear man-like.) There can be no such thing as fineness of proportions in any person in whom the head is too large, especially in those in whom there is that exaggerated protrusion of the frontal portion of the brain so much admired by phrenologists. Anything that increases the apparent size of the head belittles the general body. A statue of mean proportions is meaner in proportion as its bulk is greater. A statue of fine proportions is fine in proportion as its bulk is greater (within certain visional limits). When a statue is to be of great size, something of the proportions of men of the finest development should be given to it, that is, size which is an element of proportion affecting the sensibilities may not be contradicted by the personalities of its individual forms.

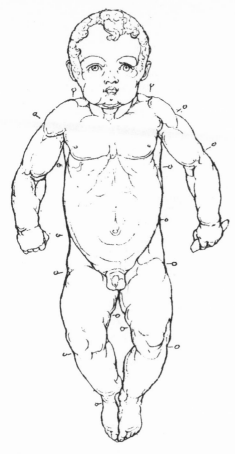

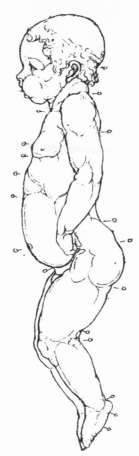

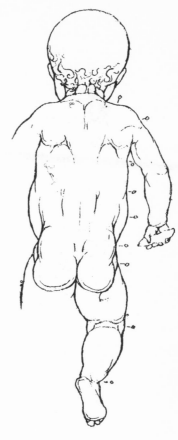

No. 246
4-1/8 Heads. Average
9 months.

No. 247
3-3/4 Heads. Average
4 months.

No. 250
4 Heads.

At the period of early infancy the abdomen is circular and pendulous; the pelvis narrower than the abdomen; the distance from the pubis to the sacrum short; the pubis far behind the umbilicus; the scapular bones small and high up upon the back, and the distance between them much greater than in the adult body; the loins long; the neck short and thin; the cervical portion of the trapezius thin and well defined, generally a fold of integument between the top of the back and the trapezius; the sterno-mastoid small and generally well defined; the thyroid cartilage small; the cheeks pendulous; the neck small at the base; the distance from the neck to the top of the shoulder short; shoulders high and narrow; the distance from the back to the breast bone greater often than the distance at the lower border of the axillae, from one side of the ribs to the other; sternum high; ribs short and wide apart at their base; local sections undefined in very young children; joints small and loose and, more or less, in consequence of the thickness of the integument covering them, dimpled; the form of the joints obscured by thick folds of integument; the feet and hands small; the nates narrow; the trochanters small; the arm long; the thigh short; the heel, as in the adult body, extending when the leg is bent fully to the ischium; the gluteal section small and well defined; the outlines of the front of the body and limbs generally circular.

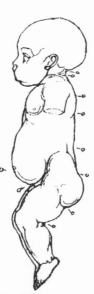

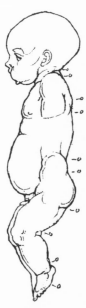

No. 248
3-7/8 Heads. Average
6 months.

No. 249
5-1/8 Heads. Average
12 months.

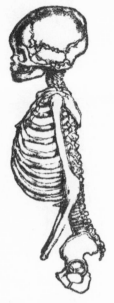

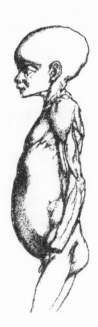

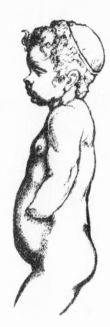

No. 251
Bones

No. 252
Muscles

No. 253
Integument

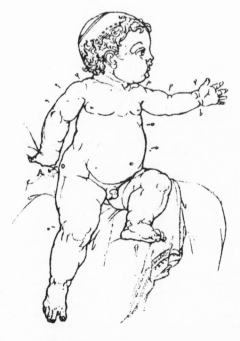

No. 255

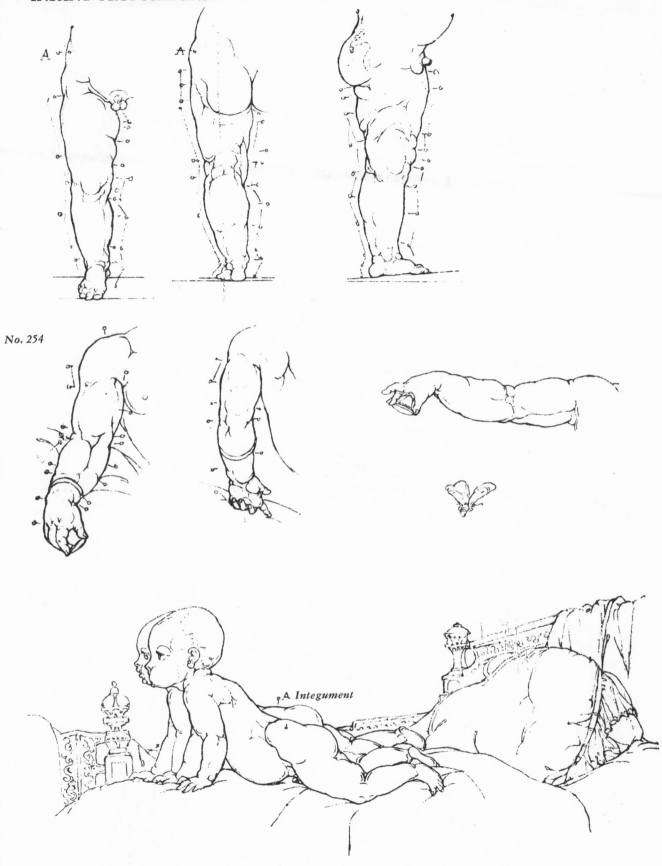

No. 254

A Integument

No. 256

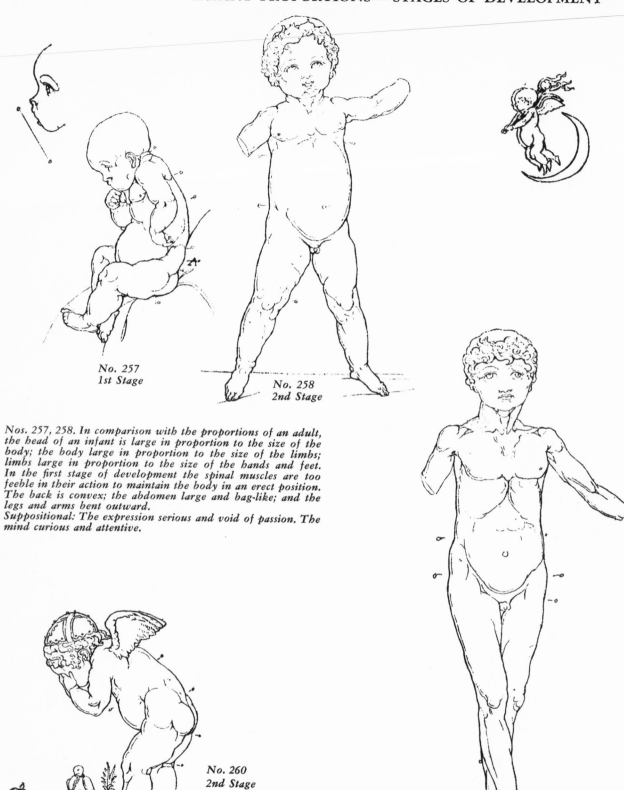

No. 257
1st Stage

No. 258
2nd Stage

Nos. 257, 258. *In comparison with the proportions of an adult, the head of an infant is large in proportion to the size of the body; the body large in proportion to the size of the limbs; limbs large in proportion to the size of the hands and feet. In the first stage of development the spinal muscles are too feeble in their action to maintain the body in an erect position. The back is convex; the abdomen large and bag-like; and the legs and arms bent outward.*
Suppositional: The expression serious and void of passion. The mind curious and attentive.

No. 260
2nd Stage

No. 259
3rd Stage

Female Male

No. 261

*Showing the peculiarities of form which
distinguish the male from the female body.
(A sexual difference in the shape of the body
common, in some degree, to all vertebrate animals.)*

*In Men, the principles of structure are in nowise sub-
ordinate to the sexual functions. In Women, the prin-
ciples of structure are adapted to the sexual functions
and are their subordinates. Women, notwithstanding
the great perfection of the general body, resemble
children more than they do men. Their bones are
small; joints loose; shoulders and back weak; the face
small; the brain large; the lower abdomen full; the
chest thin; the small of the back, or upper part of the
loins, thin and feeble; the integument of the pelvis,
arms, and legs, thick; the hands and feet small; the
back flat; shoulder blades small; and the movement
of the body and arms generally from the hips. The
average female body is one quarter less in size than
the male body. Male brains of the largest size weigh
from 60 to 64 ounces; female brains of the same order
in any variety weigh 4 ounces less. The width of the
hips should never exceed the width of the shoulders.*

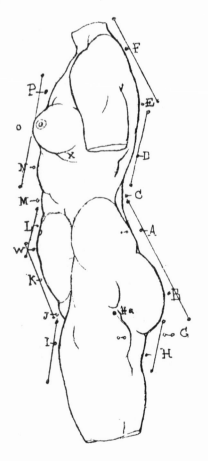

No. 263
A. *Integumentary Body.*
B. *Gluteal section.*
C. *Spinal muscles.*
D. *Latissimus Dorsi.*
E. *Scapular section.*
F. *Integument covering the top of the back.*
G. *Integument covering the upper part
 of the outside of the thigh. Peculiar to
 women and children, and corresponding
 to the strongest portion of the Vastus
 externus muscle.*
Ha. *Cavity.*
I. *Crest of the thigh. Integumentary
 body covering the strongest portion of
 the Rectus muscle.*
H. *First plane of the back of the thigh.*
J. *Pubic integument.*
K. *Lower and upper planes of the um-
 bilical section.*
W. *Crest of umbilical section.*
M. *Supra-umbilical section.*
N. *Epigastric section.*

P. *Sternal section.*

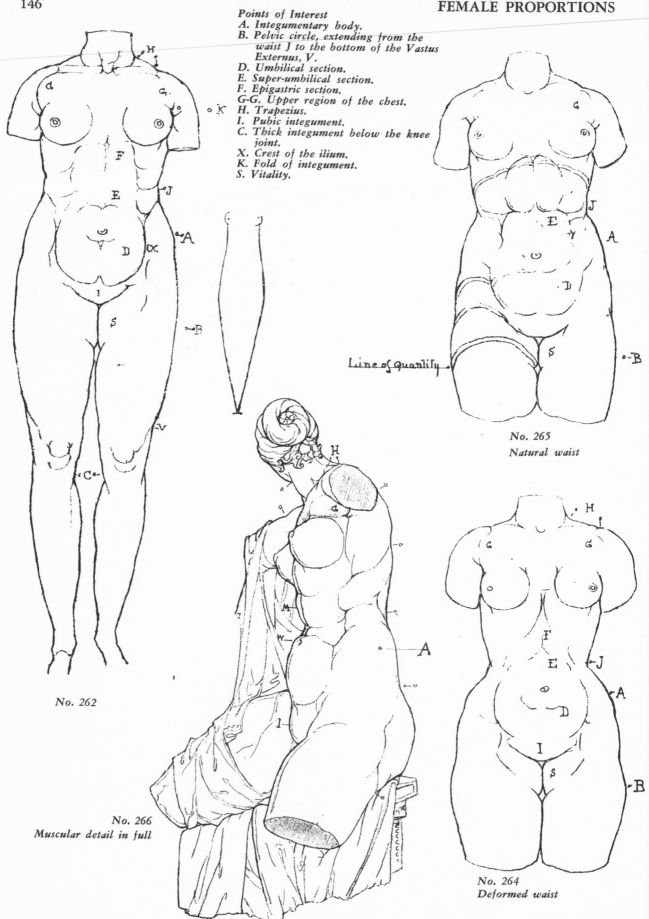

Points of Interest
A. *Integumentary body.*
B. *Pelvic circle, extending from the waist J to the bottom of the Vastus Externus, V.*
D. *Umbilical section.*
E. *Super-umbilical section.*
F. *Epigastric section.*
G-G. *Upper region of the chest.*
H. *Trapezius.*
I. *Pubic integument.*
C. *Thick integument below the knee joint.*
X. *Crest of the ilium.*
K. *Fold of integument.*
S. *Vitality.*

Line of Quantity

No. 265
Natural waist

No. 262

No. 266
Muscular detail in full

No. 264
Deformed waist

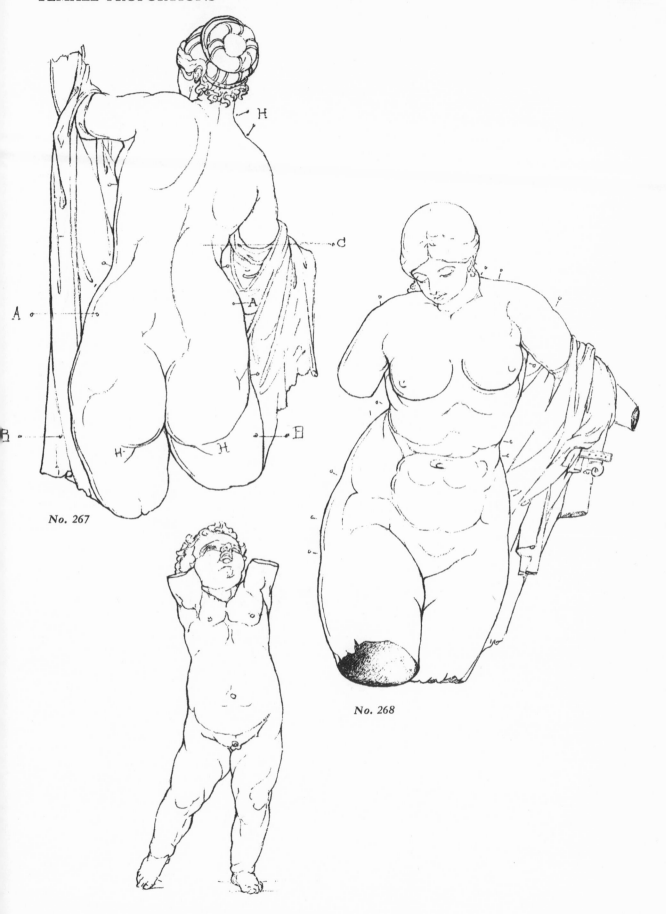

No. 267

No. 268

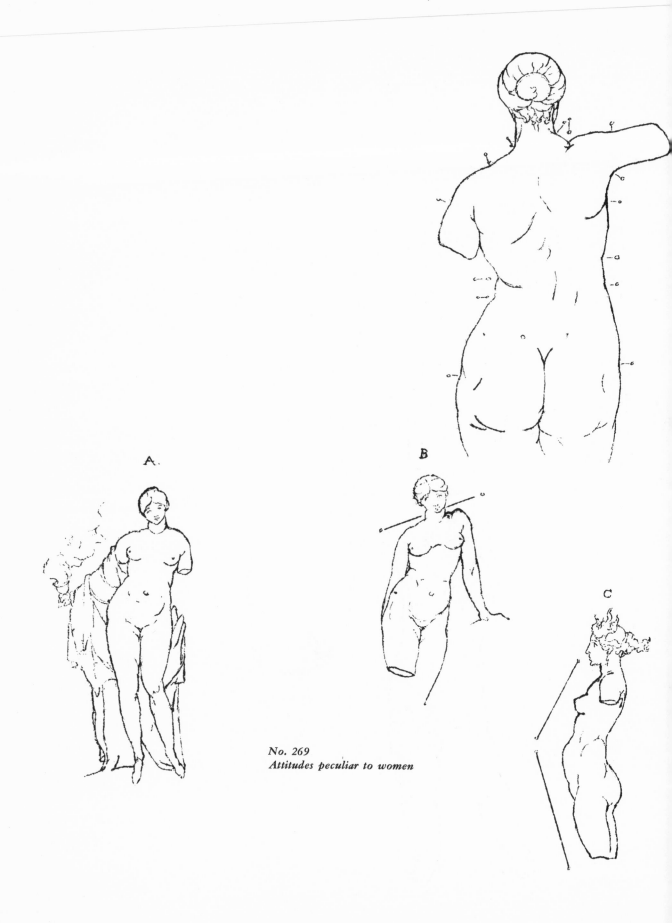

A.

B

C

No. 269
Attitudes peculiar to women

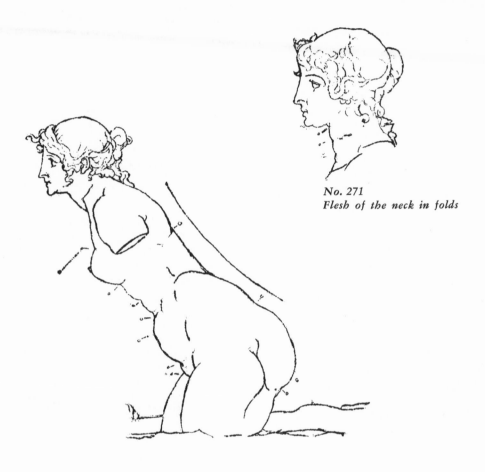

No. 271
Flesh of the neck in folds

No. 270

No. 272 Pelvic section, thigh, arm, and
shoulder seen from beneath.

In Fore-shortening, we represent the transverse pro-
portions of the local sections, and a careful study of
the outline in the vertical figure will show the relative
surface elevations of the different parts.

Parts which are fore-shortened should be supported
by an exhibition of parts which are not fore-shortened,
as in Nos. 273, 277, 278, 279. The transverse elements
can be fore-shortened only in their perspective re-
lations.

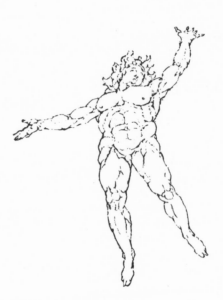

No. 273 Form of the pectoral and abdominal
sections one half fore-shortened.

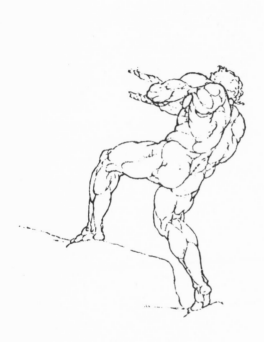

No. 274 One quarter fore-shortened.

No. 275 Three-quarters view. One third
fore-shortened.

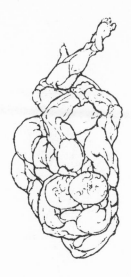

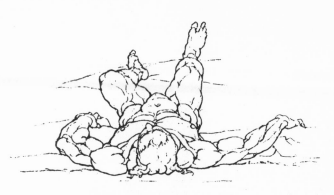

No. 277 Shoulder, clavicular, pectoral, abdominal, and flank sections seen from above and in front.

No. 276 Outline of shoulder and pelvic sections seen from above.

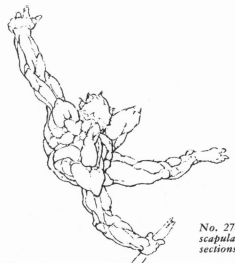

No. 278 Outline of the neck, shoulder, scapular, dorsal, clavicular, and umbilical sections seen from above and behind.

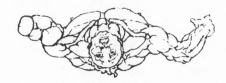

No. 279 Direct fore-shortening from above.

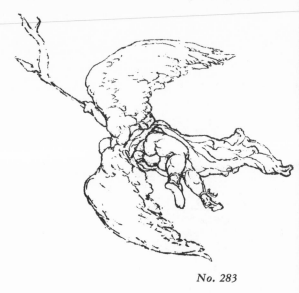

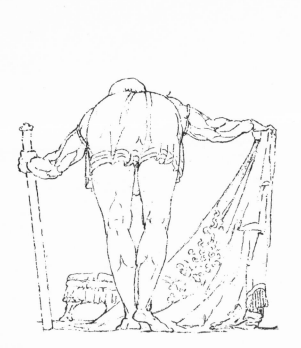

No. 283

No. 280

When such parts of the body as are not fore-shortened cover other parts, which from the character of the position must be fore-shortened, if seen, the truthfulness of the fore-shortening will depend upon the accuracy of the projecting part in relation to the supposed place of the part obscured. Fore-shortening of this description may be known as Fore-shortening by Obscuration.

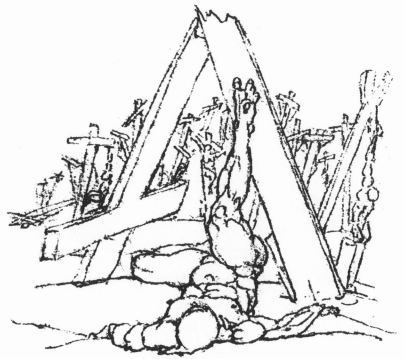

No. 285

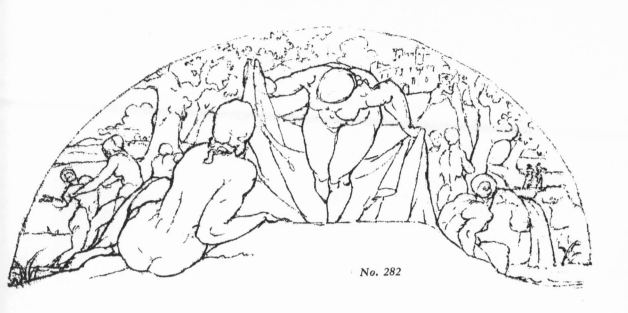

No. 282

No. 284

No. 281

Dover Books on Art

GRAPHIC WORLDS OF PETER BRUEGEL THE ELDER,
H. A. Klein. 64 of the finest etchings and engravings made from
the drawings of the Flemish master Peter Bruegel. Every aspect
of the artist's diversified style and subject matter is represented,
with notes providing biographical and other background in-
formation. Excellent reproductions on opaque stock with nothing
on reverse side. 63 engravings, 1 woodcut. Bibliography. xviii +
289pp. 11⅜ x 8¼. T1132 Paperbound $3.00

THE COMPLETE WOODCUTS OF ALBRECHT DURER,
edited by Dr. Willi Kurth. Albrecht Dürer was a master in vari-
ous media, but it was in woodcut design that his creative genius
reached its highest expression. Here are all of his extant wood-
cuts, a collection of over 300 great works, many of which are
not available elsewhere. An indispensable work for the art his-
torian and critic and all art lovers. 346 plates. Index. 285pp.
8½ x 12¼. T1097 Paperbound $2.50

GRAPHIC REPRODUCTION IN PRINTING, H. Curwen. A
behind-the-scenes account of the various processes of graphic
reproduction—relief, intaglio, stenciling, lithography, line
methods, continuous tone methods, photogravure, collotype—
and the advantages and limitations of each. Invaluable for all
artists, advertising art directors, commercial designers, adver-
tisers, publishers, and all art lovers who buy prints as a hobby.
137 illustrations, including 13 full-page plates, 10 in color. xvi +
171pp. 5¼ x 8½. T512 Clothbound $6.00

WILD FOWL DECOYS, Joel Barber. Antique dealers, collectors,
craftsmen, hunters, readers of Americana, etc. will find this the
only thorough and reliable guide on the market today to this
unique folk art. It contains the history, cultural significance, re-
gional design variations; unusual decoy lore; working plans for
constructing decoys; and loads of illustrations. 140 full-page
plates, 4 in color. 14 additional plates of drawings and plans by
the author. xxvii + 156pp. 7⅞ x 10¾. T11 Paperbound $2.75

1800 WOODCUTS BY THOMAS BEWICK AND HIS SCHOOL.
This is the largest collection of first-rate pictorial woodcuts in
print—an indispensable part of the working library of every
commercial artist, art director, production designer, packaging
artist, craftsman, manufacturer, librarian, art collector, and
artist. And best of all, when you buy your copy of Bewick, you
buy the rights to reproduce individual illustrations—no permis-
sion needed, no acknowledgments, no clearance fees! Classified
index. Bibliography and sources. xiv + 246pp. 9 x 12.
T766 Clothbound $10.00

THE SCRIPT LETTER, Tommy Thompson. Prepared by a noted
authority, this is a thorough, straightforward course of instruc-
tion with advice on virtually every facet of the art of script
lettering. Also a brief history of lettering with examples from
early copy books and illustrations from present day advertising
and packaging. Copiously illustrated. Bibliography. 128pp.
6½ x 9⅛. T1311 Paperbound $1.00

PRINCIPLES OF ART HISTORY, H. Wölfflin. This remarkably instructive work demonstrates the tremendous change in artistic conception from the 14th to the 18th centuries, by analyzing 164 works by Botticelli, Dürer, Hobbema, Holbein, Hals, Titian, Rembrandt, Vermeer, etc., and pointing out exactly what is meant by "baroque," "classic," "primitive," "picturesque," and other basic terms of art history and criticism. "A remarkable lesson in the art of seeing," SAT. REV. OF LITERATURE. Translated from the 7th German edition. 150 illus. 254pp. 6⅛ x 9¼. T276 Paperbound $2.00

FOUNDATIONS OF MODERN ART, A. Ozenfant. Stimulating discussion of human creativity from paleolithic cave painting to modern painting, architecture, decorative arts. Fully illustrated with works of Gris, Lipchitz, Léger, Picasso, primitive, modern artifacts, architecture, industrial art, much more. 226 illustrations. 368pp. 6⅛ x 9¼. T215 Paperbound $2.00

METALWORK AND ENAMELLING, H. Maryon. Probably the best book ever written on the subject. Tells everything necessary for the home manufacture of jewelry, rings, ear pendants, bowls, etc. Covers materials, tools, soldering, filigree, setting stones, raising patterns, repoussé work, damascening, niello, cloisonné, polishing, assaying, casting, and dozens of other techniques. The best substitute for apprenticeship to a master metalworker. 363 photos and figures. 374pp. 5½ x 8½.
T183 Clothbound $8.50

SHAKER FURNITURE, E. D. and F. Andrews. The most illuminating study of Shaker furniture ever written. Covers chronology, craftsmanship, houses, shops, etc. Includes over 200 photographs of chairs, tables, clocks, beds, benches, etc. "Mr. & Mrs. Andrews know all there is to know about Shaker furniture," Mark Van Doren, NATION. 48 full-page plates. 192pp. 7⅞ x 10¾. T679 Paperbound $2.00

LETTERING AND ALPHABETS, J. A. Cavanagh. An unabridged reissue of "Lettering," containing the full discussion, analysis, illustration of 89 basic hand lettering styles based on Caslon, Bodoni, Gothic, many other types. Hundreds of technical hints on construction, strokes, pens, brushes, etc. 89 alphabets, 72 lettered specimens, which may be reproduced permission-free. 121pp. 9¾ x 8. T53 Paperbound $1.35

THE HUMAN FIGURE IN MOTION, Eadweard Muybridge. The largest collection in print of Muybridge's famous high-speed action photos. 4789 photographs in more than 500 action-strip-sequences (at shutter speeds up to 1/6000th of a second) illustrate men, women, children—mostly undraped—performing such actions as walking, running, getting up, lying down, carrying objects, throwing, etc. "An unparalleled dictionary of action for all artists," AMERICAN ARTIST. 390 full-page plates, with 4789 photographs. Heavy glossy stock, reinforced binding with headbands. 7⅞ x 10¾. T204 Clothbound $10.00

ART ANATOMY, Dr. William Rimmer. One of the few books on art anatomy that are themselves works of art, this is a faithful reproduction (rearranged for handy use) of the extremely rare masterpiece of the famous 19th century anatomist, sculptor, and art teacher. Beautiful, clear line drawings show every part of the body—bony structure, muscles, features, etc. Unusual are the sections on falling bodies, foreshortenings, muscles in tension, grotesque personalities, and Rimmer's remarkable interpretation of emotions and personalities as expressed by facial features. It will supplement every other book on art anatomy you are likely to have. Reproduced clearer than the lithographic original (which sells for $500 on up on the rare book market.) Over 1,200 illustrations. xiii + 153pp. 7¾ x 10¾.

T908 Paperbound $2.00

THE CRAFTSMAN'S HANDBOOK, Cennino Cennini. The finest English translation of IL LIBRO DELL' ARTE, the 15th century introduction to art technique that is both a mirror of Quatrocento life and a source of many useful but nearly forgotten facets of the painter's art. 4 illustrations. xxvii + 142pp. D. V. Thompson, translator. 5⅜ x 8. T54 Paperbound $1.35

THE BROWN DECADES, Lewis Mumford. A picture of the "buried renaissance" of the post-Civil War period, and the founding of modern architecture (Sullivan, Richardson, Root, Roebling), landscape development (Marsh, Olmstead, Eliot), and the graphic arts (Homer, Eakins, Ryder). 2nd revised, enlarged edition. Bibliography. 12 illustrations. xiv + 266 pp. 5⅜ x 8.

T200 Paperbound $1.75

THE STYLES OF ORNAMENT, A. Speltz. The largest collection of line ornament in print, with 3750 numbered illustrations arranged chronologically from Egypt, Assyria, Greeks, Romans, Etruscans, through Medieval, Renaissance, 18th century, and Victorian. No permissions, no fees needed to use or reproduce illustrations. 400 plates with 3750 illustrations. Bibliography. Index. 640pp. 6 x 9. T577 Paperbound $2.50

THE ART OF ETCHING, E. S. Lumsden. Every step of the etching process from essential materials to completed proof is carefully and clearly explained, with 24 annotated plates exemplifying every technique and approach discussed. The book also features a rich survey of the art, with 105 annotated plates by masters. Invaluable for beginner to advanced etcher. 374pp. 5⅜ x 8. T49 Paperbound $2.50

OF THE JUST SHAPING OF LETTERS, Albrecht Dürer. This remarkable volume reveals Albrecht Dürer's rules for the geometric construction of Roman capitals and the formation of Gothic lower case and capital letters, complete with construction diagrams and directions. Of considerable practical interest to the contemporary illustrator, artist, and designer. Translated from the Latin text of the edition of 1535 by R. T. Nichol. Numerous letterform designs, construction diagrams, illustrations. iv + 43pp. 7⅞ x 10¾. T1306 Paperbound $1.25

ANIMALS IN MOTION, Eadweard Muybridge. The largest collection of animal action photos in print. 34 different animals (horses, mules, oxen, goats, camels, pigs, cats, lions, gnus, deer, monkeys, eagles—and 22 others) in 132 characteristic actions. All 3919 photographs are taken in series at speeds up to 1/1600th of a second, offering artists, biologists, cartoonists a remarkable opportunity to see exactly how an ostrich's head bobs when running, how a lion puts his foot down, how an elephant's knee bends, how a bird flaps his wings, thousands of other hard-to-catch details. "A really marvellous series of plates," NATURE. 380 full-page plates. Heavy glossy stock, reinforced binding with headbands. 7⅞ x 10¾. T203 Clothbound $10.00

THE BOOK OF SIGNS, R. Koch. 493 symbols—crosses, monograms, astrological, biological symbols, runes, etc.—from ancient manuscripts, cathedrals, coins, catacombs, pottery. May be reproduced permission-free. 493 illustrations by Fritz Kredel. 104pp. 6⅛ x 9¼. T162 Paperbound $1.00

A HANDBOOK OF EARLY ADVERTISING ART, C. P. Hornung. The largest collection of copyright-free early advertising art ever compiled. Vol. I: 2,000 illustrations of animals, old automobiles, buildings, allegorical figures, fire engines, Indians, ships, trains, more than 33 other categories! Vol. II: Over 4,000 typographical specimens; 600 Roman, Gothic, Barnum, Old English faces; 630 ornamental type faces; hundreds of scrolls, initials, flourishes, etc. "A remarkable collection," PRINTERS' INK.

Vol. I: Pictorial Volume. Over 2000 illustrations. 256pp. 9 x 12.
 T122 Clothbound $10.00

Vol. II: Typographical Volume. Over 4000 specimens. 319pp.
9 x 12. T123 Clothbound $10.00
 Two volume set, Clothbound, only $18.50

THE UNIVERSAL PENMAN, George Bickham. Exact reproduction of beautiful 18th-century book of handwriting. 22 complete alphabets in finest English roundhand, other scripts, over 2000 elaborate flourishes, 122 calligraphic illustrations, etc. Material is copyright-free. "An essential part of any art library, and a book of permanent value," AMERICAN ARTIST. 212 plates. 224pp. 9 x 13¾. T20 Clothbound $10.00

AN ATLAS OF ANATOMY FOR ARTISTS, F. Schider. This standard work contains 189 full-page plates, more than 647 illustrations of all aspects of the human skeleton, musculature, cutaway portions of the body, each part of the anatomy, hand forms, eyelids, breasts, location of muscles under the flesh, etc. 59 plates illustrate how Michelangelo, da Vinci, Goya, 15 others, drew human anatomy. New 3rd edition enlarged by 52 new illustrations by Cloquet, Barcsay. "The standard reference tool," AMERICAN LIBRARY ASSOCIATION. "Excellent," AMERICAN ARTIST. 189 plates, 647 illustrations. xxvi + 192pp. 7⅞ x 10⅝. T241 Clothbound $6.00

AN ATLAS OF ANIMAL ANATOMY FOR ARTISTS, W. Ellenberger, H. Baum, H. Dittrich. The largest, richest animal anatomy for artists in English. Form, musculature, tendons, bone structure, expression, detailed cross sections of head, other features, of the horse, lion, dog, cat, deer, seal, kangaroo, cow, bull, goat, monkey, hare, many other animals. "Highly recommended," DESIGN. Second, revised, enlarged edition with new plates from Cuvier, Stubbs, etc. 288 illustrations. 153pp. 11⅜ x 9.
<div align="right">T82 Clothbound $6.00</div>

ANIMAL DRAWING: ANATOMY AND ACTION FOR ARTISTS, C. R. Knight. 158 studies, with full accompanying text, of such animals as the gorilla, bear, bison, dromedary, camel, vulture, pelican, iguana, shark, etc., by one of the greatest modern masters of animal drawing. Innumerable tips on how to get life expression into your work. "An excellent reference work," SAN FRANCISCO CHRONICLE. 158 illustrations. 156pp. 10½ x 8½.
<div align="right">T426 Paperbound $2.00</div>

ARCHITECTURAL AND PERSPECTIVE DESIGNS, Giuseppe Galli Bibiena. 50 imaginative scenic drawings of Giuseppe Galli Bibiena, principal theatrical engineer and architect to the Viennese court of Charles VI. Aside from its interest to art historians, students, and art lovers, there is a whole Baroque world of material in this book for the commercial artist. Portrait of Charles VI by Martin de Meytens. 1 allegorical plate. 50 additional plates. New introduction. vi + 103pp. 10⅛ x 13¼.
<div align="right">T1263 Paperbound $2.25</div>

HANDBOOK OF DESIGNS AND DEVICES, C. P. Hornung. A remarkable working collection of 1836 basic designs and variations, all copyright-free. Variations of circle, line, cross, diamond, swastika, star, scroll, shield, many more. Notes on symbolism. "A necessity to every designer who would be original without having to labor heavily," ARTIST AND ADVERTISER. 204 plates. 240pp. 5⅜ x 8.
<div align="right">T125 Paperbound $1.90</div>

CHINESE HOUSEHOLD FURNITURE, G. N. Kates. A summary of virtually everything that is known about authentic Chinese furniture before it was contaminated by the influence of the West. The text covers history of styles, materials used, principles of design and craftsmanship, and furniture arrangement—all fully illustrated. xiii + 190pp. 5⅝ x 8½.
<div align="right">T958 Paperbound $1.50</div>

DECORATIVE ART OF THE SOUTHWESTERN INDIANS, D. S. Sides. 300 black and white reproductions from one of the most beautiful art traditions of the primitive world, ranging from the geometric art of the Great Pueblo period of the 13th century to modern folk art. Motives from basketry, beadwork, Zuni masks, Hopi kachina dolls, Navajo sand pictures and blankets, and ceramic ware. Unusual and imaginative designs will inspire craftsmen in all media, and commercial artists may reproduce any of them without permission or payment. xviii + 101pp. 5⅝ x 8⅜.
<div align="right">T139 Paperbound $1.00</div>

MASTERPIECES OF FURNITURE, Verna Cook Salomonsky. Photographs and measured drawings of some of the finest examples of Colonial American, 17th century English, Windsor, Sheraton, Hepplewhite, Chippendale, Louis XIV, Queen Anne, and various other furniture styles. The textual matter includes information on traditions, characteristics, background, etc. of various pieces. 101 plates. Bibliography. 224pp. 7⅞ x 10¾.

T1381 Paperbound $2.00

PRIMITIVE ART, Franz Boas. In this exhaustive volume, a great American anthropologist analyzes all the fundamental traits of primitive art, covering the formal element in art, representative art, symbolism, style, literature, music, and the dance. Illustrations of Indian embroidery, paleolithic paintings, woven blankets, wing and tail designs, totem poles, cutlery, earthenware, baskets and many other primitive objects and motifs. Over 900 illustrations. 376pp. 5⅜ x 8. T25 Paperbound $2.00

AN INTRODUCTION TO A HISTORY OF WOODCUT, A. M. Hind. Nearly all of this authoritative 2-volume set is devoted to the 15th century—the period during which the woodcut came of age as an important art form. It is the most complete compendium of information on this period, the artists who contributed to it, and their technical and artistic accomplishments. Profusely illustrated with cuts by 15th century masters, and later works for comparative purposes. 484 illustrations. 5 indexes. Total of xi + 838pp. 5⅜ x 8½. Two-volume set, T952-3 Paperbound $5.00

A HISTORY OF ENGRAVING AND ETCHING, A. M. Hind. Beginning with the anonymous masters of 15th century engraving, this highly regarded and thorough survey carries you through Italy, Holland, and Germany to the great engravers and beginnings of etching in the 16th century, through the portrait engravers, master etchers, practicioners of mezzotint, crayon manner and stipple, aquatint, color prints, to modern etching in the period just prior to World War I. Beautifully illustrated —sharp clear prints on heavy opaque paper. Author's preface. 3 appendixes. 111 illustrations. xviii + 487 pp. 5⅜ x 8½.

T954 Paperbound $2.75

ART STUDENTS' ANATOMY, E. J. Farris. Teaching anatomy by using chiefly living objects for illustration, this study has enjoyed long popularity and success in art courses and home-study programs. All the basic elements of the human anatomy are illustrated in minute detail, diagrammed and pictured as they pass through common movements and actions. 158 drawings, photographs, and roentgenograms. Glossary of anatomical terms. x + 159pp. 5⅝ x 8⅜. T744 Paperbound $1.50

Prices subject to change without notice.

Dover publishes books on art, music, philosophy, literature, languages, history, social sciences, psychology, handcrafts, orientalia, puzzles and entertainments, chess, pets and gardens, books explaining science, intermediate and higher mathematics, mathematical physics, engineering, biological sciences, earth sciences, classics of science, etc. Write to:

Dept. catrr.
Dover Publications, Inc.
180 Varick Street, N.Y. 14, N.Y.